I seems the whole
world is being
stripped of innocence.
or maybe it's just
that I see things too
clearly now.

Sept 2011

(ie photographs)
Pictures are
everywhere
you just have to
Look

THE
Joy of
Life
TO Wake up
TOMORROW

every day
is
christmas Day

imagination is more
important than Knowledge,
Knowledge is limited,
whereas imagination
encompasses the whole
world
~ albert einstein ~

Start Something NEW
—
THE LOVE OF LIFE
—
NO ONE CARES HOW GOOD
YOU USED TO BE
KEEP HUMBLE
—

Claridge's LIBERATION
IN OUT
SIMPLE PRETENTIOUS
COOKING CUISINE
HUMBLE FLASH
INDIVIDUALLY LARGE
OWNED SHOPS OVER DISTRIBUTED
 BRANDS

Brook Street, London W1K 4HR
Telephone (020) 7629 8860. Facsimile (020) 7499 2210

Taps you turn.
Doors you bolt
lights you switch
on

DON'T COUNT THE
DAYS
MAKE THE DAYS
COUNT!

EVERY DAY
IS A NEW
BEGINNING

HELLO, MY NAME IS PAUL SMITH

FASHION AND OTHER STORIES

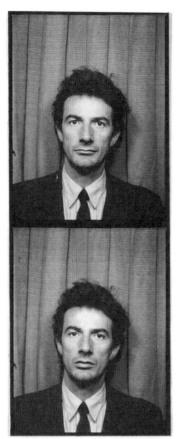
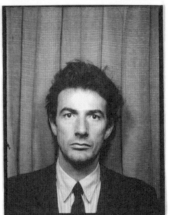
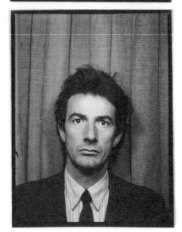

HELLO, MY NAME IS PAUL SMITH

FASHION AND OTHER STORIES

BY PAUL SMITH, DEYAN SUDJIC AND DONNA LOVEDAY
EDITED BY ALAN ABOUD

RIZZOLI
NEW YORK

New York · Paris · London · Milan

OPPOSITE *Painting of Paul by Karl Kopinski, 2012*

First published in the United States of America in 2013
by RIZZOLI INTERNATIONAL PUBLICATIONS
300 Park Avenue South
New York, NY 10010
www.rizzoliusa.com

In association with
DESIGN MUSEUM, LONDON
Shad Thames
London SE1 2YD
www.designmuseum.org

Edited by Alan Aboud

Rizzoli Editor: Dung Ngo
Art Direction: Aboud Creative
Design: Alan Aboud, Lisa Comerford, Jo Mansfield
Image and Design Production: Jamie Register
Editorial Assistant: Giulia Ascoli
Cover photography: Stephen Langmanis and Alan Aboud

ISBN-13: 978-0-8478-4158-5
Library of Congress Control Number: 2013944697

Printed and bound in Italy

2016 2017 2018 2019 / 10 9 8 7 6 5 4 3

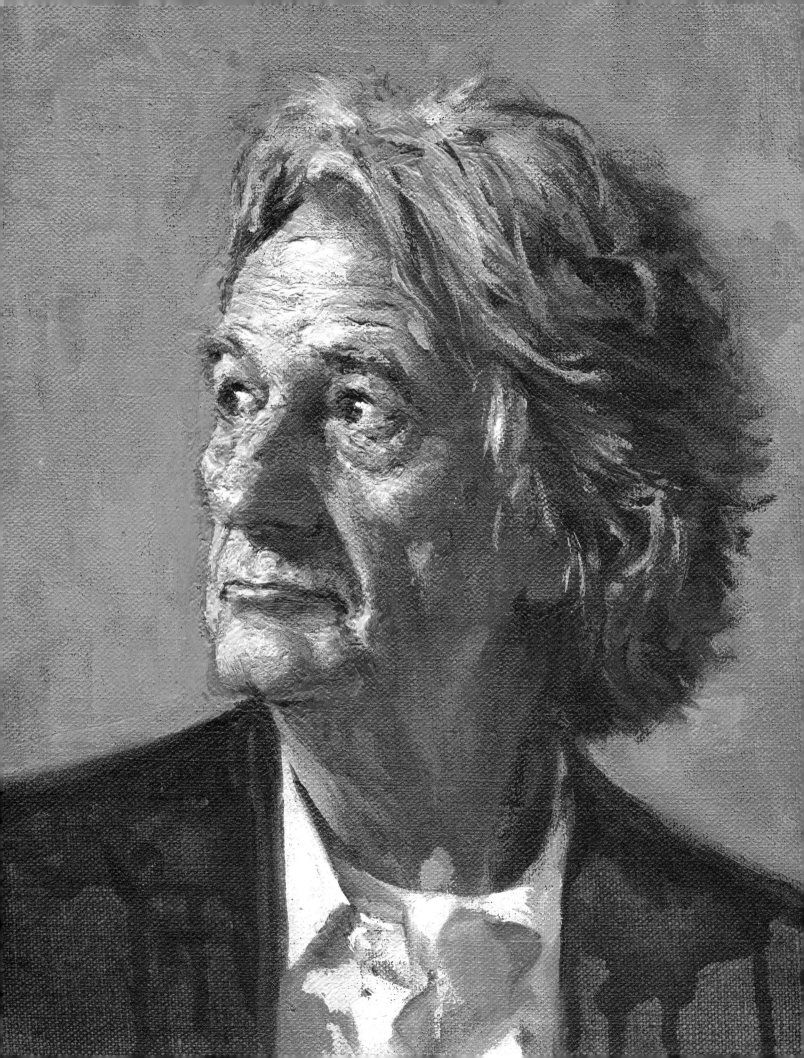

CONTENTS

PAUL B. SMITH

39 Abbey Road · Beeston
Nottingham Tel. 254204

Paul Smith

10 Byard Lane, Nottingham, Tel. (0602) 48105

PAUL SMITH **33 TATTERSHALL DRIVE**

THE PARK

NOTTINGHAM

TELEPHONE 48105

Paul Smith

Paul Smith

40-44 Floral Street, London WC2E 9DG, England.
Telephone +44 0207 836 7828 Facsimile +44 0207 379 0241

Personal Assistant: Colette Youell
Telephone +44 0207 240 5420 Ext. 210

Paul Smith

Limited

Paul Smith

Studio & Shop
43-44 Floral Street, Covent Garden, London WC2E 9DJ, England. Tel: 01 379 7133, Telex: 277288
Warehouse
Stanford House, 6 Stanford Street, Nottingham NG1 7BQ, England. Tel: (0602) 590823, Telex: 377288

Paul Smith

41 Bridlesmith Gate
NOTTINGHAM
(0602) 55326

International clothing by
Saint Laurent
Daniel Hechter
Newman
Cacharel

and many more

Paul Smith

LINCROFT CLOTHING CO. LTD.

Lincroft House
38-40 Kennington Park Road
London SE 11
Telephone 01-735-6256/7/8

Telephone Nottm. 48105

**PAUL SMITH
AGENCY**

6, BYARD LANE
NOTTINGHAM

Represented by
Rob Bayliss

Stock room open
Friday & Saturday only

PAUL AND MY WARDROBE

BY
DEYAN SUDJIC

Of the many critics and writers who, over the years, have tried to come up with a convincing way of accounting for the endlessly puzzling underlying dynamics of the world of fashion, none have done so more succinctly or with more wit than James Laver. He was a curator in the department of prints and drawings at the Victoria and Albert Museum with an unlikely sideline as a successful poet and novelist. In 1937 he wrote *Taste and Fashion: From the French Revolution to the Present Day*, a book in which he outlined what has come to be known as Laver's Law. This was the concept with which he tried to define precisely how many years it would take for transgressive dress to come to be seen as nothing more challenging than the newest version of the avant-garde and then to decay into being simply old hat. Laver, in his amusing and amused way, drew our attention to how our attitudes towards clothes change as we become more familiar with the multiple languages of fashion on which they depend. If clothes look too far ahead of their time, they are unacceptably outrageous. Fashion that is not past its time enough is regarded with scorn rather than nostalgia. But after this stage, the formerly outrageous, which subsequently becomes the dowdy, will sooner or later come to be reconsidered once again and understood as constituting the beautiful. Laver believed that it takes at least ten years for the indecent to move through the shameless and then for the outré stage to become smart. One year later, it will be considered dowdy; in ten years' time, it will be seen as plain hideous. In the course of the passing of another century, it will have become in turn ridiculous, amusing, quaint, charming, and romantic.

When I described this trajectory to Paul Smith, sitting at a table in the café at the Design Museum early one morning, he took out one of the endless sequence of little blue-lined notebooks that he has carried with him everywhere that he goes for many decades. He uncapped his fountain pen, wrote down the name Laver, and underlined it in turquoise-blue ink. And then, he put the notebook away again, tucking it into the inner pocket of the dark wool suit jacket that he was wearing over a pair of denim jeans.

10 YEARS BEFORE ITS TIME

INDECENT

5 YEARS BEFORE ITS TIME

SHAMELESS

1 YEAR BEFORE ITS TIME

OUTRÉ

'CURRENT FASHION'

SMART

1 YEAR AFTER ITS TIME

DOWDY

10 YEARS AFTER ITS TIME

HIDEOUS

20 YEARS AFTER ITS TIME

RIDICULOUS

30 YEARS AFTER ITS TIME

AMUSING

50 YEARS AFTER ITS TIME

QUAINT

70 YEARS AFTER ITS TIME

CHARMING

100 YEARS AFTER ITS TIME

Romantic

150 YEARS AFTER ITS TIME

BEAUTIFUL

LAVER'S LAW, TASTE AND FASHION (1937)

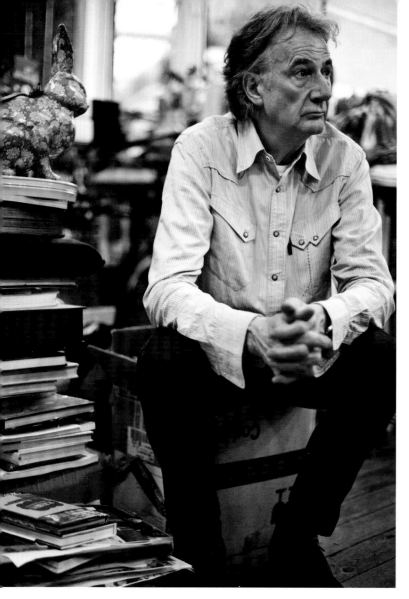

LEFT *Paul in his office at Kean Street, London*
ABOVE *Paul's notebook*
OPPOSITE *Paul and his camera*

Writing things down is one of the ways that Smith keeps track of the countless images and ideas that cross his insatiably curious mind every waking minute of every day. When I first saw him do it, I had assumed that all his notes would end up back at his office, to be carefully collated by an assistant (very probably of the kind that works for Meryl Streep in *The Devil Wears Prada*), typed, and placed in ring binders for follow-up. Having seen his desk, I am now not sure that this is exactly how it works.

Smith is always hungry for new ideas, and he always wants to record them in some way, even though his dyslexia means that he is not exactly an enthusiastic reader of text. The notes, sometimes made on a scrap of paper rather than in a notebook, are one way of doing that. His digital camera is another.

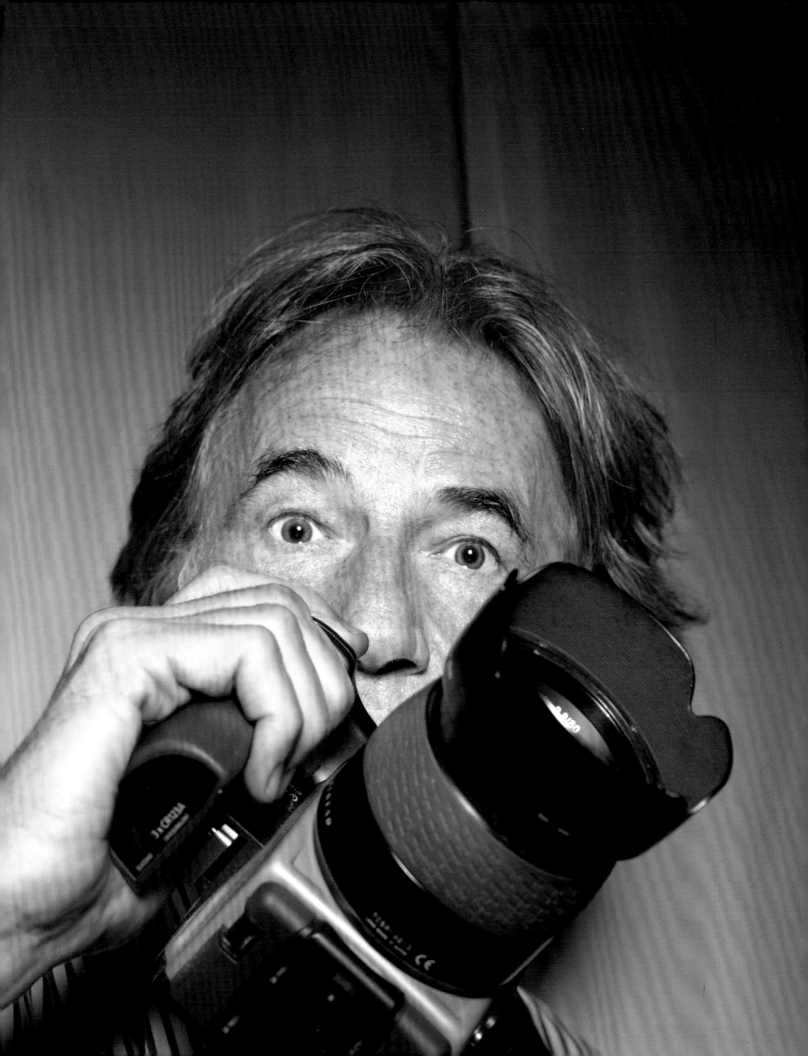

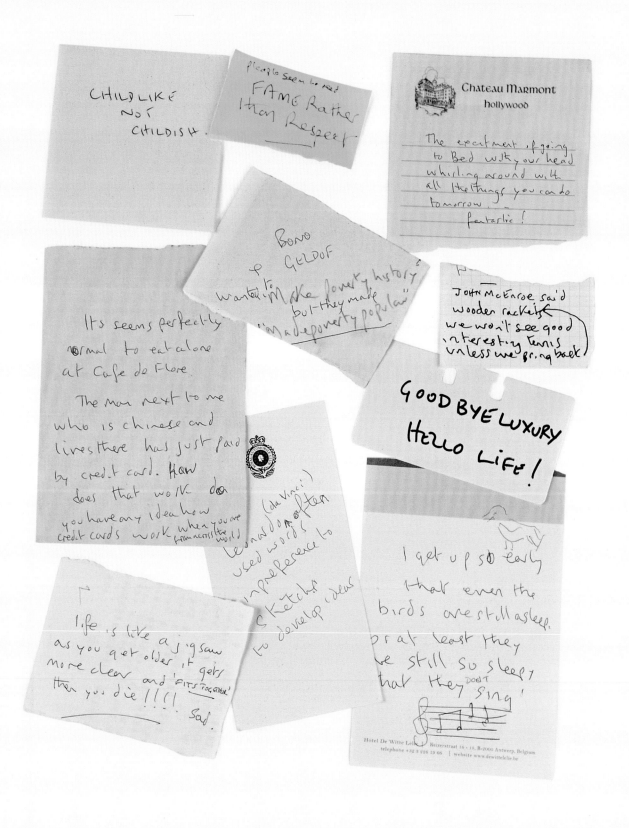

CHILDLIKE
NOT
CHILDISH.

people seem to need
FAME Rather
than Respect

Chateau Marmont
hollywood

The excitement of going
to Bed with your head
whirling around with
all the things you can do
tomorrow...
fantastic!

Bono
GELDOF
wanted to "make poverty history"
but they made
"made poverty popular"

JOHN McEnroe said
wooden rackets
we won't see good
interesting tennis
unless we bring back

Its seems perfectly
normal to eat alone
at Cafe de Flore.

The man next to me
who is chinese and
lives there has just paid
by credit card. How
does that work do
you have any idea how
credit cards work when you are
from across the world

(da Vinci)
Leonardo da often
used words
in preference to
sketches
to develop ideas

GOOD BYE LUXURY
HELLO LIFE!

I get up so early
that even the
birds are still asleep.
or at least they
are still so sleepy
that they DON'T sing!

Life is like a jigsaw
as you get older it gets
more clear and "fits together"
then you die!!!! Sad.

Hôtel De Witte Lelie Keizerstraat 16 - 18, B-2000 Antwerp, Belgium
telephone +32 3 226 19 66 | website www.dewittelelie.be

16

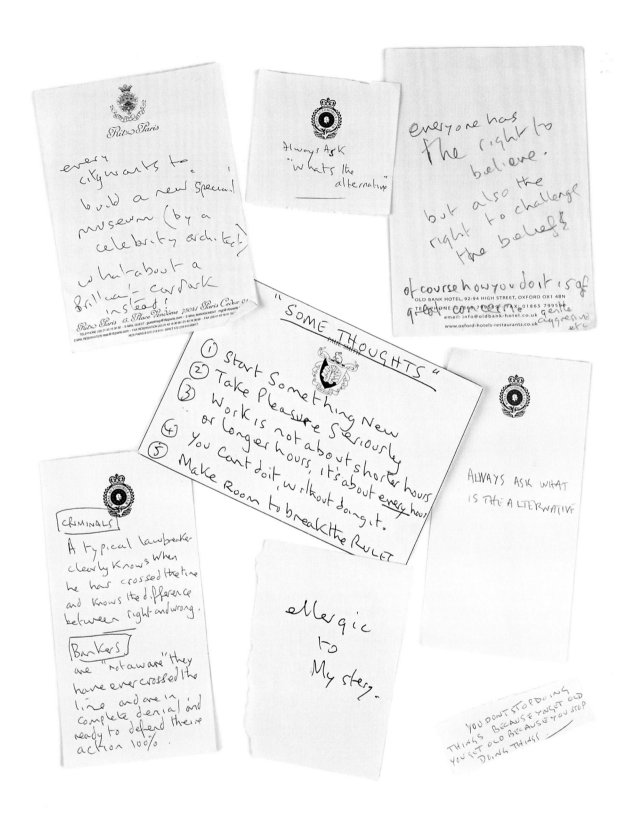

every city wants to build a new special museum (by a celebrity architect) what about a brilliant carpark instead!

Ritz Paris 15, Place Vendôme 75041 Paris Cedex 01
TELEPHONE (33) 01 43 16 30 30 · E MAIL GUEST : guest@ritzparis.com · E MAIL MANAGEMENT : mgt@ritzparis.com
E MAIL RESERVATION resa@ritzparis.com (33) 01 43 16 36 68 / 01 43 16 36 68 · FAX (33) 01 43 16 31 78 /
RCS PARIS B 572 219 913 · SIRET 572 219 913 00017

Always Ask "what's the alternative"

everyone has the right to believe. but also the right to challenge the beliefs.

of course how you do it is of great concern gentle aggresive etc

OLD BANK HOTEL, 92-94 HIGH STREET, OXFORD OX1 4BN
TELEPHONE: 01865 799599 · FAX: 01865 799598
email: info@oldbank-hotel.co.uk
www.oxford-hotels-restaurants.co.uk

"SOME THOUGHTS"

① Start Something New
② Take Pleasure Seriously
③ Work is not about shorter hours or longer hours, it's about every hour
④ You Cant do it, without doing it.
⑤ Make Room to break the RULES

ALWAYS ASK WHAT IS THE ALTERNATIVE

CRIMINALS
A typical lawbreaker clearly knows when he has crossed the line and knows the difference between right and wrong.

Bankers
are "not aware" they have ever crossed the line and are in complete denial and ready to defend their action 100%.

Magic to Mystery.

YOU DONT STOP DOING THINGS BECAUSE YOU GET OLD YOU GET OLD BECAUSE YOU STOP DOING THINGS

17

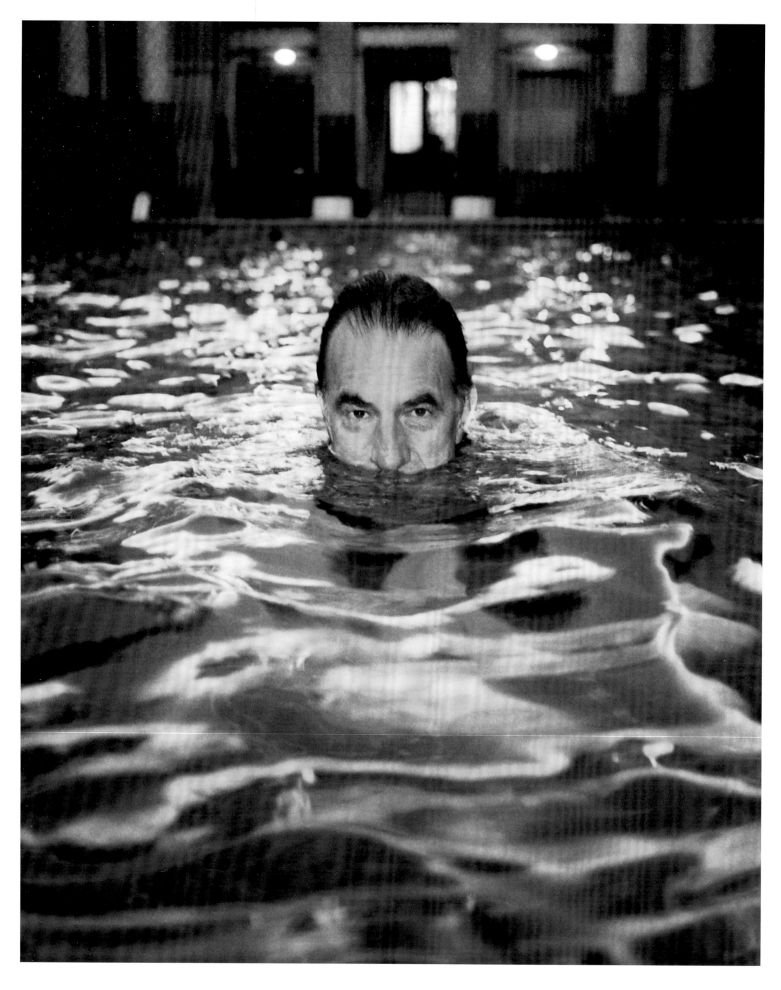

He was in the museum on one of his regular early morning visits to Shad Thames. Over the years he has come to see a lot of the museum's exhibitions, from retrospectives on the classic modernism of Jean Prouvé to the work in progress of Ettore Sottsass, from the minimalism of Dieter Rams's monochrome vision for Braun to the work of Wim Crouwel, the most austere of Dutch graphic designers. He uses these visits to catch up with the classics, but he is equally interested in the young unknowns.

He is interested in seeing more of the designers that we showcase but also in the designers that we work with to make our shows. How the shows are designed and who did the graphics and the layouts matter to him as much as the content. And he is always looking for new designers to work with on anything from packaging to brochures and buildings.

Smith is also interested in what every other museum and gallery is doing. He has an extraordinarily impressive ability to go on being curious about new work, no matter how much he has already seen of it. He gives the impression of having been inoculated against becoming jaded or cynical about youthful experimentation. He has an enthusiasm for creativity that shows not the least sign of drying up. He has a constant fascination with what the next generation is up to, but he is not uncritical. He is unimpressed by self-promotion and pretension, and he is not afraid to say so, despite his unfeigned and ever-present politeness.

Smith had started the day early. Like most mornings when he is in London, he was up before 6 a.m. Before coming to the museum, he had swum multiple laps in the pool at the Royal Automobile Club (RAC) in Pall Mall, with its opulent Edwardian setting of white marble, mahogany doors, and polished brass fittings. A lot of other mornings, however, he is not in London. Every year he makes at least two trips to Japan, where he is one of the most prominent names in the fashion landscape. Going to Tokyo regularly allows him to keep his finger on the pulse of one of his most important markets – and to swim in the pool at the Park Hyatt.

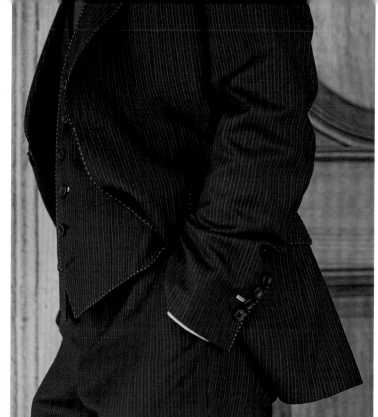

ABOVE *Suit cloth during manufacture*
RIGHT *Autumn Winter 2013, Paul Smith Collection pinstripe suit*
OPPOSITE *Clothing patterns in the archive, Nottingham*

Then there are the essential fabric-buying trips to Italy and France, notably to the annual trade fairs, Milano Unica in Milan and Première Vision in Paris. These are the places where the mills set up their stalls and show their new lines. It's where the deals are done, and quick decisions are made in corridors about the quantities and prices that will shape the way that a collection looks, and how well it will sell eight or nine months later.

These trips are the starting points for Smith's design work. Every suit begins with a bolt of cloth. Every shirt begins with the choice of the cotton or wool or linen from which it is going to be made. Every tie starts with a search through hundreds of fabric swatches, sometimes with the use of a cardboard template, which provides a handy tie-shaped frame that helps Smith to make quick decisions about colour, pattern, and finish when faced with endless alternatives.

Textiles are fundamental. They are the bedrock of fashion and where the fashion story begins. It is not just the cut of a suit or the length of a skirt that reflects the zeitgeist. Textiles can be an equally clear expression of the flavour of a particular moment. The pinstripes that were once an essential part of the Smith range of suits all but vanished in the wake of the banking scandals of the credit-crunch

years. In the aftermath of the financial meltdown of 2008, nobody wanted to look like a banker, or to be identifiable as a broker or a hedge-fund manager or as a master of any department of the universe. Any textile mill that did not realize that truth was in trouble. And as a result, for some years, pinstripes all but vanished from the fashion palette.

The relationship between fashion houses and textile mills is an essential element in the fashion cycle. A fashion house like Smith's depends not only on the innovation of the mills it works with but also on how reliable they will be in delivering the cloth on time. Smith uses trusted manufacturers to produce the designs that are ordered every season. It's an intricate process, one in which reliability is as important as quality and creativity. It is vital that the factory is able to deliver the textiles in time for them to be made up and shipped ready for the next season to shops in New York and London, in Hong Kong and Moscow. And if the fabric hasn't arrived in time from the mills to the factories, then the completed clothes won't be with the buyers in time to get them into the shops on the contracted dates. If that happens, it is Smith's reputation for reliability that suffers most, not that of his suppliers. And it is Smith who has to face the angry retailers left with fewer days to sell the collection before the next season arrives.

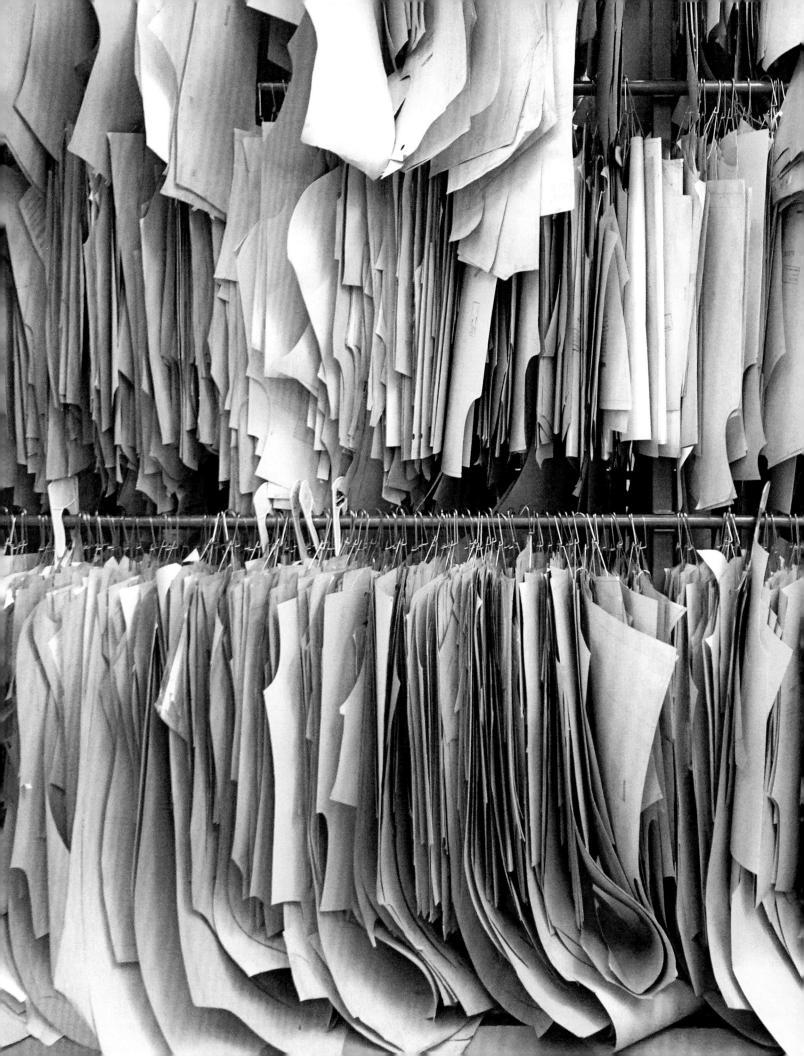

When he was getting started, Smith worked with English mills in the Midlands and Yorkshire. These were the places that made the traditional textiles that Smith used in unfamiliar ways. Since then, he has looked everywhere. For example, Italian suiting fabrics have a strong reputation for both quality and creativity.

To Smith's teams, it's as obvious which country a textile comes from as it is that Citroëns are from France and Volkswagens are from Germany. Inevitably mills prefer to work with those designers whose clothes not only sell in large quantities but also reflect well on their suppliers. The prestige of one reinforces that of the other. Unknown designers wanting to place orders for a few yards of fabric are not going to be able to work with mills that would rather be selling their designs exclusively to Giorgio Armani or Prada. On the other hand, being associated with the up-and-comers can also be helpful for the image of a long-established mill. In the early days, Smith struggled to make orders that would be large enough to interest the more successful mills. And he had to work hard to get the extended credit that it takes to fill the gap between ordering the cloth and getting paid by the stores that bought the finished clothes. He experimented with various mills that were ready to take creative risks, but he found that they couldn't always deliver on time, or control quality consistently enough. As Smith's business has grown, his

label has become one that ambitious mills are interested in working with. They are much readier now to offer him keener prices and to make exclusive designs for him.

Smith has been based in a plain brick Victorian building in Covent Garden since 2003. It's a short walk from 43 Floral Street where he had his first London shop, with an office in the attic, when he moved down from Nottingham. On the outside there is little more than a copper ribbon that serves as a door handle to suggest that this is not a conventional office block, or even a warehouse.

Inside, the reception desk looks as if it was salvaged from the drapery section of an elderly department store. The bare brick walls, the Bruce Weber photographs, and the cascade of naked light bulbs hanging from the ceiling set a different tone. Some fashion houses photograph each visitor and put the result in a plastic name badge to be worn at all times. This is not the way that they do things in Kean Street. As you progress up the building towards Smith's own two rooms on the top floor, it's the smells you encounter on the way that tell you that this is no ordinary office block. There is the distinctive tang of bolts of woollen cloth. In the studio that works on accessories, you get the sharp smell of cured-leather hides. In another studio, there is the dusty scent of ancient books of textile samples from long-gone mills and fragments of nineteenth-century wallpaper.

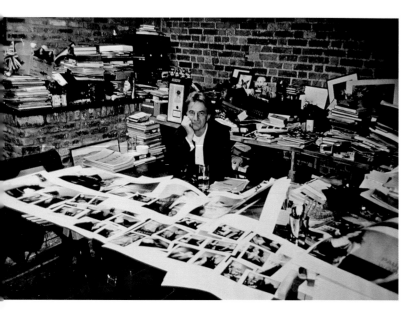

ABOVE *The original office at Floral Street, London*
RIGHT *Reception at Kean Street, London*
OPPOSITE *A vintage wallpaper pattern sample book*

23

Each collection attempts to interpret the essence of the Paul Smith approach in a way that works for a particular audience.

The specialist teams that guide each of the collections, carefully targeted at particular customers, are based here. There are fourteen main collections now, from Jeans and PS to Paul Smith London and the Men's catwalk collection at the poles, respectively of the price and formality spectrums. There are similar gradations in the women's collections. Each collection attempts to interpret the essence of the Paul Smith approach in a way that works for a particular audience. It's not only a question of price. Somebody wearing a Paul Smith suit to the office during the week is going to want something else to wear to a party, or on holiday. The work of the designers has to respond to specific price ranges, which is essentially a product of the quantity and quality of the fabric, and its degree of exclusivity. There is a room devoted to shoes. The two young men who work there, surrounded by samples, seek to find ways of using new and unfamiliar materials and unconventional soles. There are pattern cutters and illustrators. On the floor above, there are the store designers who work on how the shops look – no two are the same – and on footwear, luggage, and accessories. There is another room, staffed by people who were not yet born when Smith first came to Covent Garden, which is devoted to the Smith online presence, as well as a press room.

OPPOSITE *Family tree showing the Paul Smith Collections*

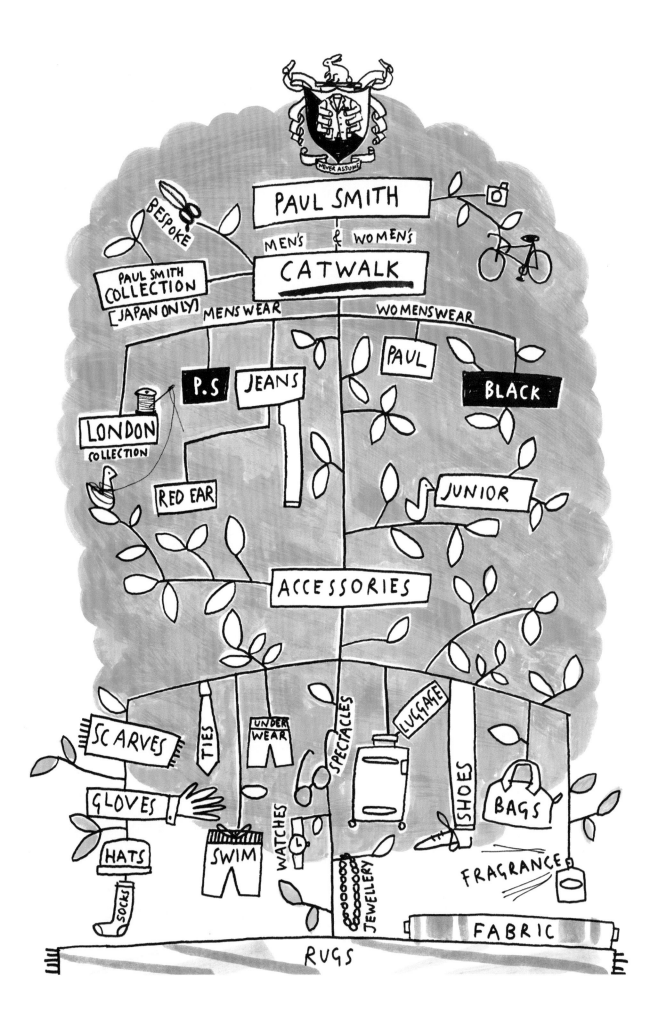

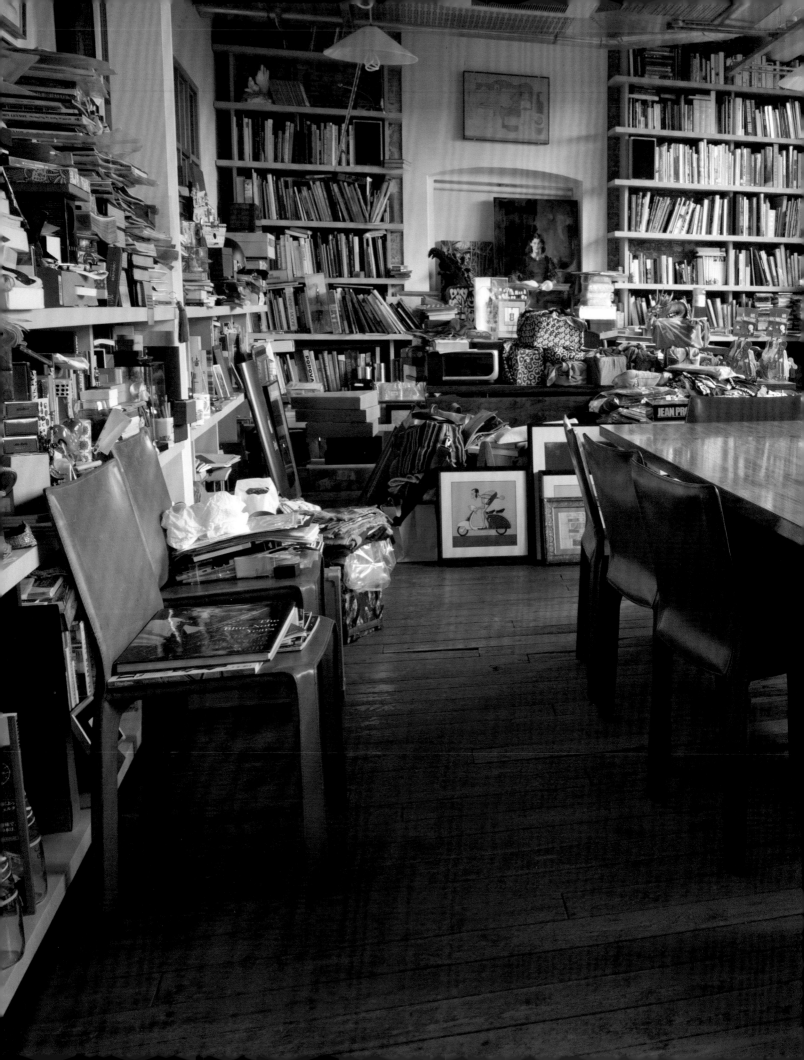

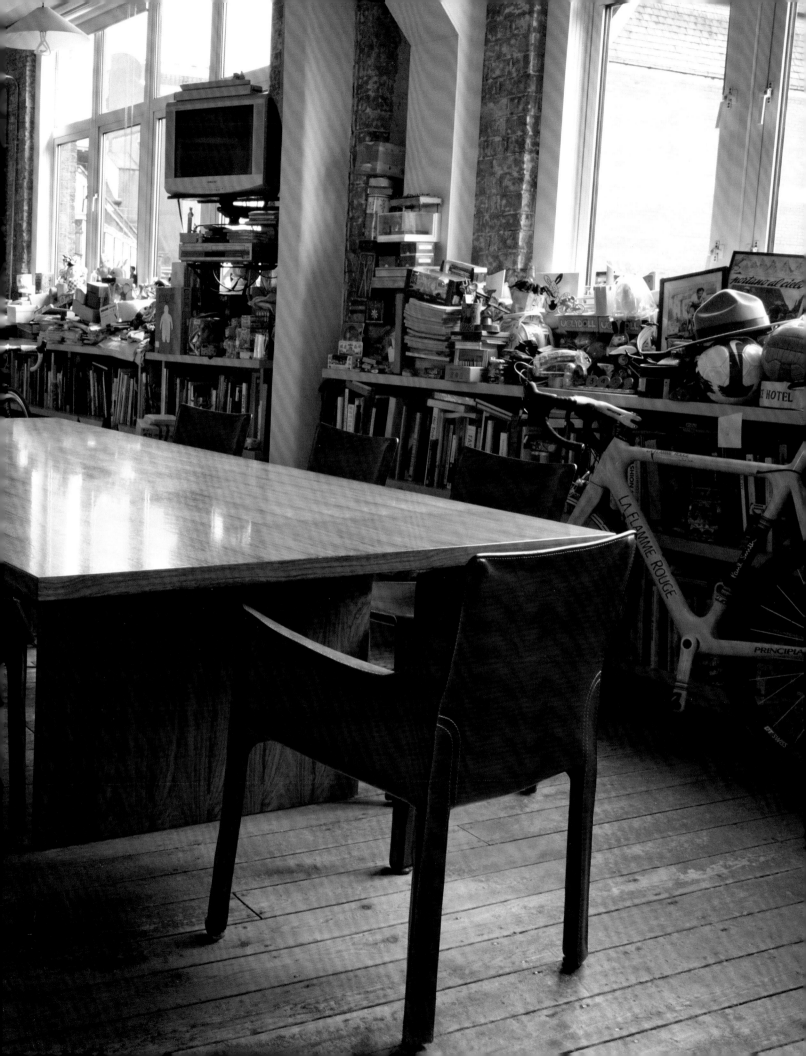

One of Smith's two rooms is relatively ordered; classic pieces of mid-century modern Italian furniture are only slightly subverted by the bicycles leaning against one wall. It is a place to retreat and relax. And as a result, it is almost always empty. Smith isn't interested in retreating or relaxing. He is continually roaming the building when he is in town, picking his way through storyboards, looking at the colour-ways. The second room is where Smith meets people: the people who work with him, the designers, the logistics team, the press, and all the visitors who come and go. There are design meetings here to approve the fabric orders for each collection. The designers present their selections, and the logistics team is there to answer questions about prices and quantities. Minutes are taken. On one side of the room is a glazed partition that lets light into the outer office. On the other is a windowed wall, which overlooks the attics of Covent Garden. The walls are partly plastered and partly bare brick. The floors are made from recycled bare boards. Milky-white glass shades that I recognize from Smith's first London shop hang from the ceiling over a large mid-century modern table. Around the table is a cordon of leather *Cab* chairs designed by Mario Bellini in the 1970s. At one end of the room is what must have once been meant to be a desk. Clearly it's not something that Smith needs: He doesn't use a computer. He isn't that fond of the telephone. He does have a mobile, but even he doesn't know its number. What was meant to be Smith's desk has long since been overwhelmed by snowdrifts of stuff. There are toy tin cars in glass cases. There are O-gauge models of railway stations. There are stacks of books and magazines on the floor, collections of bottles from Moroccan markets, and elderly calendars. Trapped unreachably behind all this, held hostage by the contents of the office, is an *Aeron*, one of those elaborate desk chairs from Herman Miller that nobody could sit in, even if they wanted to. There is a vintage Flos table lamp from the 1960s, a pink bicycle, and a lot of rabbits of all shapes, colours, and sizes. 'I once said that if I see a rabbit it brings me good luck and the rabbits just started to pour in', Smith explains of the ever-increasing number of rabbits.

 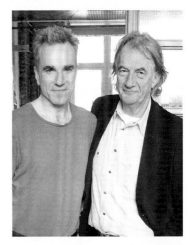 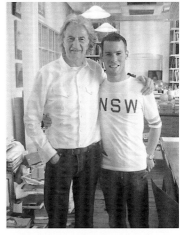

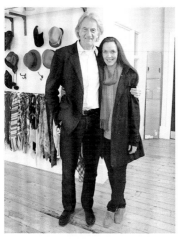 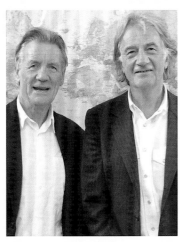

 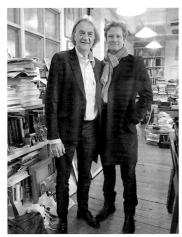 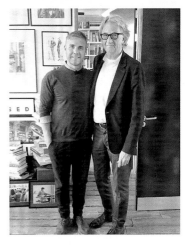 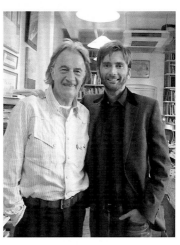

OPPOSITE *Various visitors to Kean Street, left to right from top: Jonathan Ive,
Alan Aldridge, Daniel Day-Lewis, Mark Cavendish, Victoria Pendleton, Michael Palin,
Grayson Perry, Jamie Oliver, Mos Def, Colin Firth, Gary Barlow and David Tennant*

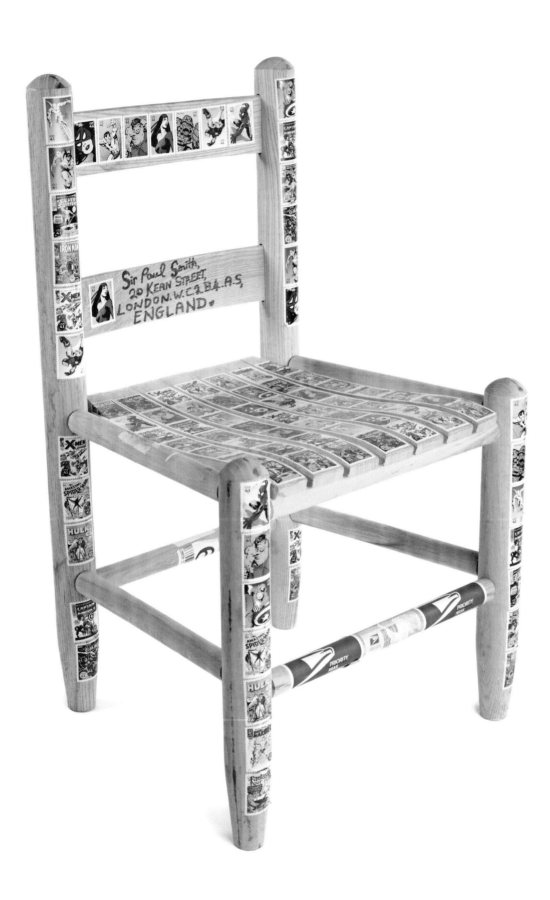

There are the gifts, from unknown admirers, dispatched from around the world. Over the years, one anonymous correspondent has sent him a mysterious and improbable range of objects, which arrive without any wrapping: a giant fluffy chicken that is covered in stamps, a walking stick, waterskis, a cowbell, and a tricycle. There are books from floor to ceiling. There is an intricate model of the office made by a Japanese visitor from a laser-cut metal sheet. There is a shelf full of cameras, including the Rolleiflex that Smith's father – who lived to be ninety-four – bought in 1958.

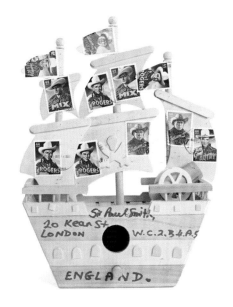

The room is a cabinet of curiosities, a reflection of the way that Smith's mind works, and the ways that thoughts about colours and patterns and influences take shape and crystallize in his mind. And it looks like a slightly more chaotic version of the design studios on the floors below. Some fashion-design studios are pristine and ordered. Smith's teams work purposefully, but they are surrounded by almost as much clutter as he is.

ABOVE *Some of Paul's camera collection*

31

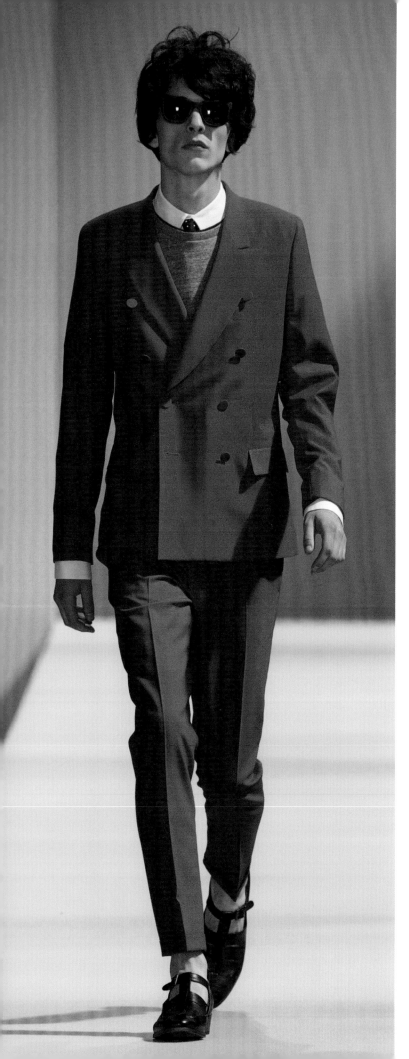

With fabrics selected, designs completed, patterns cut, and samples made, each season's collections need to be sold, not just in Smith's own shops but also to the retail audience, and to the press. Smith is the key. He has to map out his calendar months in advance in order that he can be in Paris every year for the collections, so as to show his work in France. When he is there, he will usually find the time to get to the city's massive flea market, not just to feed his collecting habit but also for the inspiration it brings. Then, too, there are the regular trips to open new shops. Every year there are new places to visit: Australia, China, and Guam are only the most recent countries to have opened Paul Smith shops. In Melbourne, Smith's shop is housed on Collins Street in a handsome heritage listed stone built neo-Gothic structure decked with elaborate bow windows. In Korea, it's a newly built, vivid white glacier -like building that sets out to look shockingly up to date. There are two stores in Moscow, one of them inside the GUM galleria just off Red Square. Built during Tsarist times, it became a state-owned retail mall during the Soviet period, when there was rarely much to buy – the best was kept for hard-currency stores. In the new Russia, it's become a place for affluent Muscovites to shop and eat pasta. Smith goes to India to find the craft workshops capable of embroidering patterns into an otherwise sober suiting material. When he is in Britain, there is the regular commute to Nottingham most weeks. His business with its offices, its 180,000 square foot high tech warehouse that packs and ships throughout the world, and its archive, is still headquartered in the city of his birth, where he now employs three hundred people.

LEFT *Spring Summer 2013 Men's fashion show, Paris*
OPPOSITE *Paul in the Nottingham warehouse, 2010*

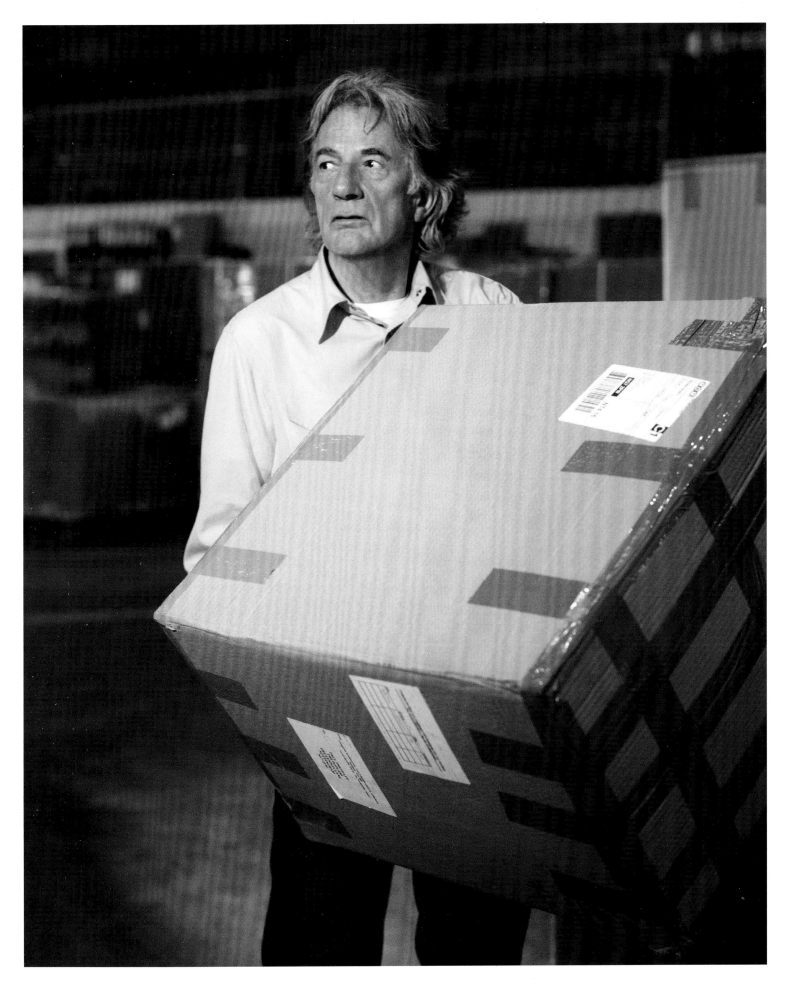

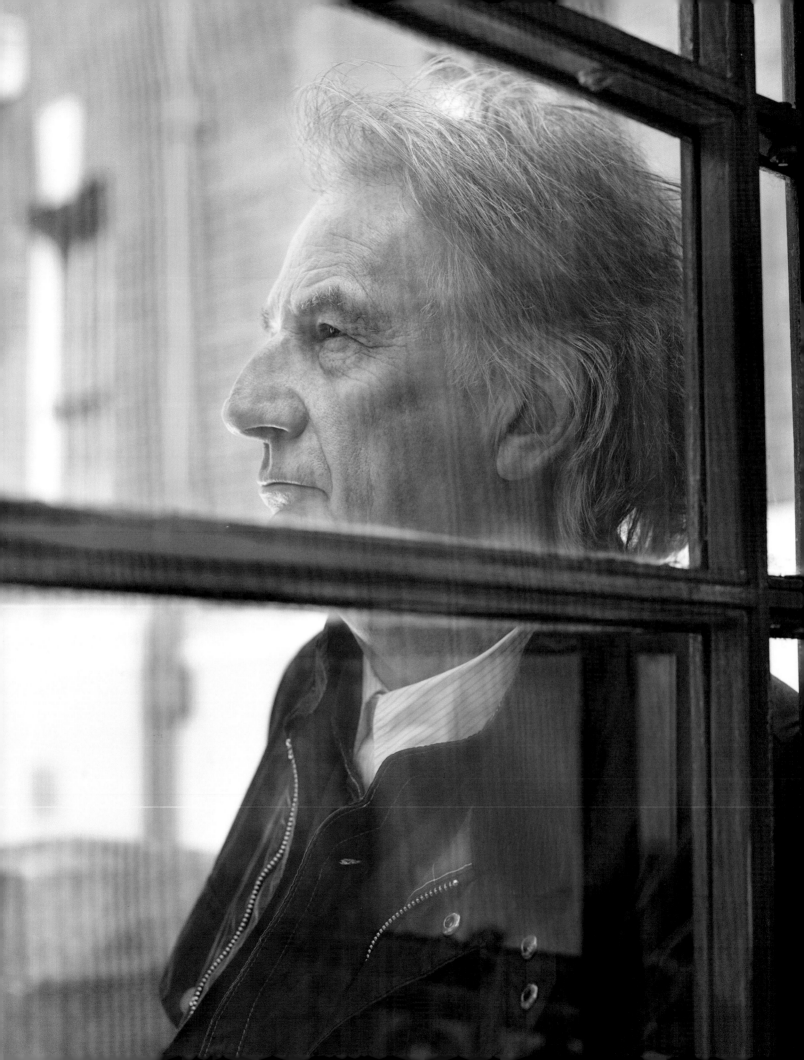

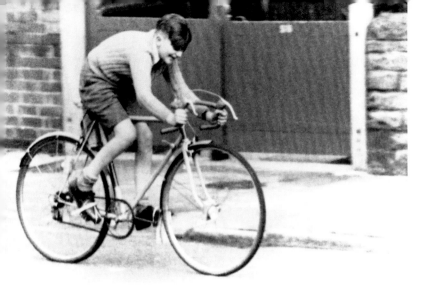

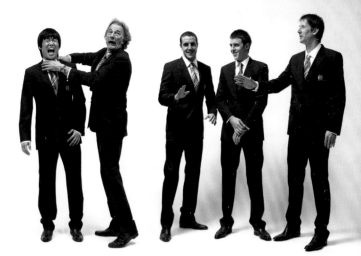

OPPOSITE *Paul in London, 2012*
ABOVE LEFT *Paul, aged 11 on his bike, 1957*
ABOVE RIGHT *Paul with Manchester United players*

Smith's hair, worn long over his collar, is greying. His face looks comfortably well lived in. His nose still bears the traces of the day nearly fifty years ago when, while training for a bike-club race, he cycled, at speed, slam into the back of a car parked at the edge of the road. He came off his machine, hit the kerb, smashed his leg in several places, and broke his nose. He ended up in traction in a hospital ward for several months.

He is 6'2"and cuts a tall and imposing figure. All that swimming, and the legacy of his days as a cyclist, have left him in good shape. In a room full of people, however, he somehow looks a little tentative, as if he were still a schoolboy. He unwinds his long arms and legs and bursts energetically into a blur of animated action in order to engage with everybody. Smith does physical comedy brilliantly. He loves word play too, and is punning and joking all the

time. It's more than a mannerism, it's a reflection of the way that he communicates.

Smith has spent long enough in the world of fashion to know perfectly well that people make judgements about others on the basis of how they look. Fashion is meant to be about airbrushed, *Vogue*-cover, lip-glossed perfection. But still, Smith betrays not the least hint of being self-conscious about his own appearance. He has no embarrassment about making himself look silly. There is a paradox here: on one level, Smith is himself a walking personification of the Paul Smith look. This is characterized by simple, straightforward clothes. It is modern, without being aggressive. It is playful and tactile, but still respectful of the best of traditional qualities. On the other hand, he is anything but a glossy and calculated representation of the brand that carries his name.

For those who grew up in the 1980s with a father who wore suits that came from Burton's the tailor, Paul Smith came as a liberation.

Smith is not the kind of designer who is going to ask for picture approval, cover and copy approval, or interviewer approval when he does a magazine interview, a phenomenon that is far from unknown in the world of conventional fashion. He has the kind of naturalness, or what you might describe as authenticity, that has given a generation or two of British men the permission they thought that they needed to wear clothes that have more sophistication than they would otherwise have been comfortable with. For some of them, the Smith approach has made them more dressed down than they would once have been comfortable with being. For others, dressing in Paul Smith clothes makes them look more formal than what they might have expected. For those who grew up in the 1980s with fathers who wore suits that came from Burton's the tailor, Paul Smith came as a liberation. For those who had never previously worn anything but trainers, fleeces, and hoodies, Paul Smith style was a pain-free path to adulthood.

Smith has a wide constituency. He is equally at home with anybody, from Eric Clapton to professional footballers, from Japanese students to the children he talked to in 2013 at the school in Nottingham that he had left so many years before. 'Polite' and 'respectful' are not words conventionally associated with fashion, which at its most conspicuous and extreme can be self-absorbed, self-indulgent, imperious, and vain. These last characteristics are the opposite of Smith. Polite and respectful are precisely the words that Smith's team use to describe the tone of voice that the business tries very hard to communicate.

Smith himself has used the word 'classless' to describe his clothes. And it is true: from his earliest work in Nottingham, he was looking at the understatement of what the privileged wore. He tried to make that approach more accessible, and in doing so, to rid it of some of the uncomfortable associations with elitism.

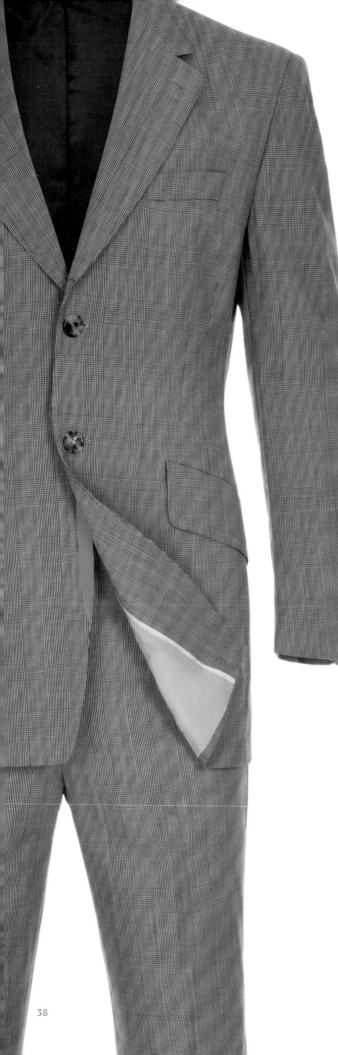

He made jackets from traditional tweed, but he used non-traditional colours. He took the most appealing elements of vernacular clothing – uniform shirts with epaulettes and carefully reinforced buttonholes, workwear designed to withstand heavy use – and gave it a new life. Smith looks to the unselfconscious ways in which to make garments perform well, to find a visual charm that makes them attractive to wear for other purposes. It's a phenomenon, of course, that began long before Smith became a designer. The hard-wearing denim jean was transformed from workwear into something much more universal. Jeans were followed by the military parka and cargo pants. Smith looked at the detail and material quality of vernacular garments at either end of the social scale and was able to find inspiration in them for his own work.

One very significant moment in Smith's history was the day in 1981 when he started working with a conventional Prince of Wales check-pattern cloth, and gave it a slightly unusual scale and colour. It was, he said at the time, 'classic with a twist', a phrase that stuck immediately, to the extent that it has come to be endlessly repeated, not just by Smith. It became a phrase so inevitably linked with him, that Smith no longer uses it, except in inverted commas. Though it now seems rather closer to the wrong end of the Laver scale than it once did, for years it was a powerful distillation of what Smith's clothes were about. But he still talks about being rooted in both modernity, and in tradition. And that is perhaps a better summation of what moves him.

In the course of his career, he has gone from his incarnation as an enthusiastic and self-initiated retailer to a worldwide force. He began in the first shop, which he opened in 1970 on a Nottingham backstreet, for just two days of the week – it would be called a pop-up store today. He now has the leadership of a worldwide creative business that directly employs one thousand people – and through a network of franchises, suppliers, and manufacturers, many more. Without really expecting to, he became a designer when he started his own label. Smith, almost in spite of himself, has become a global brand. He set up a licence in Japan. He moved into womenswear for the first time in 1994.

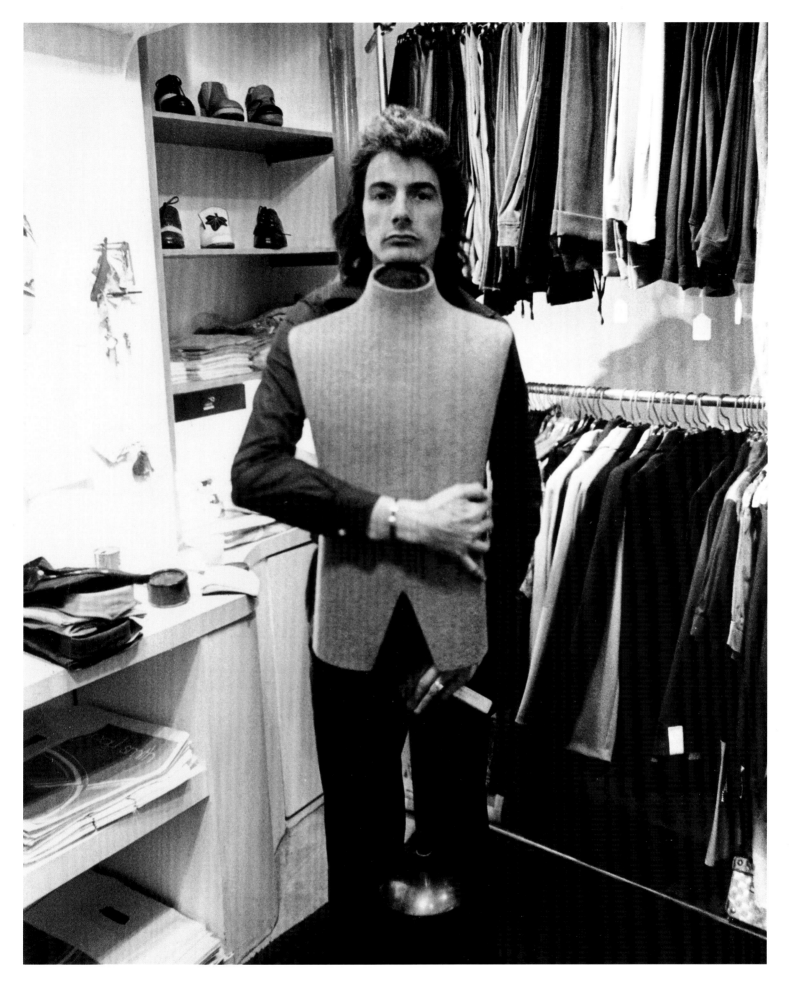

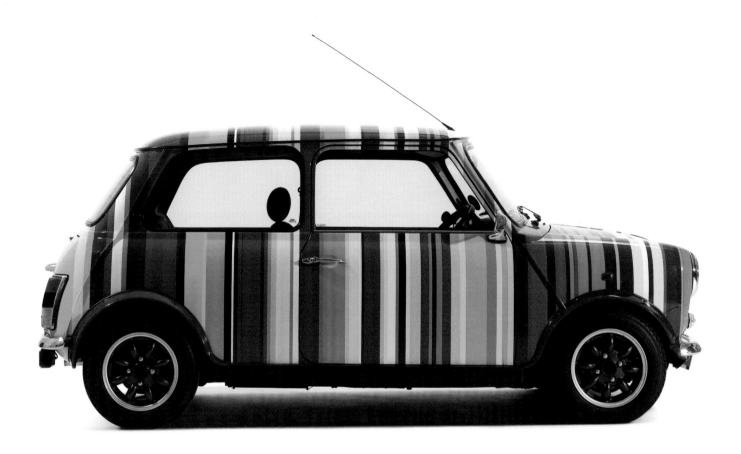

ABOVE *Paul Smith Multistripe Mini*

Now, there are Paul Smith fragrances, luggage collections, and watches. He has worked with cycle makers and car manufacturers. But he has never been content simply to licence his name. The candy-striped limited edition Mini and the racing bikes, the watches, and the scents, are all carefully considered extensions of the Smith way of looking at the world. There is even one Smith shop that includes collections of vintage furniture, art and photography.

You can buy Smith's clothes in Paul Smith shops in Australia and America, in Japan and Thailand. Given the nature of things, and the cavalier way that some parts of the world deal with intellectual property, it is

not surprising that there are also fakes and copies of his work in some of those places. Bangkok's vertical fashion malls are particularly egregious. What you can find there are not so much fakes as crudely blatant appropriations of the Smith trademarks, used in ways that obviously have nothing to do with him. Smith's lawyers fight hard to protect him from them, but it is a continual struggle.

It took a long time for Smith to feel confident enough to begin making womenswear. He has an innate sense of caution, both creatively and in business. He has always been careful not to overstretch in either area. For years he did not take up the offers of licencing deals.

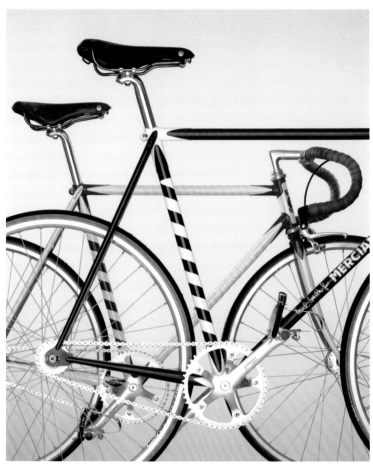

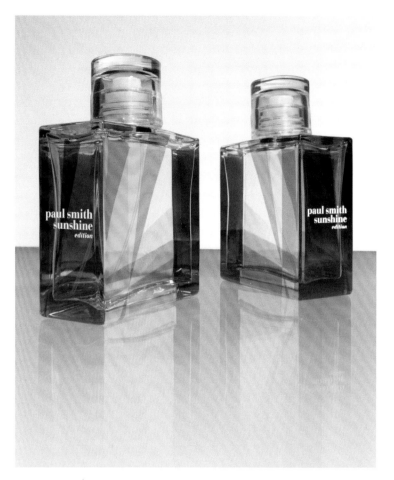

ABOVE LEFT *Mercian Cycle collaboration*
ABOVE RIGHT *Paul Smith Sunshine fragrances*
RIGHT *Spring Summer 2013 watch campaign*

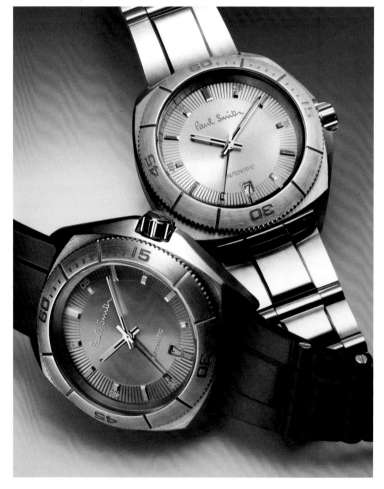

Smith has turned down more than one offer to buy his brand. But bit by bit, he has become perhaps the most successful fashion designer that Britain produced in the twentieth century. You can now find his clothes almost everywhere, even in Seoul's Incheon International Airport, which has what is perhaps the glossiest and most developed shopping mall of any airport, anywhere in the world. Its polished marble arcades accommodate the world's fashion brands, which have crowded out the alcohol, tobacco, and duty-free consumer electronics that once dominated such places. Instead there is a suitably reverential Chanel store, Burberry, and Coach. In the midst of these global brands, which are polished and burnished and protected, their names rendered in fluorescent light that seems both impersonal and somehow heartless though infinitely sophisticated, his name seems rather different in its meaning from the rest. His is a brand that is represented by the name of its founder: Paul Smith, rendered not as a piece of typography or a logo, but as a signature. It isn't, in fact, Smith's own signature. The signature 'Paul Smith', for use as a logotype, was first rendered in the handwriting of a friend, and it has been through a variety of incarnations over the years. In a curious example of life imitating art, Smith's own handwriting has gradually come closer and closer to resembling it. Amidst

the air conditioning and the gloss and precision of the airport, or the shopping mall, coming across an example of the self-deprecating Smith style is like opening a window and letting in fresh air.

In fact, it's not just Seoul's airport that sells Smith. There are also substantial Paul Smith outlets in both Terminals 5 and 3 at Heathrow Airport. The larger of the two is in the upper level of Terminal 5, designed by Richard Rogers, under the shadow of Troika's hanging installation *Cloud*, an evocation of analogue departure-board technology, turned into a cloud of rippling plastic pixelations.

The door to the shop is framed by a neoclassical limestone archway that is sympathetic to the wood paneled interior room salvaged from an eighteenth-century French chateau which both create a deliberate dissonance with the architecture of the airport. Around the doorway, factory-style hopper window frames form the shop façade. Inside, there are second-hand photography books, schoolroom globes, and, yes, clothes. Inside the apotheosis of the bland that is a contemporary airport, Paul's presence is a sharp injection of authentic character into a space in which few would willingly linger.

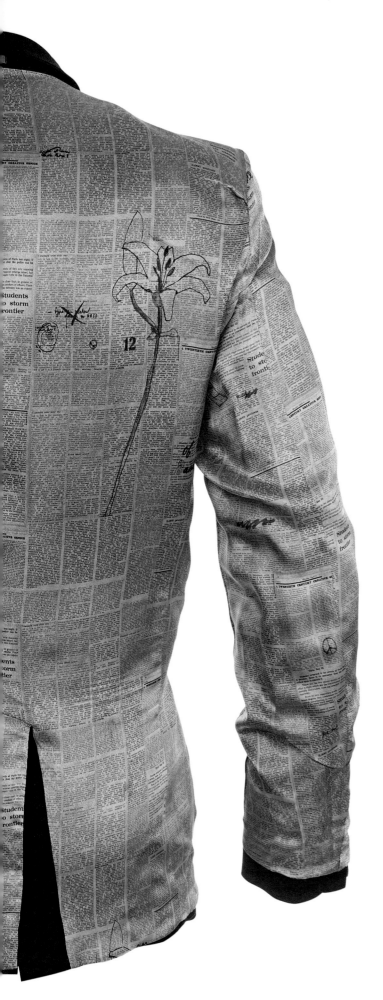

Laver's premise still holds good today, even if the time-scale that he envisaged for his sequence of perceptions has accelerated and telescoped, and the precise adjectives that he used have shifted in their emphasis and meaning. Whether he has always been aware of it, or not, Smith has demonstrated that he has had an instinctive understanding of the Laver rules of fashion throughout his career. He has been able to invent, as well as to evoke and to quote. Skinny jeans have come and gone at least twice in the last decade. Skirt lengths have risen and fallen. The colours that he has made use of have gone from vivid to monochrome and back again. Smith has always known how to charm by reminding us of the things that we might never really have known, as well as the things that we knew well when we were younger.

Adolf Loos, the Austrian architect and critic best known for provocatively equating ornament and crime was rather more intimidating in his militant view of fashion than was Laver, who had a somewhat lighter touch. In one of his more provocative newspaper essays, Loos asked the question: 'What is the point of a brain, if you don't have good clothes to set it off with?' I wish that I could say that the first suit that I ever bought came with the Paul Smith signature embroidered on the label. It didn't. I belong to the generation that was born in the 1950s, a chronology which goes some way towards explaining how it was that I suffered a series of embarrassing sartorial diversions on the way to Smith. One was a regrettable outfit that I bought when I was still a student from a shop on the King's Road in London called Take Six. It was a suit made from a window pane-check wool fabric – blue, black, and white on grey – with lapels that projected almost as far as my shoulders and were themselves padded to form perfect rectangles, perpendicular to the sleeves. It was a three-piece suit, and so there was a waistcoat, which buttoned up to just below the outsize knot of my tie. The trousers were the kind that spilled out in all directions to cover my green platform-heel boots. It was followed by the brown velvet suit that I acquired from the Village Gate, or perhaps it was Biba? It attracted attention when I took it back to my student flat in Edinburgh, in a way that would certainly have drawn Loos's disapproval. 'You spent £40 on that?' one of my flatmates wanted to know.

In the view of Adolf Loos, to be properly dressed is to attract as little attention as possible. 'What does it mean to be well dressed? It means to be correctly dressed. For fashion we use words such as beautiful, elegant, chic, smart or dashing. But that is not the main point at all. The point is to be dressed in such a manner as to attract as little attention as possible. A red tailcoat would attract attention worn in the ballroom, therefore, a red tailcoat is not the modern style for the ballroom. A top hat would attract attention when ice skating. Among the best people, to attract attention to oneself is considered vulgar. This principle however, cannot be adhered to everywhere. With a coat that would be perfectly inconspicuous worn in Hyde Park, one would certainly attract attention to oneself in Peking or Zanzibar.'

Loos would certainly have appreciated Paul Smith's way of combining private flamboyance with public sobriety. If there is one element that has always characterised Smith's work, it is the pleasure that he takes in giving his clothes aspects that only those who actually wear them will be aware of. An apparently sober grey suit will have a lining that is embroidered with a pattern based on a nineteenth-century street map of Paris – perhaps as a distant memory of the way that World War II flying jackets had maps sewn into their linings for airmen to use if they were shot down over hostile territory. Another suit lining was based on a photographic print of a broadsheet newspaper, embroidered with wild flowers. Smith's coats have multiple secret pockets; ties have unexpected linings. The clothes all tell stories; some are about the way that they were made, others about the materials that went into them, the ideas that they suggest, and the themes that they reflect.

It is detail of this kind that reflects the universal impulse to tinker with the rules of dress to express a defiant individualism. It is an impulse that starts in childhood, when schoolchildren tamper with their uniforms. They are obsessed with the precise position of a tie knot, or wearing a crew neck rather than a V-neck sweater with one too many coloured stripes around the neckline. The tighter the rules, the greater the ingenuity that goes into manipulating and subverting them.

My first encounter with Smith's clothes was after I had left university in 1976. It was in a little shop in Bath – you would have to call it a boutique – that sold his clothes alongside many other designers. I had wandered in by accident. There were a lot of different labels on the rails, but one particular outfit grabbed my attention. It wasn't quite like anything that I had seen before. Well, it was like a lot of things, but just a little different from all of them. This was the long and very hot summer of 1976, and the punk explosion was just weeks away. It was very hot, very dry, and getting steadily hotter and drier every day. But people were still wearing knitted tank tops and shirts with big collars made from cheesecloth. The suit, as I remember, was on a mannequin that was part of a window display. All the elements designed to come with it were on show, and they, too, seemed to belong to a different world than all the stiff, brash, stone-washed, tartan-trimmed ugliness of the 1970s and the decade's high-waisted baggies that were everywhere outside the shop. The jacket was double-breasted with expansive pointed lapels. As I now know, Smith had broken, some-what daringly, with traditional norms of suit construction by sewing patches of fabric to the outside of the jacket to form pockets, rather than hanging them from the inside. The piece was made from a soft, tweedy wool fabric. The colour was just on the warm side of grey, with a small check pattern. The trousers, without turn-ups, tapered in a discreet kind of a way, and they were lined. This was not something that I had encountered before. And the pockets were scooped out at the front in the manner of a pair of jeans. Smith was playing around with the conventions of suit-making, and gently subverting them. He was making something that was quietly, but unmistakably, modern. And he was about to change the way that fashion was understood and consumed in Britain.

Smith was one of the very few contemporary designers to define fashion by approaching it from a masculine point of view. It was a suit that made you feel good to wear it. It wasn't trying too hard to be interesting. Compared to the mayhem on the streets outside, it was formal. But it was also soft, and it had enough tricks up its sleeve not to feel stuffy. It seemed to be a glimpse into the near future. I

bought it, and the shirt, and the tie that seemed so naturally to belong with it in an uncharacteristic rush of acquisitiveness, leaving next to nothing from my first monthly salary cheque. The shirt was cream coloured with a very small collar, and it was made from the kind of special, scratchy woollen fabric that I distantly remembered grey school shirts were made from. The tie was whippet thin and came with an argyle pattern in several shades of rust, maroon, and green. What caught my eye in Bath was that there was nothing else quite like it in the shop. It was fashion without being fashionable. It was a suit that seemed to be sending a message about a new direction that life was going to take, one which had nothing to do with fashion as it had been defined by Take Six.

Curiously, that first Paul Smith suit also reminded me of the sort of outfit that my Yugoslav-born father, who became a journalist when he came to Britain, would have worn in the 1940s; even in its resolute unhippiness, it was catching something of the mood of punk that was in the wind. Laver's law was working. It was only when I got it home that I noticed that it had somebody's name on it, the little, apparently handwritten Paul Smith signature on a small white rectangle, stitched onto the inside jacket pocket – a name that seemed to belong to somebody I already knew. It was a signature that was not quite so artfully composed as to suggest that it belonged to an architect, but it looked vulnerable and revealing enough to give the impression that there really was somebody called Paul Smith – rather than an artfully constructed brand identity. And from the look of what seemed to be his handwriting, Smith looked to be the kind of man you wanted to get to know better. Paul Smith was such a simple, straightforward name that it had to be real. You could see that there was such a person.

The way in which Smith created that suit, shirt, and tie combo was an exercise in all the things that he has gone on to do so well and which are the foundations for his whole business. First of all, the clothes felt great: The wool mix that the suit was cut from suggested quality and had a texture that made it impossible not to engage with. The cut made you feel good about yourself.

Paul Smith

10 Byard Lane.
Nottingham
Tel. (0602) 48105

ABOVE *Early advertisement illustration*

The soft, relaxed shoulders accentuated the sense of your body inside the clothes. The suit was well made, and so it lasted year after year. And the colour was just unusual enough to demonstrate that this was not, in fact, a second-hand demob suit, but rather a suit that had been made by somebody who cared deeply about what he was doing, and what the wearer would look like. It had a silhouette that suggested it had been designed by somebody who had spent a long time closely observing 1950s Hollywood black-and-white films. Which, indeed, it was. It's the kind of suit that might have been worn by Robert Donat playing Richard Hannay in Alfred Hitchcock's *The 39 Steps*. Fashion is a phenomenon that allows us all to play with identities, to create new versions of who we are, or who we would like to be. It allows us to play with memories and characters that are not necessarily our own.

That suit was based on a combination of colour, cut, fabric, and close observation, all of which have shaped Smith's work over the last forty years. I wore the Smith suit from Bath to pick up an award. I wore it to parties, and I wore it to work. I wore it day in and day out until the hems started to fray. But it was not until a couple of years later, when I heard about a new shop that had just opened, that I would discover for myself what Paul Smith actually looked like.

It was the end of the 1970s: Floral Street in London's Covent Garden was still half derelict. The smell of the recently departed fruit and vegetable market still lingered. Work was just getting underway to bring the cast-iron-and-glass structure of the original Victorian market hall back into use. It and the surrounding area had been rescued at the last minute from the threat of wholesale demolition to make way for an urban motorway. In its days as a market, it had been one of central London's last surviving industrial communities. Though the streets were still dominated by wholesale dealers, their porters pushing barrows back and forth to stores stacked with boxes, the migration to a new market south of the river had begun, and with physical destruction ruled out, nobody had a clear idea of what was going to happen to the area. There were very few shop windows, just roller shutters mostly painted green, presumably to associate them with the fruit and vegetables that they harboured. The pubs were still geared to the early working hours of the market. In those days of strict licencing controls, Covent Garden was a place in which pubs were still allowed to open at dawn, so that the market workers were able to order a pint of Guinness to go with their breakfast fry-up.

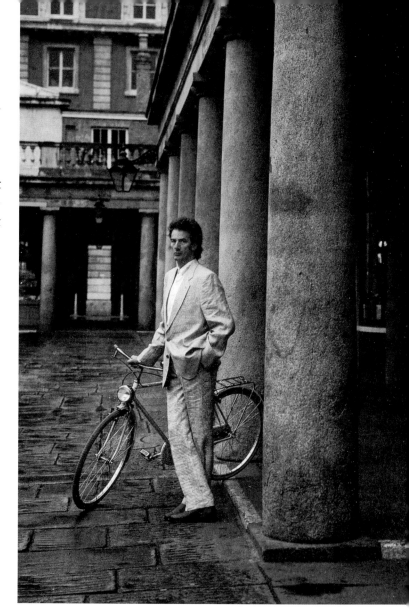

ABOVE *Paul outside the Royal Opera House, Covent Garden, London*
OPPOSITE *Covent Garden Market, 1970*

The Royal Opera House was the other big presence in the area. The combination of market and opera meant that there were some streets where, amidst the fruit and vegetable stalls, you could find musical instrument suppliers, scene painters' workshops, and costume makers' studios. Floral Street at that time was a snapshot of a city that was about to change beyond all recognition. London had yet to see gentrification on the scale that was about to take place here, a process that took Covent Garden from trading courgettes and tomatoes to embracing the counterculture and then the super-fashionable to being hollowed out by the dulling effect of too much success, which in turn was followed by too much mass tourism. Laver's Law it seemed, could be applied to urbanism as well as fashion.

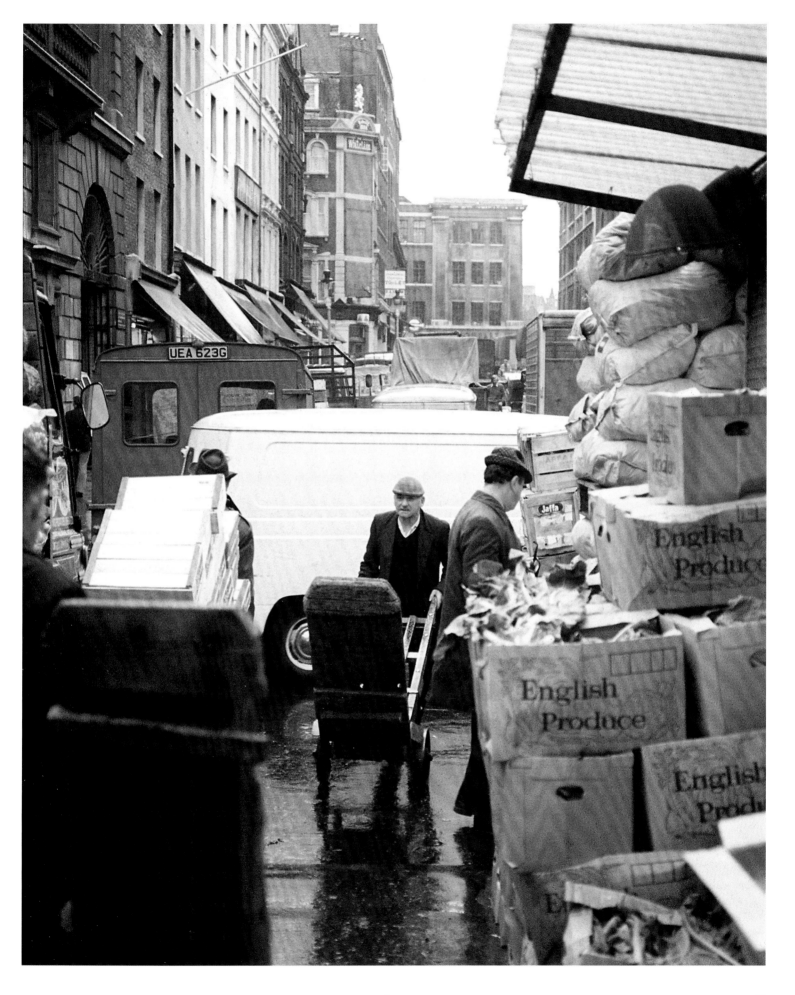

He wanted to encourage people to get over their inhibitions about opening the door to his shop and to come inside.

When Smith first saw the area, he witnessed the first signs of a new kind of life. The Middle Earth club had been set up a couple of years earlier in a basement in King Street, offering a diet of light shows, Pink Floyd, and Soft Machine. But when Smith finally opened his shop there in 1979, it was a move that seemed anything but obvious. He had walked the pavements in 1976 until he found the vacant building in Floral Street, tracked down the owner, and persuaded him through sheer willpower to let him have it for £25,000. It was more money than Smith had at the time, and it would take another three years for him to raise enough cash to start work, and to actually fit out, stock, and open the shop. It was a move that could only be called brave. What kind of a fashion shop was going to open up in an area with no customers or passing street traffic – and which was still closely associated with Eliza Doolittle? And what kind of a shopkeeper was going to open a shop that looked nothing like a shop? It was a design that certainly stood out.

By this time, Carnaby Street had come and gone. The bottom end of the Kings Road was past its best: The American car protruding from the façade of Granny Takes a Trip had faded. Antony Price, with his calculatedly hostile façade, caused some ripples with his brief presence at the World's End and its displays inside, in which garments were nailed to boards like a quartermaster's store for Bryan Ferry clones. Just across the road, Vivienne Westwood and Malcolm McLaren went through the changes from Seditionaries to Sex. These were fashion stores that were designed to act as self-censoring filters. If you were uncomfortable crossing the threshold, you would be unlikely to be comfortable with the clothes inside. Better to scare off the time-wasters and the fainthearted and to enforce the sense of a shared secret among the enthusiasts. That was never the Smith approach. He wanted to encourage people to get over their inhibitions about opening the door to his shop and to come inside. And he wanted them to leave having enjoyed the experience, preferably with a purchase. To that end, he has never kept to any single formula for what a Smith environment should look like.

In retailing design, there had been the surrealistic spectacle of Mister Freedom, and there had been the nostalgia of Biba. But the Smith shop was like nothing else in Britain at the time.

PAUL SMITH

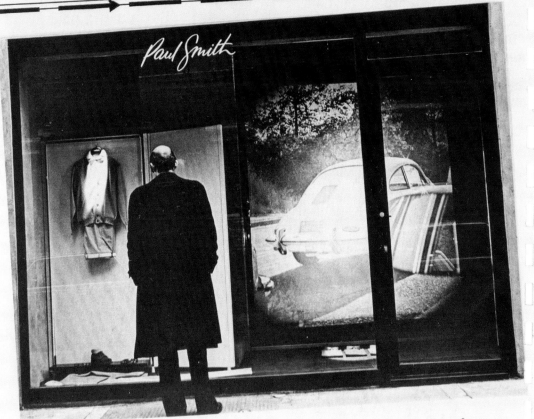

Paul Smith's attitude to clothes is absolutely functional, with a rejection of overdesign and fussiness. They must work for the person, for a life style. His love of the classics has led him to an emphasis on colour. With Pauline Denyer, his partner, he chooses ten colours working out the basics, through to the mixes of plaids, tartans, tweeds and wools. This season the colours are smokey, muted - sage, grey, dusty rose and blue, grape and mauve, with an occassional lift of brilliants. The shapes, classic tailored suits, jackets, moleskin pants, single breasted wool coats, thick heavy-knit sweaters, checked cotton and wool shirts with wool T shirts to wear underneath, a spectrum of plain and tartan mufflers in Lambswool, Shetland, cashmere. To quote him, "People imagine that a designer must produce a few tricks, a brand new garment, something spectacular. Our designs are basic, minimal if you like. Successful design is what you take out". His look relies on colour, shape and fabric. The same clothes that can be bought in his London and Nottingham shops can be seen in Beverley Hills. He is also a consultant in the I.W.S. (International Wool Secretariate) and a fabric designer for the Leigh Mills who make much of the cloth for the Paul Smith collections.

Even his new shop in London's Covent Garden is representational of his taste. It is minimal, functional - utility grey carpet, concrete, matt black steel and glass. Every night the wide spaced glass frontage becomes a screen as slides and films are projected in a non-stop show. Raincoats, for example, get a Hockney rain print for a backdrop. Jeans have a back projected slide of the original Levi-Strauss factory.

ABOVE *Window display of the Floral Street shop, London*

OPPOSITE *Original interior of the Floral Street shop, London*
ABOVE *Plastic spaghetti from the window display*

The raw, concrete interior prefigured what subsequently became the conventional model for selling a certain kind of fashion. Smith made it a place that constantly entertained and engaged its customers. Of course, the point of the exercise was to sell shirts, suits, and shoes. But Smith offered more than a cynically manipulative transaction. There was wit in his displays, and a constantly changing display of unlikely objects for sale alongside the clothes.

In his shop windows a spotlit plate of very life like spaghetti made from wax and apparently levitating, with a fork stuck in the middle of it, took pride of place one week, but it would be moved to make way for a plastic lobster the next. Most Saturdays he would be in the shop himself, twitching at displays, folding socks and ties. And he would be looking all the time, looking at what people were wearing, how they reacted, what they liked, at what they left behind on the rails.

The first London shop had what appeared to be a raw, concrete floor, bare concrete walls, and a window display that appeared to have nothing to do with clothes. There were display racks: black, carefully detailed steel rods. And there were beautiful, hard-to-find Italian milky-white glass lamps hanging from the ceiling. It was minimalism before the world had noticed that there was any such thing.

I was working for *Design* magazine at the time, and I did a piece about the interior – designed for Smith by Peter Wigglesworth and his imaginatively named company, Plush Kicker. Smith's shop was a burst of modernity in a London whose architects seemed to have temporarily run out of ideas.

The shop was described to me by an architect friend, but he hadn't mentioned the name on the door, and it was only on my first trip that I connected it with the suit that I was still wearing. I went back on the next Saturday, and a tall thin man with the hairstyle of an Afghan hound, detached himself from the back of the store and came up to say hello – just as he did to most of the other customers. He had the knack of making you feel at home and part of the conversation. When he picked out a shirt, or a tie, he had the talent of making them feel fresh, crisp, and special. He had the ability to talk to anybody, to infect you with the enthusiasm that he had for the precise density of the thread of the weave of the cloth from which a suit was made, the detail of a buttonhole, the cut of a suit, and the colour of a lining. I had no idea where he had come from, or what this particular shop meant. I didn't really know anything about clothes – or fashion, as the Take Six suit episode so unerringly demonstrated. I think I even owned a polka-dot bow tie as big as a kite at one point.

What I was seeing was the second act of the continuing story of the man who has turned into one of the most successful British designers. He has been knighted, his portrait hangs in the National Portrait Gallery, and he has appeared on BBC Radio's venerable *Desert Island Discs*, choosing the eight records that he would want to have with him were he to become a castaway.

It was Smith's shop that rescued me from the sartorial wastelands and, eventually, made me look like a relatively convincing member of the modern world.

Smith furnished me with the bespoke suit from Westbourne House that I got married in – a two-tone olive coloured wool with a sky-blue lining – which I bought after a two-bottles-of-wine lunch immediately after my fortieth birthday to help soothe the unexpected stress of the arrival of middle age. I have a shiny black-satin dinner jacket from Smith. I have bought innumerable striped shirts – some with buttons and clashing bits of fabric in unexpected places. I have bought second-hand books and colourful wrist-watches. I have acquired sweaters and jackets, swimming trunks, polo shirts, spotted socks, and boxer shorts over the years. I have carried them home in bags that went from grey to multicoloured stripes. I have a Paul Smith parka – part of the Jeans collection line – and at least two overcoats. There have been mistakes along the way: the cream-coloured shirt with the jumbo collar and the herringbone-weave cotton, the outsize spotted tie with a full-colour pin-up girl printed on the fabric lining. She's invisible to everybody else, but you know she's there. But these diversions apart, over the years his clothes have served me well.

Of course, for the continued health and prosperity of a fashion label, the idea of a generation clinging limpet-like to its superstructure is a mixed blessing. A loyal fan base can also look seriously discouraging to the next generation – and the generation after that. The fashionable, as Laver suggested, are interested in the very recent and the very distant past, but not the middle ground. And why would the young want to wear the kinds of clothes that their parents were wearing, even if they might be more kindly disposed to what they once wore but is no longer considered fashionable.

One of the several keys to Smith's continued success is the speed with which he grasped the fact that it is impossible to stand still in the world of fashion. To stay the same, you have to change all the time. You must if you are going to go on being relevant. But change is also the thing that alienates the early adopters, those who expect Paul Smith to go on looking and feeling just as it did when they first discovered the brand, to go on standing for the same things, to go on projecting the same message. They don't want the brand to change, and they don't want everybody to know about what they see as their personal discovery. The essential strategy for a fashion brand is to balance heritage and innovation. Fashion has to change if it is to retain the freshness and the inventiveness that made it what it was in the first place. A fashion designer needs to have enough of a grip on the essential DNA of a label in order to remain authentic to its roots, but also to retain a creative edge and a willingness to experiment to keep it from being reduced to the repetition of a formula.

Smith's clothes have a kind of signature and a handwriting. He loves the playful gesture and the sign of the handmade, the signifiers of quality. He puts maximum effort into the places at which we come most into contact with an artifact. The buttons on shirts, on cuffs, and on jackets matter a great deal. Smith, at various times, has used metal charms as buttons; buttons covered in fabric; mother-of-pearl, enamel, vintage, and military buttons. He loves to embellish his buttonholes with hand-stitching, often in strong colours. He puts eccentric numbers of buttonholes in his jacket sleeves and his lapels. He also loves to surprise you with the lining of a sober suit, an old trick that never stops working. I have a bespoke grey suit from Westbourne House with a lining that is vivid pink, and another that is sky blue. It's not entirely true to say that nobody but the wearer sees them. Jackets go on and off; vents pull back to reveal that something else is going on beyond the outward appearance.

There was a time when Smith was able to maintain the creative direction of his brand through the series of notebooks that he constantly fills with sketches, ideas, words, and telephone numbers; through the way that sample books of cloth weights and pattern weaves passed through his long fingers; through the way in which he could plan colour combinations; and occasionally through a brilliant intuitive leap – such as the one that he made when he met an Italian printer who had a clever machine that could print photographs on textile and he saw the potential for doing surprising things with it.

Designing a collection is about choosing textiles. It is about specifying colour, about pattern, about cut and shape, and about creating a balance and a look that can hang together by giving every piece in a collection some of the character-istics of the whole. It also helps if it can allow for a range of potential wearers, from the cautious to the confident, to feel that it has something to offer. It is about being able to create a carefully graded cascade of collections that feel part of a coherent whole, but also work on their own terms without seeming to cannibalize one audience or one price point for another. And it is about continually changing, without alienating the most loyal and long-term – and affluent – consumers, and at the same time continuing to find new and different audiences at the younger end of the spectrum.

Paul Smith

10 Byard Lane,
Nottingham, England.
Tel. (0602) 48105

21.4.77

Mr.H.B.Smith
39 Abbey Rd
Beeston
Nottingham

Dear Mr.Smith,
 I hereby acknowledge receipt of a loan
of £3000 on April 12th 1977 from you to Paul Smith Ltd.
The loan is for a period of 5 years and is repayable
in full on April 12th 1982 , or at any time on demand.
Interest is to be paid monthly at a rate of 11.50% per
annum. This gives a yearly interest of £345 which is
to be paid in 12 monthly instalments of £28.75, by
standing order to your account no.221803361617 at the
Trustee savings Bank in Beeston. The first payment
will be made on May 12th 1977.

B.J.Brooke
Paul Smith Ltd

Directors: Paul Smith P. H. Christoforou
Paul Smith Limited Reg. in England No. 1170719 Reg. Office: Regent House, Clinton Avenue, Nottingham.

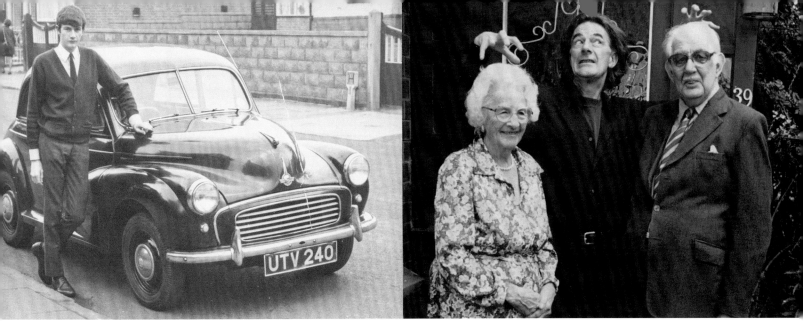

PREVIOUS PAGE *Paul Smith jacket lining*
OPPOSITE *Loan agreement with Paul's father*
ABOVE LEFT *The family Morris Minor*
ABOVE RIGHT *Paul with his parents*

Fashion, in the sense that Smith practices it, is an inspired craft rather than an art. It can be beautiful and revealing of his character and his interests, but it is not self-expression at the expense of everything else. From early on Smith understood that. He made collections that were carefully balanced. He would always include a few pieces that would attract attention. Press photographs of a suit that featured an allover ivy print went a long way in securing media coverage in the early days, when there was no budget for marketing, or for buying the advertising pages in the magazines to show the clothes worn in the way that the designer saw them. In the interest of getting noticed, he would use a recognizable model. There would also be enough just slightly on the edge of challenging to attract the bold, to ensure that Paul Smith was located on the cool end of the spectrum. And there would be enough of the familiar material to ensure that the first generation of men Paul Smith dressed did not feel alienated. It was a difficult manoeuvre to get right at first, when Paul Smith was a single label, with two collections a year. As the business grew, it was possible to create sub-brands of the label with collections that spoke to different generations and different

budgets, from a jeans collection to bespoke, which is where the Smith brand is now. Of course, that also brings its own difficulties: the various labels need to be juggled simultaneously. Since each is created by a separate design team, a coordinated hand has to ensure that they do not stray into each other's territory, that they look related but not trying to occupy identical parts of the fashion spectrum.

Paul Smith was born in Nottingham in 1946. He inherited his height, his fascination with photography, and his way with people from his father, Harold Smith. Smith's father was a credit draper, which is to say that he made his living by selling clothing and other items door to door on installment. The customers got the clothes upon making a down payment, and then every week, Harold Smith would be back to collect the next few shillings as they came due. It was an occupation that demanded the ability to put people at ease, and to judge character. He wasn't going to sell more than a customer could afford to buy. These were the qualities that his son inherited. Harold Smith was successful enough to be able to afford a car: the young Smith was taken on trips to the seaside in the family's Morris Minor.

ABOVE *Paul flying a magic carpet over Brighton Royal Pavilion*
BELOW *Beeston Camera Club, Harold. B. Smith (1903-98)*
retrospective exhibition catalogue, 1998
OPPOSITE *Geography field trip, 1960*

He was also a founding member of the Beeston Camera Club. Harold Smith's accomplished black-and-white photographs reflect the wit and the idiosyncratic eye for a telling detail that has come to characterize his son's work. Smith's father developed and printed his own photographs and taught his son to use a darkroom. He liked to manipulate images and, on one occasion, superimposed a ten-year-old Smith on a backdrop of the Brighton Royal Pavilion, as if the boy were navigating a magic carpet in mid-air.

The transformation of the Britain of 1946, when it came stumbling and dazed out of a war that had pauperized the country and left it struggling with rationing, bomb damage, and the legacy of utility clothing to the present of comparative plenty is unparalleled. It's a transformation that has been physical, material, and social. It was a shift that not only reshaped Britain, but also Smith himself. His family lived just outside Nottingham in a suburban house in the town of Beeston. Smith had good reports at his secondary modern school, as the British described educational establishments of the period designed for those not destined for a university,

Streets. The <u>negalatation</u> of Fountains Fell is tufty with cotton grass in it. Peat hogsare formed by it being washed away by water = 20 mls

Having a rest at the top of Great Close Scar.

CAMP LOG 1960

CAMP SITE

but left at the age of fifteen as was the norm in those days. Thanks to his father's efforts, he found a job in a clothing warehouse. It was work in which, at first, he took very little interest. He was sustained by his early passion for cycling – a passion that remains with him to this day. (He was in the crowd watching Bradley Wiggins and Mark Cavendish in the mens cycling, the first event at the 2012 London Olympic Games in London.) He has an impressive collection – among many others – of cycling jerseys. But a catastrophic accident that hospitalized him for some months put an end to any dreams of a career as a professional cyclist. Finally back at work after three months in traction, he started to develop his innate interest in design by starting to put displays together in the showroom attached to the warehouse in which he worked. What took Smith out of the limited horizons of the world of provincial England in the early 1960s was the energy of the British art school tradition. The art schools were where young people were given licence to find themselves and to explore the world of ideas and creativity. They allowed a few years of grace in which to experiment with paint or design, with fashion, or with music. Smith found himself drinking in a Nottingham pub that was full of art students, and he felt himself being caught up in their conversations. Words like 'Bauhaus', 'Charles Eames', 'pop art', and 'Andy Warhol' floated around in the smoky pub atmosphere. He wanted to know who and what they all were.

As he learned about modernism and design and art, he became fascinated. He began to get more interested in his job at the warehouse, and he worked hard enough to impress his boss. One of the fashion students in the pub had found just enough money to open her own shop in Nottingham. She called it Birdcage and asked Smith to help her to get it going. He left the warehouse job, and he found a place, did the legal work on the lease, decorated the interior, and helped to run the shop for a number of years. It was at this time that Smith became close to one of the tutors at the local art school, Pauline Denyer, a young woman who had recently graduated in fashion from the Royal College of Art (RCA). At first she was his girlfriend, and then she became his business partner, his first designer, and eventually his wife.

ABOVE *Flyer for Birdcage, Nottingham*

ABOVE *Pauline and Lancelot*

Denyer first came to Nottingham as a part-time tutor in the fashion school, while still working in London designing ready-to-wear fashion, and Smith left his parents' home in 1967 to live with her. Their relationship has been the basis for everything that Smith has done, and everything that he has become. Denyer taught Smith the rudiments of the business of fashion. Essentially, she helped him learn how to look, and how to see his passion for clothes as part of a wider cultural landscape. Her sense of style shaped how Smith would see the world. She was an early enthusiast for Yves Saint Laurent and his smoking jackets. She was also the source of a sense of stability and proportion in Smith's life and his business. She was creatively important, offering a constant voice in Smith's ear, and at the same time, she was the source of Smith's sense of emotional balance.

Pauline Denyer's parents first met in Nottingham, but they raised their daughter in West London. Her father had been a chef in the same Nottingham hotel in which her mother worked as a chambermaid, but they moved to London. On the strength of a diet of Sunday-afternoon double features at the Commodore cinema in Hammersmith, shared with an audience full of Teddy Boys, Denyer developed an early fascination with fashion. Leaving school before taking A-levels, she went to Hammersmith School of Art and Building in Lime Grove, where she did a foundation year, learning pottery and lettering before concentrating on fashion. The school had an impressive reputation – the sculptor Richard Smith was on the faculty. After getting her diploma, she assembled a portfolio, and in 1960 entered the RCA to do their three-year fashion course, which was presided over by the formidable, by name and by nature, Janey Ironside.

London, by this stage, was beginning to establish itself as a centre for youthful fashion, aimed at a rather different audience from successful couture houses such as that of Norman Hartnell. Mary Quant had opened her first shop, Bazaar, on the Kings Road five years earlier in 1955. She opened a second, stylishly designed by Terence Conran, in Knightsbridge. John Stephen opened His Clothes, the first fashion shop in Carnaby Street, in 1958. Stephen came to characterize the mod look: white jeans and unlined, three-button jackets. Quant had been to art school to study illustration and came to fashion through an apprenticeship. Stephen had been a welder in a Glasgow shipyard before moving to London. The Royal College was trying to professionalize fashion within the art college system and to give it an academic underpinning – though Ironside herself, the wife of a distinguished artist and the daughter of a colonial civil servant, had not had a formal fashion education. She had worked at *Vogue* and established her own studio, producing outfits inspired by Paris but at more affordable prices. Ironside had said that she wanted to establish an internationally recognized English 'New Look', but she was also realistic about finding her students work in the British mass market. She employed a number of inspirational tutors, including Joanne Brogden. A generation of British fashion designers emerged from the course, most notably Ossie Clark and Antony Price.

When Smith opened Paul Smith Vêtements Pour l'Homme on 6 Byard Lane in 1970, Denyer helped him to find the stock that made it the most distinctive place of its kind outside of London.

Denyer was at the RCA at exactly the same time as David Hockney and R. B. Kitaj – although, in those days, when the college was still completing its new building on Kensington Gore, painting students were in one building on Exhibition Road and fashion students were in another in Ennismore Gardens. Students from different departments mainly met in the Junior Common Room. Despite the radical new departures reshaping art and music in the 1960s, fashion students were still expected to own sufficient pairs of white cotton gloves to be able to wear a fresh pair to any of the couture shows that they were expected to see. Hats were also considered useful, even after the invention of the mini skirt. Denyer enjoyed her time at the RCA. She learned pattern-making, and toile-modelling. She remembers Elsbeth Juda as an extremely stylish external examiner who hosted cocktail parties for graduating students at her penthouse. Denyer moved into the RCA's smart new home on Kensington Gore in her last year, and she was in the first group of students to show their graduation collections in the Gulbenkian Theatre. Two students in the year ahead of her, Marion Foale and Sally Tuffin, became stars and started to sell their collections at Woollands 21, a shop next to Harvey Nichols in Knightsbridge that became a showcase for the new fashion designers. Denyer helped them to make one of their collections.

After graduating, Denyer worked for various manufacturers, and then she began to teach at Nottingham's School of Art and Design. At first, after London, life in Nottingham came as something of a shock. (It was only years later that her father told her it was the city where her parents had met.)

She first encountered Smith in Yate's Wine Lodge in the city centre, on the night of the art school ball. There was sawdust on the floor. Smith had a *Sgt. Pepper's* era droopy moustache – it was 1967, and he was drinking whisky and ginger. At the time, Smith was still working for Birdcage, the shop started by his art school friend. Denyer remembers the night he came home after a disagreement at the shop. 'He was really upset, and I told him that he could do it on his own.'

Denyer went full-time at the at the art school; the couple needed the security of at least one regular salary between the two of them. This decision gave Smith the chance to begin making and selling his own clothes, and then to start his own shop. When Smith opened Paul Smith Vêtements Pour l'Homme on 6 Byard Lane in 1970, Denyer helped him to find the stock that made it the most distinctive place of its kind outside of London. There was no discussion that it would be anything other than a menswear shop. Smith was interested in selling the kind of clothes that he himself would wear. When he couldn't find what he wanted, he started designing it. Customers travelled long distances to go to Nottingham to be able to buy such, at the time, exotic-seeming labels as Kenzo and Margaret Howell, which were simply unobtainable elsewhere. Getting to stock them was not initially straightforward. Smith had to do more than establish his creditworthiness. He had to create the sense that his was a shop that would make the brands that he stocked look good. It was a natural next step to start producing clothes under his own label. And, at first, it was Denyer who designed them.

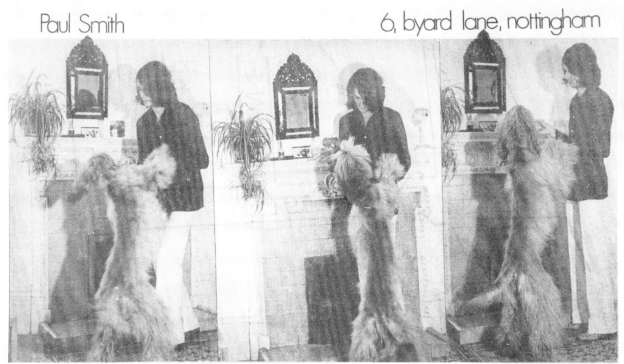

Paul Smith 6, byard lane, nottingham

homer (& paul) have left the 'birdcage' and are now at, what they hope to be temporary premises, at 6 byard lane, selling clothes for both sexes & some antique jewellery

all past customers and friends are more than welcome.

business hours......friday & saturday only......10 till 6.

ABOVE *Flyer announcing Paul's move to Byard Lane, Nottingham*

ABOVE *Homer, manager at 6 Byard Lane, Nottingham*

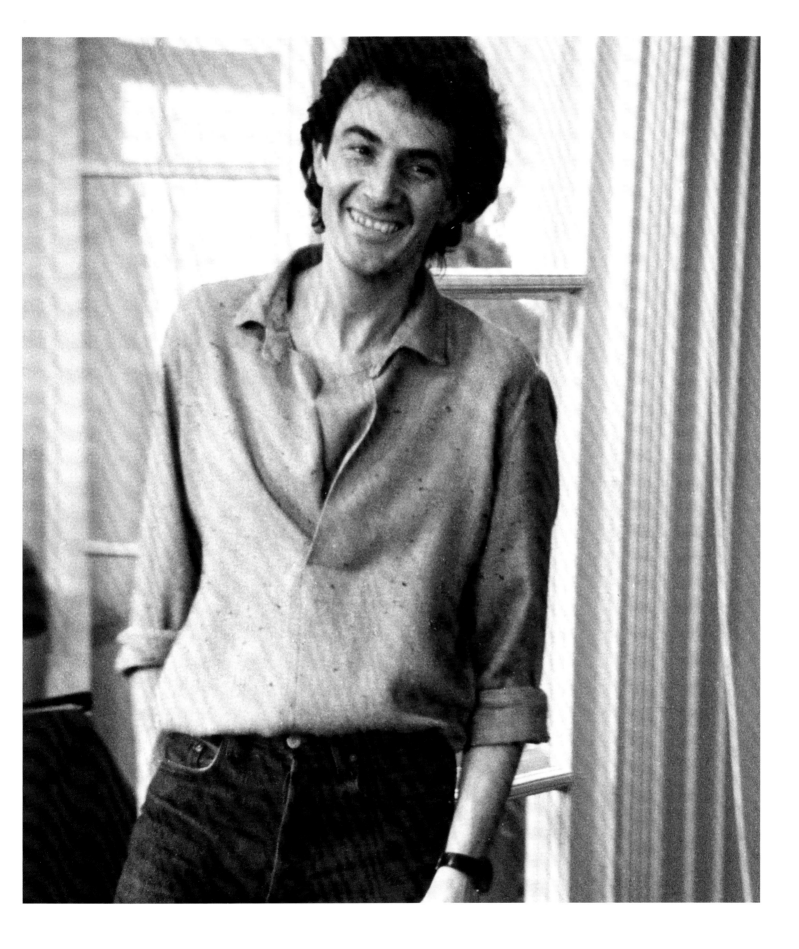

ABOVE *Paul in Paris, 1979*

STYLE 5

ABOVE *Sketches for the first Paul Smith collection by Pauline*

STYLE 6 & 7

STYLE 6, GENTS MAXI O/COAT
STYLE 7, LADIES ——————
 (LEATHER SUEDE)

		MAKING.	9	0	0
2		PIGSKIN 7 of 2/9 sks	18	15	0
38	51.12.0	P.T ON TRIMMINGS		3	0
SOLD AT COST			27	18	0
		SELLING	42	0	0
35		SELLING STROKE	46	0	0
WHOLESALE					
PRICE					
		P.T ON TRIMMING		6	0
1	1.1.71	MAKING	9	0	0
10		IMMITATION SUADE SKIN	4	0	0
			13	6	0
		SELLING	18	18	0
		STROKE £21			

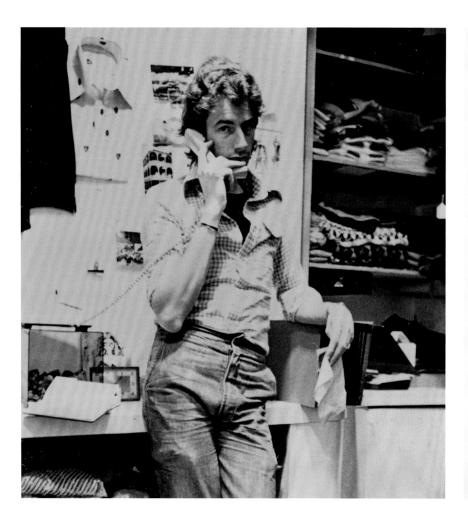

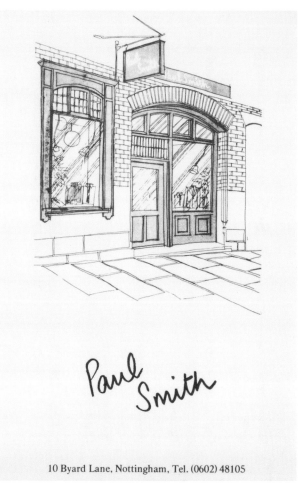

Paul
Smith

10 Byard Lane, Nottingham, Tel. (0602) 48105

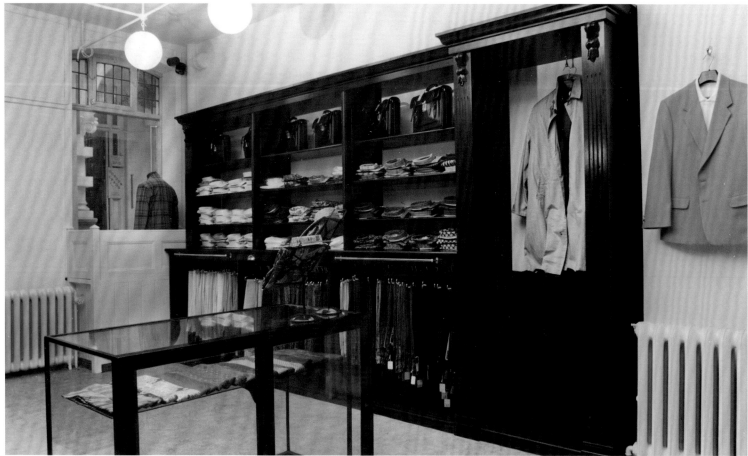

OPPOSITE TOP LEFT *Paul in his first shop, 6 Byard Lane, Nottingham*
OPPOSITE TOP RIGHT *Flyer for the second shop, 10 Byard Lane, Nottingham*
OPPOSITE BOTTOM *Interior at 10 Byard Lane, Nottingham*

Denyer remembers: 'We started with trousers; people were wanting to buy flairs, but most of the manufacturers were still making them with straight legs. With trousers there aren't that many design choices. We went to manufacturers with our designs, and they made them for us – for the shop, but also for Paul to sell in shops all over the Midlands.' In those days, Smith was the public face of the business and Denyer was the designer. 'I would make a pattern; Paul would go to get them made up.' They diversified quickly. 'First it was trousers, and then it was shirts.' They ran the business from their flat in Nottingham. 'We sat at the kitchen table with piles of cloth swatches. When we talked about fashion, it was to do with fit, and colour, strangely enough. The actual fabric was important; we didn't want anything too fiddly about the design.'

To open a shop was a casual, lighthearted decision, taken without too much planning, or spreadsheets. 'It wasn't scary then. We both had a vision.' But doing his own label clothes, and running a shop on weekends, weren't enough for Smith's driving energy. He started designing himself and began working as a freelance designer for Lincroft's, the London-based firm run by Howard Tillman and his father. Lincroft's did extremely well for a while. Smith was successful enough in his work there that he was able to buy the first of a series of Porsche 911s.

Initially the tiny shop was open only on Fridays and Saturdays; the rest of the week, Smith did a range of jobs – cutting clothes, window dressing, consulting, anything that it took to support himself. 'For the rest of the week I would make all the compromises that I had to, but for the two days a week in the shop, I was able to keep it completely pure', Smith says now. The shop did well enough to expand. Smith acquired a bigger place on the street, with a shop front rather than a back room at the end of a corridor. Then he started to think about opening an outlet in London, and about selling his clothes to wholesalers and to other shops. It's a path that would look a lot more difficult now, and that is a measure of the way in which Britain has become a place

that is more difficult, rather than less, for the talented but unqualified to make their way. Smith had begun to make clothes under his own label; he was constrained by his lack of capital and outlets to fulfill his orders for cloth, and his manufacturing orders were so small that there were very few factories that would take them. Denyer was responsible for broadening Smith's view of clothes, and of the wider world. She was taking her students to see the couture collections in Paris and Smith went, too. 'The couture shows were more difficult to get into but we saw Dior, and Yves Saint Laurent. We were fascinated by Saint Laurent.'

The shop in Nottingham was successful enough at attracting customers to be able to expand. 'It went from being a single back room at 6 Byard Lane to a proper shop, with staff, open six days a week at 10 Byard Lane', as Denyer puts it. And Smith began to sell his clothes wholesale to fashion retailers around the world. Denyer remembers their first sales trip to America: 'In New York I had to move out of the hotel room while Paul sold the collections. In 1976 he took his collection to Paris and showed it to buyers, a step on the road to becoming a successful business and a chance to build up his range – still exclusively in menswear. The first show in Paris was in a flat on the Boulevard Vaugirard that belonged to our friends Alan Cleaver and Keith Varty, who were working for a company in Paris. They were really kind to us – they let us move all their furniture out. We wrote to people to ask them to come. We had professional models, and music. It was very crowded, very successful, and really exciting.' Investing in making the samples and hiring the models was a big step, but in those days, the financial commitment involved in designing a collection wasn't as demanding as it would be for an emerging designer today. You could still wait until you could see which samples were in demand, and which were less popular, before committing financially to an order for cloth. 'In those days, you could make the samples, then order the fabric after you had taken the orders. Nowadays, if you are going to meet the deadlines, you have to buy the cloth first.'

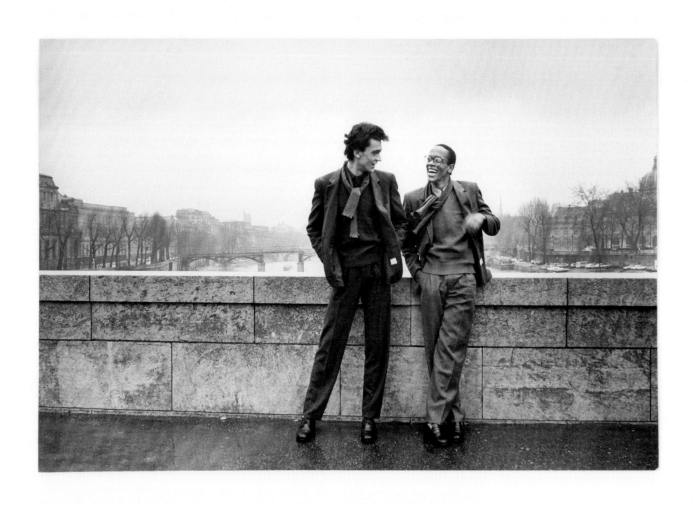

ABOVE AND OPPOSITE *Paris photo shoot, 1978*
OVERLEAF *Paris fashion show, 1978*

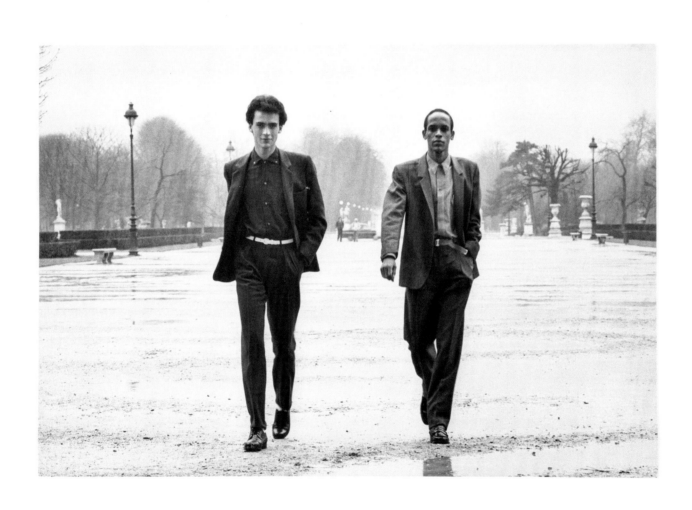

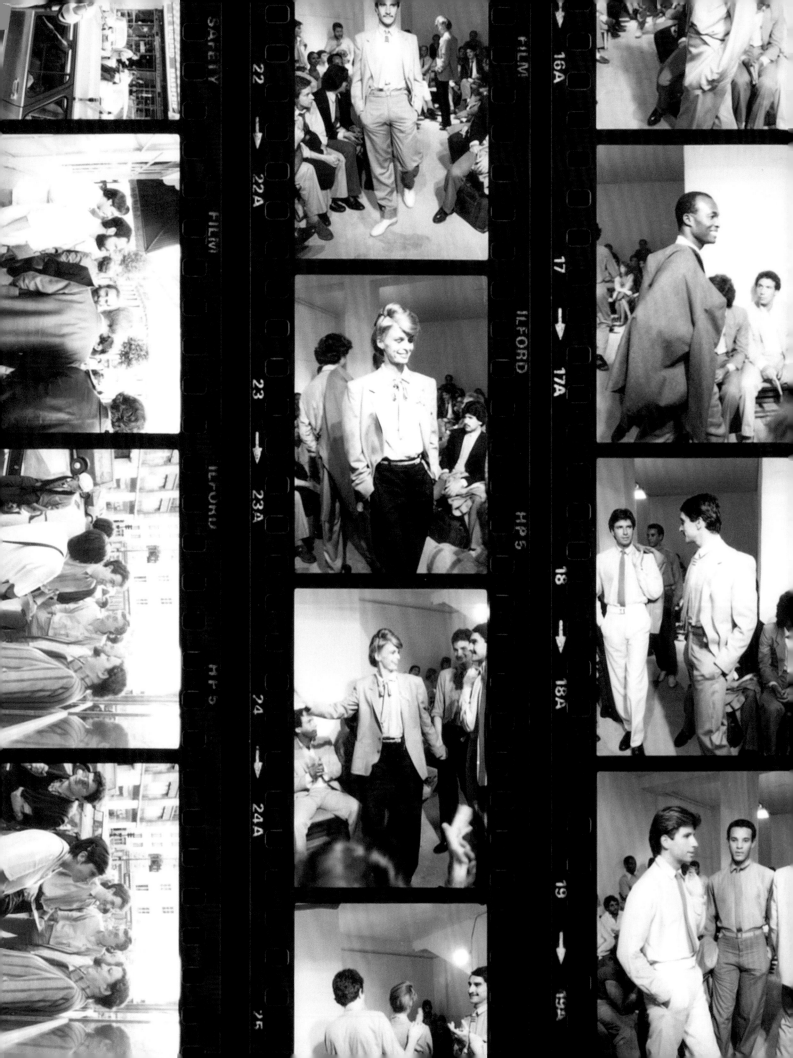

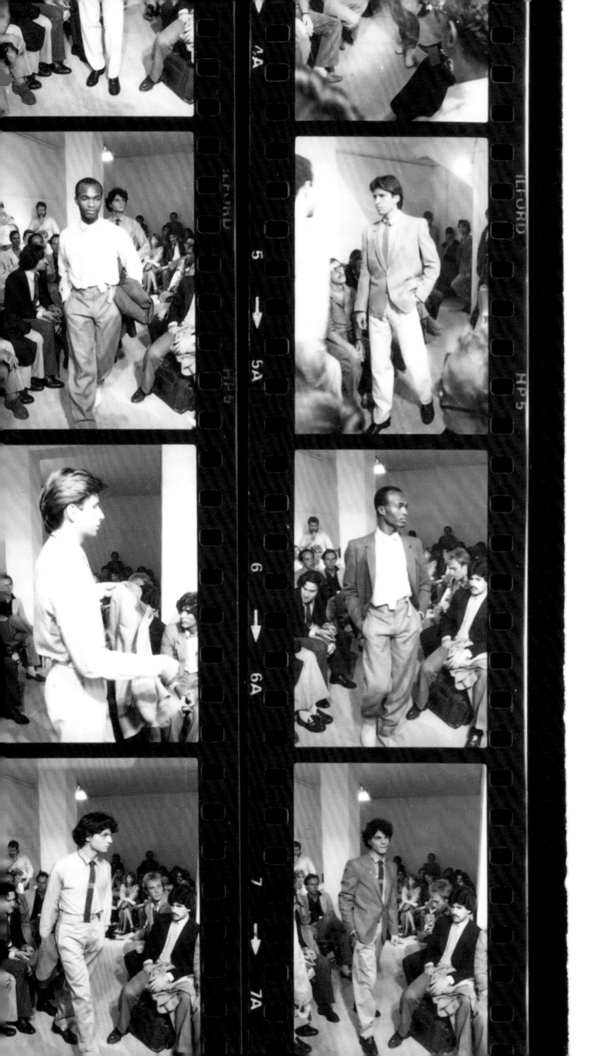

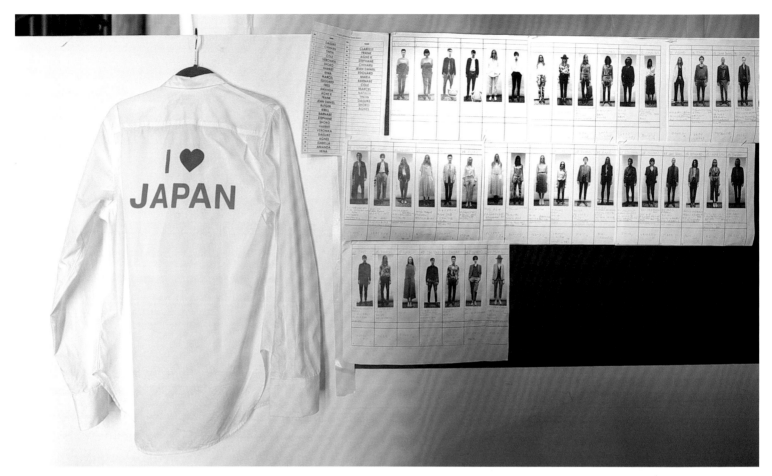

ABOVE *Runway line-up at the Tokyo fashion show, 2012*
OPPOSITE TOP AND BOTTOM *Paul at the Tokyo fashion show, 2012*
RIGHT *Behind the scenes at London Fashion Week, 2011*

That first show in Paris was the forerunner of every Smith show since. In the early years, London was not seen as significant enough for serious fashion players, Smith among them, to stage a formal fashion show. There were times when the shows were seen as ends in themselves. But showing a collection cannot only be an image-building event, or a piece of self-indulgent theatre. The investment in the sample-making, in the models, in the hair and make-up, in the music, and in the setup is huge. The point is not just to get pictures in newspapers of celebrities sitting in the front row, or to get column inches in the fashion pages – or nowadays in the blogs. It's not even to build an aura around a brand to boost fragrance sales. Smith has been a crucial part of London's emergence as a city that not only educates fashion students, who have gone on to run the Italian and French studios, but also has a fashion economy of its own.

If London has not yet grown enough to be considered a real rival to Paris, Milan, and New York as a place for designers to show their collections, then it has, at the least, become a city that deserves to be taken seriously, and designers have worked harder and harder to find impressive places to show their work. For Smith to take on the monumental, marble Duveen Galleries at the Tate Britain, a place that has been used to show the massive work of Richard Serra and the sculpture of Antony Caro, as he did to show his Autumn 2013 Women's collection, was to make a significant statement. A temporary runway was installed, with a battery of lights like the floodlights at a football stadium at one end, massed over a stand crammed full of photographers equipped with telephoto lenses that looked more like rocket launchers. The whole length of the runway was lined on both sides with benches full of well-groomed faces. Behind the seated rows was a surprisingly well-behaved mob. There were television crews, and momentary social anxieties about the seating hierarchy. There were senior members of the Smith management team standing front of house, surveying the faces of the crowds, like a presidential secret-service entourage, looking for any signs of trouble. Then the music started, and the first model appeared, swaggering confidently through the darkness, picked out by the bold lighting, a vivid splash of primary colour.

It was a substantial investment. Its purpose in the end was to put Smith's clothes in front of the various audiences – the people who will eventually wear them, the journalists, the opinion formers, and also the buyers from around the world who would be ordering the clothes from the rails in the showrooms. It is both a ritual and a practical way of giving buyers a view of what the clothes look like when they are animated on a model and presented in the combinations that the designer envisaged.

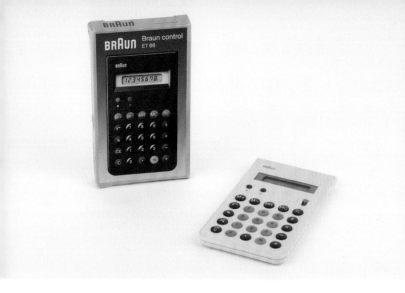

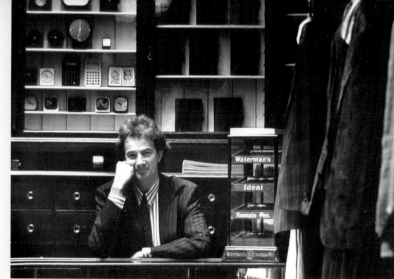

ABOVE LEFT *The classic Braun calculators*
ABOVE RIGHT *Electronic gadgets alongside fashion*
OPPOSITE *Paul Smith Filofax leaflet, 1982*

The Paul Smith business was formally incorporated as a limited company in 1974. As it grew, Smith and Denyer began to bring in people to help them run the business. 'Our friend Barry Brooke who was a zoologist, kept us going at first, and then it got so big that he needed help, and so John Morley, who was our chartered accountant joined', remembers Denyer. As the business expanded, Smith began to recruit the first of many gifted designers, and to look at expanding down to London. 'Paul's dream was to open the shop in Covent Garden, and to live there, too. I thought it was mad', remembers Denyer. The shop in Covent Garden, tiny though it was in its first version, was an important step forward. Smith was beginning to get noticed and to attract a loyal audience, men cautious about being too flamboyantly fashionable without wanting to be typecast as conventional about their clothes.

After that first piece in *Design* magazine about the shop in Floral Street, the next time that I published anything on Paul Smith was an article for the *Sunday Times Magazine*. It wasn't about clothes at all, but it dealt with some of the other things that he had taken to stocking in his shop.

Smith was interested in showing more than clothes. He treated his shop like a constantly changing museum display, crammed with the things that had caught his always-curious eye. I had been to Frankfurt to meet the German designer Dieter Rams at Braun, who is responsible for the perfect calculator and the perfect radio. It turned out that the only place in Britain that you could buy one of those calculators - the ET 22, in matt-black polycarbonate with glossy button-like keys the colour of Smarties, that came in its own moulded matt-black plastic wallet - was in Smith's shop. This was the calculator that Smith's friend Jonathan Ive celebrated two decades later with the calculator interface for the first-generation iPhone. Smith had demonstrated the same unerring eye for a seductive object which caused him to buy a building in Covent Garden, the most unlikely fashion location that was about to become the most obvious. He had understood that the kind of person who wanted to buy a Smith suit, a Smith pair of socks, or a Smith knitted tie in eye-searing bands of oscillating lime green and sky blue, or brick red and muddy ochre, would be exactly the kind of person who might be interested in buying a Braun calculator.

December 1982

20 Monday

21 Tuesday

22 Wednesday

23 Thursday

24 Friday

25 Saturday Christmas Day

26 Sunday St. Stephen

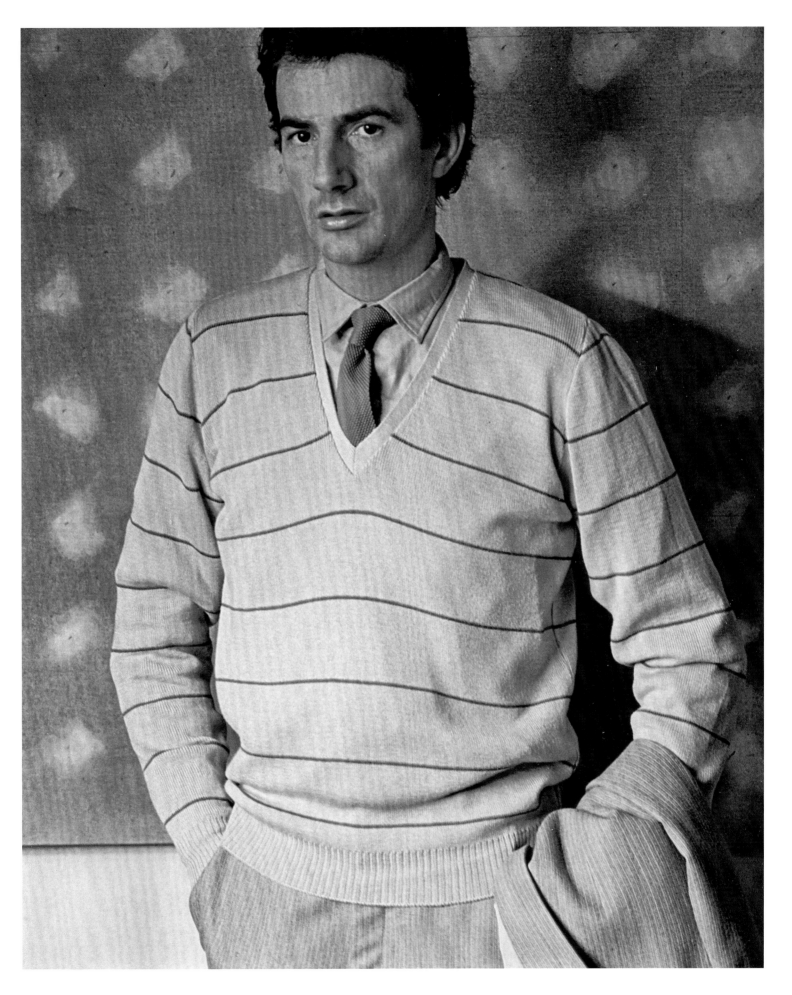

Next to the calculator, there was a shelf on which you could see another of the objects that was to become a defining artifact of the 1980s: the Filofax would eventually collapse into caricature as the badge of shame of 'The Me Generation' of the 1980s boom years. But for a while, it was the quintessential Smith object. He had spotted the loose-leaf organizer, which had been around for half a century. It seemed to represent no-nonsense authenticity, a ring-binder diary. It just needed to be seen in the right context to make you understand that you simply had to have one. It was about to become the smart phone of the analogue age, the essential accessory of the 1980s, along with the red braces – that Smith never sold – and a black Volkswagen Golf with a red-rimmed radiator grille. At first the Filofax was a little like a once-great-but-now-gone-to-seed restaurant. Smith rediscovered it and gave it relevance for a new generation. In 1979 he had seen a Filofax belonging to a friend, and wanted one. He tracked it down to Norman & Hill, the company that had been making them for generations. They were struggling to survive, with offices in a railway arch in the East End of London. Smith started ordering their products and quickly became Norman & Hill's biggest customer as sales took off not just in Covent Garden and Nottingham but also in Smith's shops in Japan. The Filofax became a craze, with ever more elaborate inserts and printed pages becoming available, from street maps to expenses forms and wallets. They amounted to analogue apps. The Filofax began to be sold everywhere. The company offered to sell Smith the business, but Smith didn't take up the offer. 'I sold a lot of them, but I was not happy with what it came to represent.'

Not long after, another object appeared in the window of Smith's shop, an object that appeared to have even less to do with the world of fashion than the Filofax. The young James Dyson had recently graduated from designing wheelbarrows with no wheels and inflatable motorboats to an idea for a vacuum cleaner with no bags. This was before Dyson had won his legal battle with an American retailer who not only appropriated his idea but also claimed that Dyson had stolen it from them. And that was before Dyson had set up his own factories. In those days, the Dyson vacuum cleaner was licensed to a Japanese manufacturer and came in a shade of shocking pink that gave it the look of an unusually elaborate sex toy. And it cost an improbable £1000. But there was nothing else like it. It looked extraordinary, and so it looked right at home in the Smith window. It worked for Smith because it helped to create the sense that the shop was always worth a visit – because you could always be sure that there would be something new

and interesting to look at. And for Dyson it was a useful place to establish the new product as something that belonged in the world of cool. There were new things, like the Dyson, in the shop all the time, as well as second-hand finds – a shelf of old pens, and vintage Japanese gadgets. There were postcards and T-shirts printed with drawings by Glen Baxter, whose brand of surrealist wit seemed to coincide precisely with Smith's.

In 1983, when a group of writers, designers, photographers, and illustrators, launched *Blueprint* magazine to try to make design and architecture, and art and fashion part of a single conversation, we asked the wry social commentator Peter York, co-discoverer of the Sloane Ranger style, to do a round-up on the state of fashion in London. By this time, Paul Smith was an essential part of the picture and he was always going to be part of the piece. But who else should we think about including? We commissioned Phil Sayer to photograph Scott Crolla and Georgina Godley, who were making waves in their louche shop in Dover Street; Margaret Howell, who had a passionate enthusiasm for Englishness in dress, characterized by leather-patched corduroy jackets as worn by Jack Nicholson in *The Shining*, checked shirts, and belt-and-braces trousers; and Katharine Hamnett, who made her name by wearing her T-shirt bearing the anti-cruise missile slogan when she was photographed alongside Prime Minister Margaret Thatcher at Downing Street, London. We might well have included Joseph Ettedgui, the hairdresser turned retailer, who was to do very well indeed with his Joseph chain. We were too unversed in the ways of fashion at the time to fully understand that there was a difference between a designer like Hamnett or Godley or Smith, and a retailer like Joseph, who put his brand on his own ranges but also sold other people's brands and was essentially running a shop. And we completely missed out on the significance of Vivienne Westwood – or maybe she simply wasn't available to be photographed for *Blueprint*. In retrospect, what was really significant about the Crolla/Godley, Hamnett, Howell, and Smith quartet was how much more successful Smith was going to turn out to be than them – or indeed, than anybody else who set out to build a fashion business at the time. He was able to maintain a stable business and remain creative. Crolla vanished from the fashion press after expanding into Japan for a year or two. Hamnett went under and then bounced back. Howell, who was, perhaps in the early days, the closest to Smith in her approach, in her love of Englishness in clothes, and in her making and detail, has quietly and patiently built a global business.

On the cover of the magazine:

BLUEPRINT

THE LEADING MAGAZINE OF ARCHITECTURE AND DESIGN JULY & AUGUST 1986 / NUMBER 29 / £1·50

HOW ETTORE
SOTTSASS IS HELPING
MAKE ESPRIT BIGGER
THAN BENETTON
THE ESSENTIAL
GUIDE TO FESTIVAL
EDINBURGH
MICHAEL GRAVES
IN LONDON

PAUL SMITH AND THE DESIGNER BAG MAN

PAUL SMITH PHOTOGRAPHED BY DAVID BANKS

ABOVE *Paul on the cover of Blueprint, 1986*

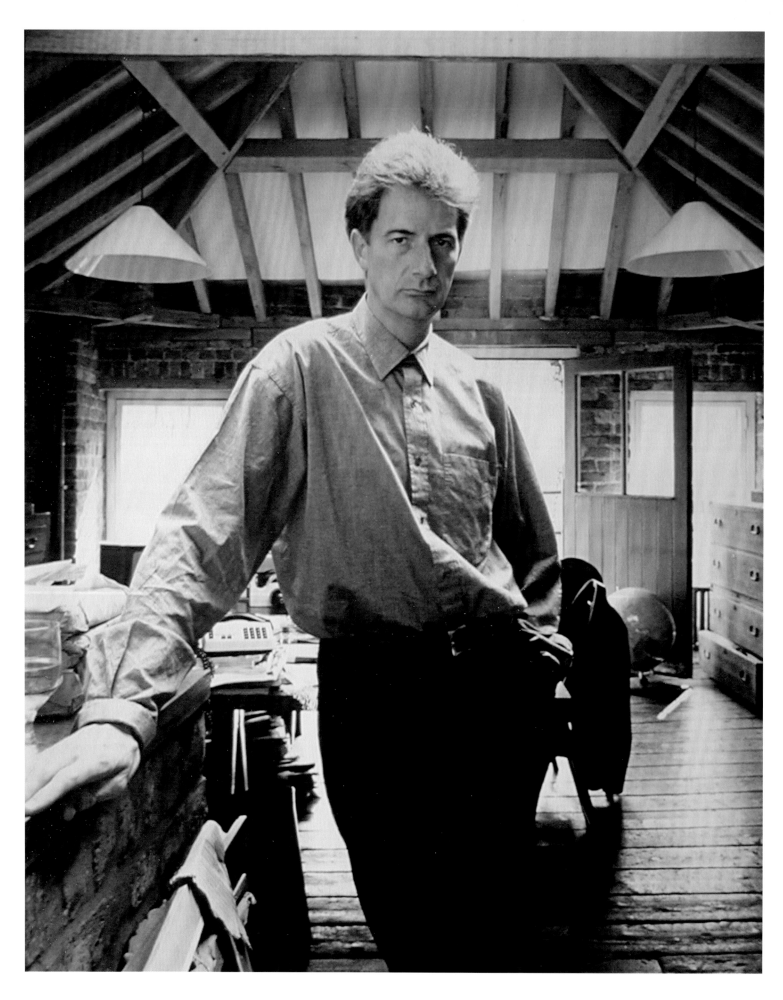

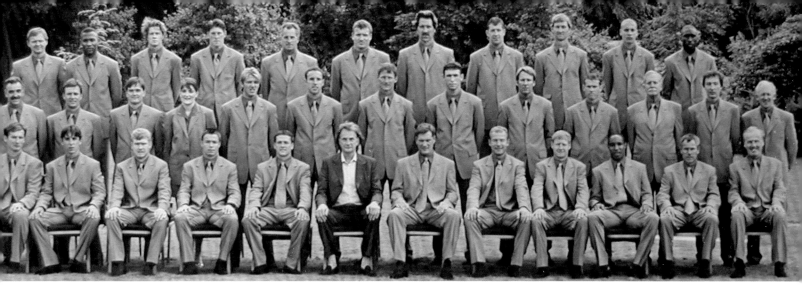

There were so many other names at the time, the great might-have-beens – Body Map, for example, who made a suit out of the cloths that the breweries used to put behind the beer taps in pubs in the 1970s, or Richmond-Cornejo. From the previous generation, there had been Ossie Clark and Quorum, and even the nostalgic look of Laura Ashley, who had suddenly become huge but was unable to go beyond the Edwardian revival that characterized her biggest success. None of them was able to rival the discipline and rootedness of Smith and his eye for detail. None of them had the steel to survive finding themselves dressing Tony Blair and Eric Clapton and the England football team without losing their sense of proportion.

Blueprint photographed Smith in his newest shop, which was a couple of doors down from the first concrete-floored shop. Inside it, you could find mahogany counters, rescued from derelict pharmacists, displaying a lovingly assembled collection of second-hand books, tin toys, and eccentric cigarette lighters. There was dark wood and panelling, and salvaged-wood floorboards. It was nostalgia, but it was defanged with a healthy dose of wit. This was not, Smith suggests, some sort of tipping point. He did not suddenly decide to present himself as a traditionalist rather than a modernist. What happened was that things were going so well for his shop in Covent Garden that he was able to buy the building next door. And when he did that, he looked at the floor and decided that he didn't have the heart to tear it out. The next shop turned out to be one that was based on old resonances, more than on new insertions. By the time that Smith opened his third shop in Floral Street, and set up his office on the top floor of the building, which is reached by a tightly coiled spiral staircase, he had already taken the next key step in the development of his career.

ABOVE *Paul at one of his early presentations in Tokyo*
LEFT AND OPPOSITE *Paul dining out in Japan*

He had a visit one day from a Japanese scout, a man who had documented every aspect of the shop: Smith's clothes, his look, the labels, the packaging, and his shows. He had put together a book full of cuttings and photographs. Smith was amazed. Here was somebody from the other side of the world who knew almost as much about his business as he did himself. 'It was a bit terrifying; it felt a bit like being stalked', remembers Denyer. This was still a moment when Japan seemed as impossibly remote as Mars. It was a culture as different from that of Europe as could be imagined. Smith's visitor wanted to introduce him to a Japanese company that was interested in a partnership with a young British designer. It was a conversation that would change Smith's life. The American Jacket Corporation had a retail presence throughout Japan's network of department stores and its fashion buildings. They also had manufacturing capacity. What they needed was a new designer to push them forward from the Ivy League preppiness on which they had built their success towards the tastes of another generation. The quirky Englishness of Smith's approach was what they thought would give them a new edge. Smith was intrigued by their interest. He and Denyer went to Japan to meet their potential partners. A deal was struck that would see a number of Paul Smith shops in department stores and fashion buildings, modeled on the look of the London stores, as well as some stand-alone flagship stores, together with the start of production for the Japanese market in Japan.

Smith took to Japan immediately. He was fascinated by the attention to detail, the craftsmanship, and the surreal juxtaposition of cultures that characterize the country. He was interested in Japanese style – both traditional and in its new pop forms. He quickly made the decision to become deeply involved in the market, rather than to treat it as a backwater in which to licence his name to whatever end his partners cared to put it, confident that the results would never be seen outside Japan. For Smith, Japan was to become home territory rather than a dumping ground. And he always had the energy to put time into building relationships with the Japanese. It was also the point at which Denyer, having played the essential part in creating what the brand was to become, began to step back and to concentrate on her career as a painter. She had studied at the Byam Shaw School of Art, and then at the Slade School of Fine Art, where Euan Uglow was still teaching.

The younger generation of Japanese was fascinated by Paul Smith clothes. They loved English pop music and English style, but socially, they were still driven by a very different approach to working life that characterized Japanese business culture. I remember the first trip that I took to Japan with Smith, sitting down in a restaurant with him after a late-night event and finding myself next to one Japanese member of the Smith team. He spoke some English and was outwardly cheerful, but every so often he

would disappear. In the age before mobile phones, he was using the payphone in the lobby to check on the health of his sick child, who had been hospitalized that morning. He told me, 'But you must not tell Paul.' Smith, of course, would have been horrified and sent him home immediately if he had known. But he didn't. And in the Japanese business context at the time, the company came first, and everything else had to fit in behind – even a sick child.

Smith loved discovering the tiny bars in Shinjuku with just six seats at a counter in a bamboo shack, with a row of bottles behind the barman, each one of which belonged to a regular customer. He loved the taxis that had doors that opened apparently of their own accord when the driver pulled a lever. Smith was there when Nigel Coates and Philippe Starck got their first commissions to build at the height of the bubble economy. He was fascinated by the Axis Building, where you could find vintage motorcycles on sale on one floor, Shiro Kuramata's exquisite fluorescent-pink acrylic vases on another, and a Comme des Garçons store on another floor, with absolutely nothing in it. If you wanted to buy something, you had to ask, and the stock was brought out, one item at a time, like precious works of art, emerging from the vault for the scrutiny of a connoisseur. Smith loved it, but he also knew that to survive financially, he could not afford to go down the same road.

The Paul Smith shops within department stores spread rapidly over the country. In the Japanese versions of the *Face* magazine, style magazines such as *Popeye* and *Brutus*, Smith became a regular fixture, engaging the Japanese with his quirky wit, but also with the sense that he was bringing them an entirely different view of fashion, one that was nothing like what they were used to. Production of clothes was for the most part in Japan, with a few special 'Made in England' items. There were selling shows in event halls and in Smith's own spaces.

The Japanese gift for creating copies of good ideas quickly manifested itself. The Smith pattern of mixing clothes with objects, pens, Filofaxes, calculators, and other things became ubiquitous. A whole chain of menswear shops that also used salvaged dark-wood fittings as counters sprang up under the fictitious name of Karl Helmut, rendered in a handwritten script almost indistinguishable from Smith's own. Eventually the very ubiquity of Smith in Japan made him start to appear almost as if he were a domestic brand, a development that only made him work harder to engage and surprise his audience there. The Japanese business quickly outstripped the scale of Smith's presence at home. It was sustained in large part by Smith's energy. The brand became him. He was spending weeks at a time in Japan, twice a year. It was an interesting translation of an essentially English look to a very different national context.

ABOVE *Editorial coverage in* Casa Brutus *and* Popeye
BELOW AND OPPOSITE *Paul exploring Japan*

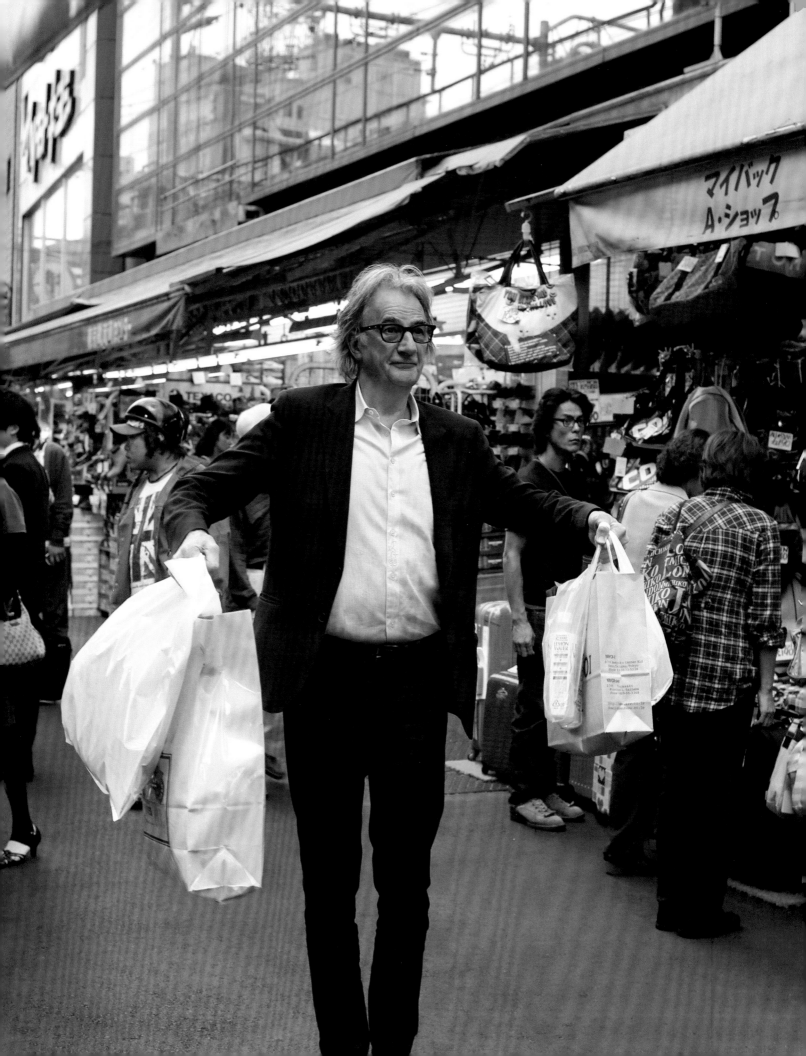

Japan, when Smith first arrived, was still coming to terms with a Western diet; a generation of Japanese was rapidly growing taller than their parents, but they still had a non-European physique; and the Japanese versions of Smith's clothes needed to be not only different sizes but also different proportions.

Japan in the 1980s was entering the bubble economy, a place and time where, for a while, anything was possible. It started to import European architects to design its restaurants and shops, as well as its museums. Smith was fascinated by everything, from the shrines to the vending machines that sold hot drinks, noodles, and the soft drink Pocari Sweat, which memorably promised, in that uniquely Japanese version of English, 'To Unfold on Your Tongue and Be a Sweet Heart'. He was intrigued by the phenomenon of Tokyu Hands, the department store offering eight floors of DIY, a museum-quality combination of stationery store, warehouse, and art gallery. He spotted a concession in the Seibu Department Store that sold only beige-coloured products that had no brand, and which turned out to be the beginning of the Muji phenomenon.

Smith loved the way that when you asked for room service at the Hotel Okura Tokyo, the time that you ordered it was recorded to the second and marked in pencil on the trolley on which it was delivered. He loved the efficiency of the bullet train to Osaka. If it was more than a minute late, it would make the news bulletins. He was fascinated by the spectacle of the airport limousine bus, which would leave the depot to the accompaniment of a deep bow from the foreman, whether there was anybody to see him or not. He liked the way that all the department stores did their best to be smarter and more up to date than each other. He noticed that change would always be tendered in crisp new notes on a small tray, and that your receipt would come in a small envelope. He was fascinated by Japanese fashion: he saw quite a bit of Rei Kawakubo, the woman behind the Comme des Garçons label. Two more different approaches to life or fashion would be hard to imagine than those of Smith and Kawakubo. But Smith, with his gift for non-verbal communication, succeeded in building a warm relationship with her. He loved the fact that one of Japan's most successful interior designers at the time had a studio called Super Potato. And he had an enthusiasm for Japan that he wanted to share. He called me up at *Blueprint* one day, and said, 'You have got to come and see it for yourself', which is how I found myself flying to Japan with Smith on the weekend that Chernobyl exploded. Every visit that Smith made to Japan in the early days would include a trip to Kiddy Land in Tokyo; the Omotesando store specializing in toys of all kinds, from which he would come back with boxes of walking false teeth, plastic chickens, cigarette lighters camouflaged as hand grenades, spectacles from which eyeballs would drop. They were the props that he would drop into any kind of conversation. Each trip he would fill a suitcase with them, charming the check-in staff into waiving the excess baggage charges for all the weight he was carrying. He was also fascinated by the work of Shiro Kuramata, the gifted Japanese architect who designed Issey Miyake's first shops and a series of exquisite sushi restaurants that were hidden in the most tangled of Tokyo's crowded alleys. He would go to the extraordinary Tokyo fish market in the morning; he knew where to find the shops that specialized in making wax food, intended for restaurant window displays, and the specialist manufacturers such as Porter, which made bags and luggage with a remarkable level of innovation.

Smith changed the face of fashion in Japan, gradually moving from shops within department stores to a network of flagship stores, in which he was able to re-create the ambience of what he had achieved in Floral Street. But Japan also had a big impact on the nature of Smith's business in Britain. The income from his partnership allowed him to grow and invest in Britain, and later in Europe and America. He was able to fund more of his own shops. He was able to begin advertising in the fashion and style magazines – showing the clothes in his own way and using a range of strong and characterful individuals to wear the clothes. The photographer David Bailey, the advertising creative director John Hegarty, and the actor John Hurt all have appeared in Smith's idiosyncratic campaign photographs.

Japan also opened Smith's eyes to other ways of doing things. Denyer's eye for classical couture fashion was one essential source for the Smith approach to clothes. Japanese inventiveness and passion for detail were others. Smith has a constant interest in finding new visual experiences and sharing them with others. A year after that 'you must come to Japan phone call', in April 1987, there was another conversation, this time about an extraordinary work of art that I just had to see. Matt's Gallery, Robin Klassnik's pioneering space for installation art, then in Martello Street in London's East End, was showing a piece by the artist Richard Wilson. 'Go right now, it's the last weekend', Smith told me. He picked me up after a Sunday morning swim at the RAC pool and a croissant at (what was then the only) Patisserie Valerie on Old Compton Street, and he took me off to the east in his car.

ABOVE *David Bailey photographs John Hurt and John Hegarty for the Spring Summer 1994 campaign*

Matt's Gallery was the first outing for *20:50* and the two hundred gallons of used sump oil that Wilson used to flood the building and distort enthralled visitors' perceptions of space. Twenty years later I wasn't surprised to see Smith emerging looking a little dazed from James Turrell's colour-saturated light installation at the Gagosian Gallery in Kings Cross. Art had changed out of all recognition in London in the meantime. And in some respects, it has come more and more to resemble the hysteria of the fashion world that Smith has little sympathy for. He is more comfortable with the work of Euan Uglow, the painter who taught Denyer at the Slade. The work is figurative, but beneath the surface, the underlying structure is made apparent. But it's not just contemporary art, or Japanese kitsch, or Indian craftwork that Smith wanted to share. I remember a summer weekend at Smith's farmhouse in Italy – he calls it the Villa San Michele on the basis that it was paid for mainly by early consultancy work he did for Marks & Spencer, the British retailing giant, and its St Michael label. We went to see the garden of a nearby country house, with a remarkable rococo water garden, where Neptunes and sea monsters spout water that catches the unwary by surprise.

There is nothing that looks remotely Japanese about Westbourne House, the flagship store that Smith created from a white stucco-fronted corner building on the edge of Westbourne Grove. But from the way that it mixes second-hand, vintage, and new items to the presence on the top floor of a bespoke suit-making service, it's retailing that has developed into a kind of theatre. And it's there in the way that Smith turned the building into a story, with each room themed, including a playroom and a living room, linked by the stairs, which are lined with personal photographs and works of art. Smith has a love-hate relationship with shops, delighting in the unexpected, but more often dismayed by the stultifying impact of the uniformity and the predictability of contemporary retailing. He is troubled by the far-reaching effects fashion-led retailing and marketing have had on so many aspects of our lives – from the way our cities work to the cultural values of consumers sated by an excess of imagery and branding. He says, 'I have always loved street markets and the act of discovering things for myself. Big retailers offer key money, and that sets a precedent allowing the rents to go up. Once it happens in a street, it means the cheese shop will be gone. In the corporate world, everything is fine but it is hard to find character.' He thinks a lot about the gentrification that he saw overtake Floral Street, and so many other streets around the world: 'When I first saw the Via della Spiga in Milan, there was still a food shop and a gentlemen's outfitters that sold good-quality socks. In Florence, I have seen the Via de' Tornabuoni transformed over the years. It used to be a street of amazing houses, each with stables attached. It began to attract little bars

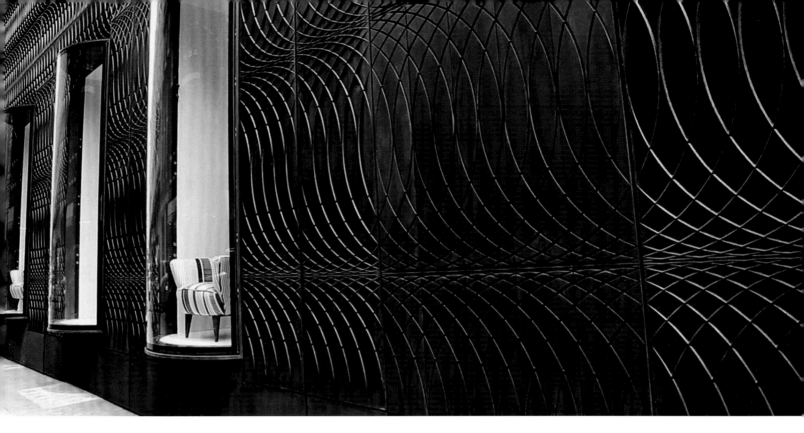

and chic coffee shops, which opened alongside the old shops selling gloves and toothbrushes. The little coffee bar that had been there since 1890 was taken over by Roberto Cavalli. The bookshop became a branch of Max Mara. The pharmacy is Hogan. In Capri every shop has the same blind, albeit with a different designer's name on it. It seems to work, but in your heart you want it to be different.' Smith's shops are lovingly created one-offs. The Los Angeles shop on Melrose is a shocking-pink box – a tribute to the Mexican architect Luis Barragán. In Cape Town, Smith's shop is in what used to be a house. In New York, it is in SoHo, in a store that is like walking through a series of flat stage sets. In London he is working with 6a Architects, who have developed an intricate cast-metal façade for his building in Albemarle Street.

'Come and look at this', he told me one day for an article that I wrote for *Domus* about his Milan shop on the Via Manzoni. Taking my arm and, with the air of a magician discovering a goldfish behind my ear, he pointed out the loving way that the original terrazzo floor had been patched with little mosaic inlays. The technique is beautiful, but the effect is deliberately designed to subvert the conventional idea of high-gloss perfection in much the same way that intricate decorative embroidery spreads over the formally tailored suits that he designs, or the hand-stitching frames the collars of his wool shirts.

OPPOSITE *Johannesburg shop exterior*
ABOVE *Albemarle Street façade by 6A Architects*

There is the same mixture of the precious with the crude in the choice of furnishings. At the back of the store is a huge oil-soaked and battered workbench that Smith found on one of his journeys around Italy. He rescued it from the industrial shed in which it had lain undisturbed for so long and installed it exactly as it was. It's so big that it is hard to imagine how anybody could have got it onto a truck. At one end, the architect, Sophie Hicks, built a sparsely detailed elegant glass bridge. But for most of its length, the bench is left exposed, and it is not exactly beautiful. The top is stained and worn, in brutal contrast to the soft cashmere and fine silk that Smith drapes across it. The structure, clearly knocked up by some casual-jobbing carpenter is makeshift, and yet sitting here in this environment, it has a powerful sculptural presence. It's almost a [Georg] Baselitz. It is also the last thing that you would expect to find in the city with the most exquisite, the most refined showcases for fashion in the world – which for Smith is the whole point.

Elsewhere, in the elegantly made glass display cases that pay tribute to the jewel-like precision of Carlo Scarpa, Smith takes the opposite tack. Rather than put beautiful things on a crude bench, he has filled the immaculately finished display cases with the pick of the toy shops of Japan. There's a flock of plastic lobsters corralled inside one, another has a model train set taking pride of place.

On the floor is toy dog, a life-size papier-mâché Airedale on wheels. As you come in from the street, you run the gauntlet of a wall of stuffed shirts pinned to the wall rising six metres up. Over it all is a light-box ceiling, apparently uniform but, in fact, subtly tuned to light each area in the most appropriate way. The walls, said Sophie Hicks, the architect responsible, were not intended to be a tasteful shade of pink. 'It's a vulgar pink. What else can you do when you have to deal with a shop which is full of different surfaces and walls, full of openings that the landlord insists you can't touch. It is, however, a beautifully finished vulgar pink.' Smith's shops are labours of love, but they are also carefully considered, and they are meant to work. Smith has given a lot of thought to how to make them function. 'Solid walls and small windows put people off. You can't underestimate how shy people are. We always try to have the doors of our shops open. It makes people more comfortable about plucking up the courage to come in. You need a long table close to the gangway. You put out something cheap and accessible, so people can touch it. It's a way to help people enter the shop, so they don't feel self-conscious about it. You go to some shops because you want to buy a specific item, a suit, casual clothes. Minimalism is visually fantastic, but it is hard to be a competitive retailer with a very minimal interior. Too much colour, and the clothes can look cluttered. It can make even the sales tickets look untidy. When Peter Wigglesworth finished my first shop in London, we looked at each other and realized that the tickets on the clothes stood out like a sore thumb, Peter said "Right, take all the tickets off", to which I replied, But Peter, how do we know what the sizes are if we do?'

Among the key things that made Smith succeed when so much other promising British talent in the 1980s faded away was his ability to think of fashion in such terms: to understand that behind the tableau of the fashion show there must be an intricate and well-ordered mechanism that can deliver the promise on time and a budget that will allow the whole process to work; that the shop needs character and personality but also must be welcoming; that a collection needs a strategic perspective as well as individually inspired pieces. Anything else, and the fashion process is turned into a kind of cargo cult, moved by the outward forms but without any substance. It's a lesson that has been learned by the generation of designers that has followed, even if many have become part of the portfolio of brands acquired by two or three of the giant groups.

Smith chooses not to take this route. Saying yes to one or the other of the offers to buy his shares might have meant adding the creative leadership of another fashion house to his existing responsibilities – and it would certainly have meant a great deal of cash. But it would have involved becoming part of the fashion machine, the machine that in its increasingly frantic attempts to attract attention to its products is resorting to the most blatant, sexually explicit imagery in its advertising – at the same time that the clothes themselves, and the surroundings in which they are sold are increasingly formulaic.

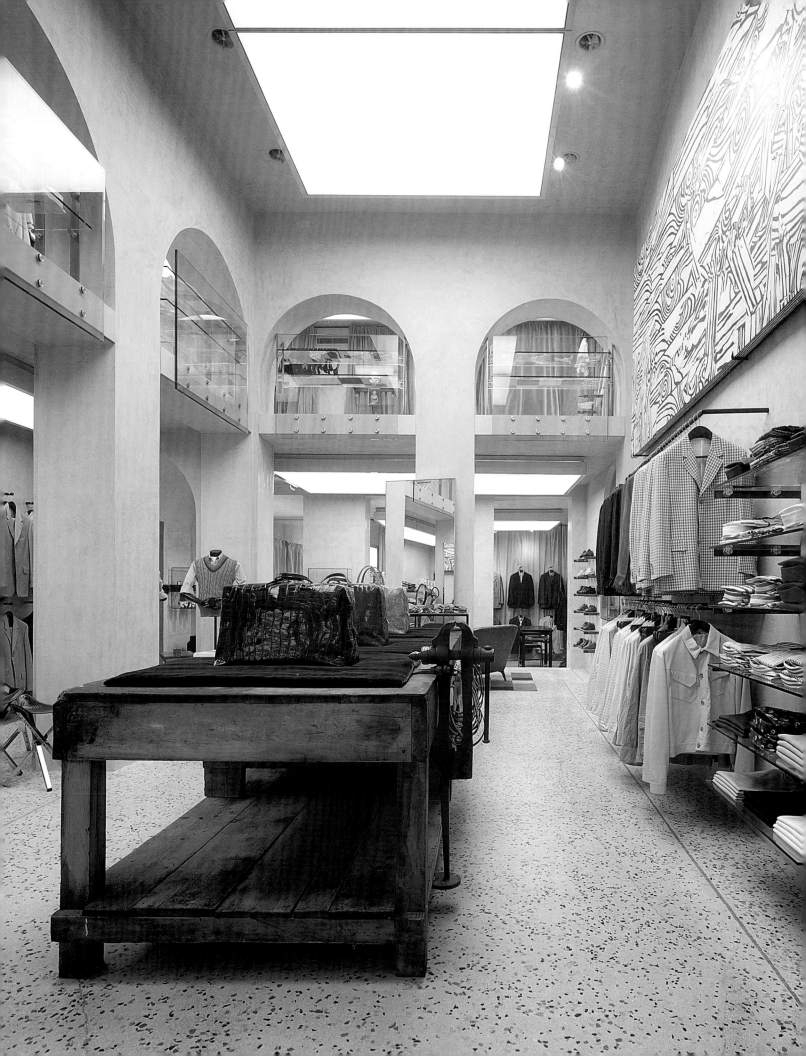

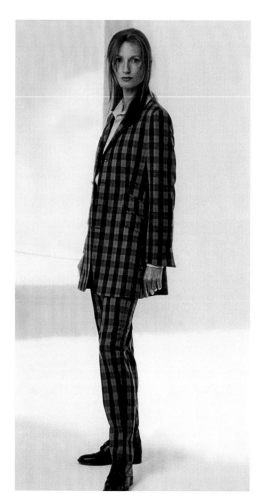
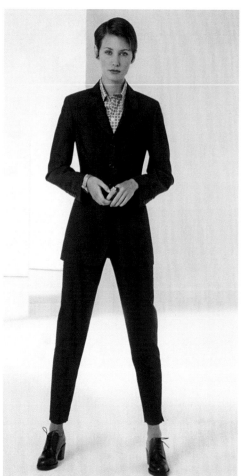

Paul Smith is a paradoxical designer. He is in the world of fashion, but in some senses, he is not of it. He has made his life about the way that the things that we wear look. But the hysteria and the air-kissing of the world of fashion is not for him. He is businesslike and very successful, and yet he is playfully anarchic. He is ready to reveal the artifice, and the stage scenery behind the magic and the spectacle. You have the sense that Smith prefers things that last, that grow old gracefully: the Bristol car that he used to drive, the way that he collects salvage. The biggest leap that Smith took was when he made the decision to move from menswear to also designing for women. For many years Smith shied away from the idea. It took him from the commanding heights of fashion for men, traditionally seen to be neither as demanding nor as creative as making fashion for women. In a way, it was like starting again. He was deliberately making himself a vulnerable beginner again. And he was also extremely cautious about doing all those things with brand extension that have so often led to disaster.

ABOVE *First Women's collection, Spring Summer 1994*
OPPOSITE *First Women's show, Autumn Winter 1998*

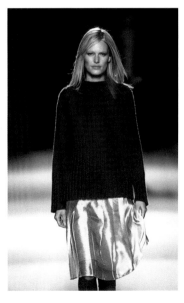

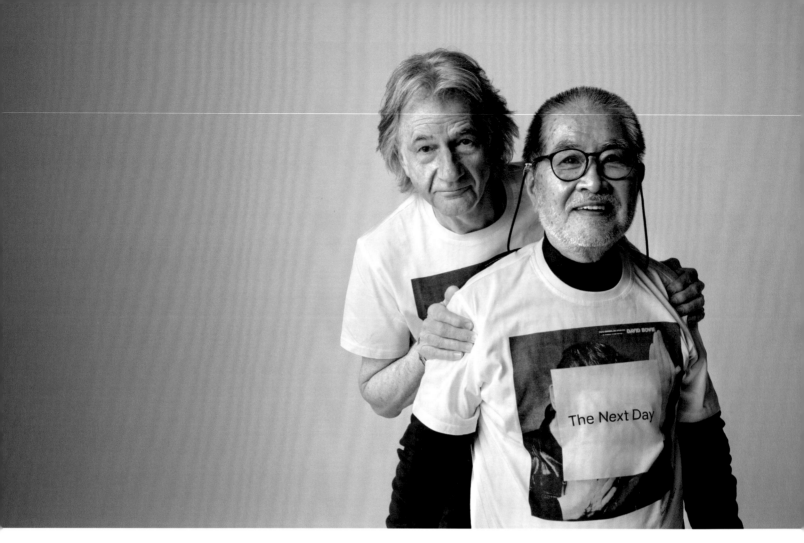

ABOVE *Photographer Masayoshi Sukita with Paul*
RIGHT *Paul's portrait of Gary Oldman for* The Times

One by one he took them all on: womenswear, children's clothes, eyewear, fragrances, luggage, and shoes. But more unusually, he also started working with companies outside fashion to come up with products that are not simple endorsements or signatures. He works with the American textile company Maharam and with the Danish tableware company Stelton. These are new products outside fashion, products that simply call on Smith's skills as a designer – in fact, on his eye. In the end, that is what Smith's skills depend on, his ability to see and to find things: in a street market, in a back street, in an Indian workshop, or in a library. What Paul Smith has is the ability to go on looking, to go on finding new things to excite him – and the ability to retain the sense of wonder to communicate that wonder to others. He was intrigued when Tomas Alfredson, director

of the film version of John le Carré's novel *Tinker, Tailor, Soldier, Spy*, wanted to talk to him about how the film would look. What kind of colour palette would make the film look true to the period? Alfredson, who had heard Smith give a talk in Stockholm asked him for his acute observations of how London had looked in the 1970s. What was the mood? What were the colours like? Smith went on to photograph Oldman in the run up to the film's opening.

Remarkably, Smith's eye and his skill as a storyteller have managed to translate themselves from that first tiny back room in Nottingham, open only two days a week, into a company with a global reach. Even in the departure hall at Incheon, or in Terminal 5 at Heathrow in London, there is still a sense of Smith's spirit.

ABOVE *Paul and Pauline in Italy, 1972*

ABOVE *Illustration by Tarout, 2013*

THE STORY SO FAR ○ ○ ○

DONNA LOVEDAY TALKS WITH PAUL SMITH

I've often likened it to spinning plates, like those entertainers you see sometimes, who have poles with the spinning plates on top. That's what my job is really like.

My job is very varied… Of course, I'm a clothes designer, that's how I started, that's how I pay my wages – but my world is very diverse.

Probably one of the most important things is that a lot of people think that design is just about drawing something that comes from your head and the rest magically happens. Unfortunately, it's not like that. If you're fortunate to be working with one of the larger fashion houses, then you may be privileged to just be the 'designer', but you will still be asked to do interviews and communicate with the public on the Internet, on Twitter, and on Facebook. The industry has changed enormously in recent years, and so the luxury of just being a designer has long gone, even if you work for a big company.

If you work for yourself, or are somebody like myself, who is the main owner of the company, it's very much about communication, talking to people, the design, the personality of the company – it's very hands-on. Of course, being the boss, the head designer, and the main

shareholder of the company, my jobs are very varied. So I also have to be involved in business decisions: 'Do we buy a new warehouse?', 'Do we spend money on the computers?', 'Do we open this shop in somewhere… and what are the overheads of the shop?'

The other thing, of course, is publicity: answering interviews by email or being interviewed by people visiting me or when I'm in different countries. That could be TV, radio, newspaper, magazines – and often that includes a photo shoot as well.

I've often likened it to spinning plates, like those entertainers you see sometimes, who have poles with the spinning plates on top. That's what my job is really like. It hops from a design meeting from nine o'clock until eleven o'clock, then a shop-design meeting until twelve o'clock, and then an interview with a magazine, and then it could be more of a business meeting with my managing director for an hour, and then it'll be looking at colours with the design team. Because of that variety, I love it – it's very interesting.

ABOVE *Paul in action*

THE COLLECTIONS

The show is the final ingredient of a recipe that's been on the stove for six months. I am much more interested in finding the key idea and choosing the fabrics and colours.

There's the 'day job' as I call it, which is designing. These days I'm not really sitting down and designing. I'm more like a stylist as I have a team helping me. Fashion is seasonal; it used to be just two collections per year but, in some cases, it's three or four because the shops in the seventy-four countries that we sell to around the world want more of a flow of clothes, rather than just two big hits twice a year.

I'm based in Covent Garden in London. My design team is one floor down from me, and they visit me or I visit them daily. That's when I'm not travelling, which I do for several months of the year. So the inspiration normally starts off with me – it could be from something I have seen, like an exhibition or a movie, or – because I know my job very well – sometimes I just know how to progress each season. Then, of course, we have lots of talented designers and a good team, and so they also have their input.

There are twenty-eight collections a year and four fashion shows a year: two for men in Paris, two for women in London. I am not a big fan of fashion shows, but they are part of the theatre of fashion, and no one has found a replacement for this ritual that serves designers so well. The show is the final ingredient of a recipe that's been on the stove for six months. I am much more interested in finding the key idea and choosing the fabrics and colours. At that exact moment, I can already visualise the clothes that will reach the stores six months later. We also show our clothes in our showrooms in Milan, Paris, New York, Tokyo, and London – they're just showrooms, they're not fashion shows.

In Japan, we have a very substantial business, and so we take part in two *Tenjikai*, which are like exhibitions, twice a year. That's where we lay out all the clothes and that's where the local press and buyers come. So I visit Tokyo for normally about ten days, twice a year.

I still go to the fabric fairs twice a year; they are in Milan and Paris. This is where several thousand companies show their new fabrics for the forthcoming season. A lot of designers now prefer the mills to come to them, but I think if you go, you can find things that maybe surprise you, and so I think it's very important to still keep in touch.

Speaking about fabric, we are very famous for our print and, in particular, our stripes. These are all developed in our studio in Covent Garden. We're working in the studio constantly, with the three clothing collections for women and the four clothing collections for men, and so the print alone takes quite a lot of following, and my attention. That's another thing that happens on a daily basis.

So far we've got twenty-eight collections a year: two shows a year for men, two shows a year for women, two *Tenjikai*, and fabrics fairs twice a year in Milan and Paris.

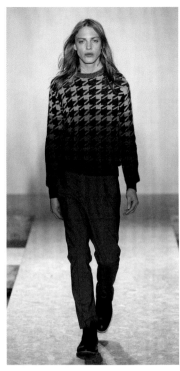 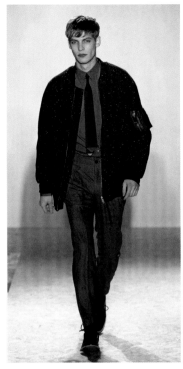 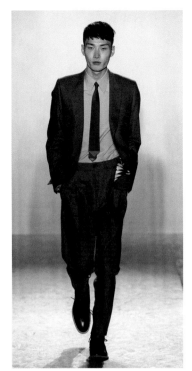 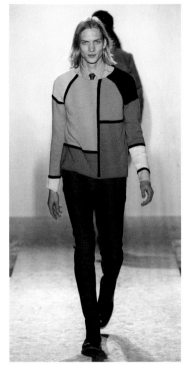

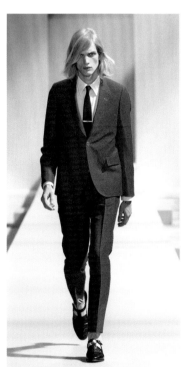 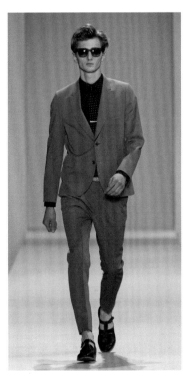 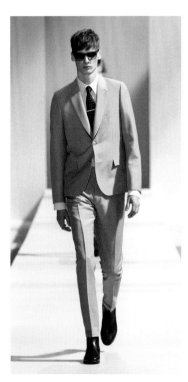

TOP *Autumn Winter 2013, Men's fashion show*
ABOVE *Spring Summer 2013, Men's fashion show*

 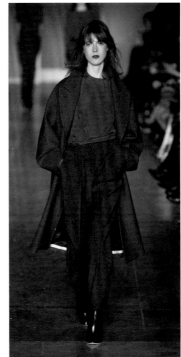 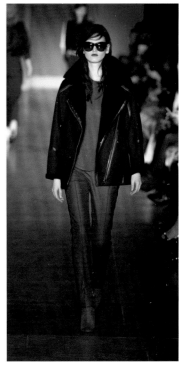

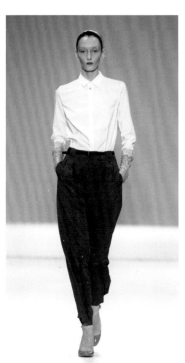 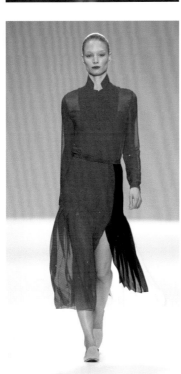 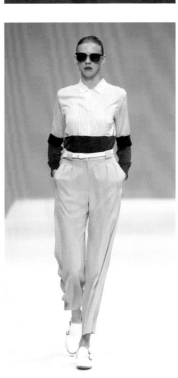 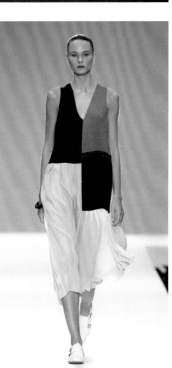

OPPOSITE AND ABOVE *Spring Summer 2013, Women's fashion show*
TOP *Autumn Winter 2013, Women's fashion show*

MEN

WOMEN

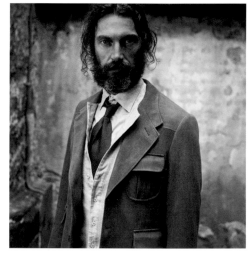

COLLECTION

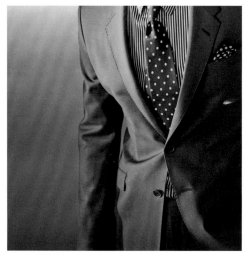

LONDON

BLACK

PAUL

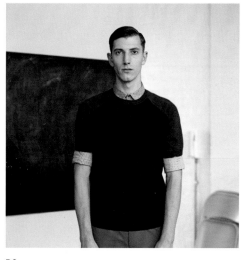

PS

JEANS

SPECTACLES

THESE PAGES *Paul Smith product lines*

114

SHOES

BAGS

SWIM

JUNIOR

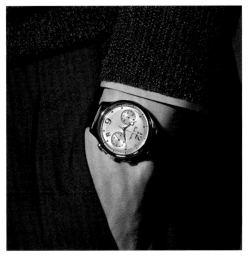

WATCHES

UNDERWEAR

ACCESSORIES

LUGGAGE

FRAGRANCE

THE ARCHIVE

British Tradition

Paul Smith designs often draw on very British traditions and motifs. Past collections have referenced a number of British music and social movements such as the dandies, rock 'n' roll, mods, the Women's Land Army, British poets, artists and eccentrics. Womenswear collections have featured prints inspired by British traditions like tea-time. The use of British fabrics such as Harris tweed, Bedford cord and barrathea has always been important to Smith, but they are often subverted by washing, fraying, re-colouring or re-sizing.

PRINT

Print has always been a hugely important feature in Paul Smith collections. This started as a way of adding individuality to menswear - a simple navy suit accompanied by a floral shirt. Print quickly became a touchstone of the collections and began to appear in every collection and at every show. A wide range of imagery has been used over the years - flowers, animals, photographs, art, kitsch and graphics. Print has extended to T-shirts, bags, scarves, and jacket-linings to add interest to more classic pieces.

colour

Paul Smith is credited with adding colour to menswear. Smith's view was that men shouldn't be afraid of colour. If used in the right way colour can add interest and express positivity. The Spring Summer 1996 men's show featured suits in Yves Klein blue. The Spring Summer 2010 women's show was inspired by the book *Gentlemen of Bacongo* with suits in bright pinks and coloured bowler hats. Colour has been added as a detail to otherwise classic garments, in the form of linings, bright overchecks, or piping on jackets.

TRAVEL

Smith travels frequently - this global view informs and influences everything that the company does. Smith tries to see common threads and differences between world cultures and wardrobes. Collections have featured a wide range of references - Afghan jackets and suits, a collection for women inspired by Chinese sequinned cheongsams and chinoiserie prints, Indian embroidered velvet kaftans, coats inspired by Russian Constructivism, and mens shirts printed with the names of Buenos Aires barrios.

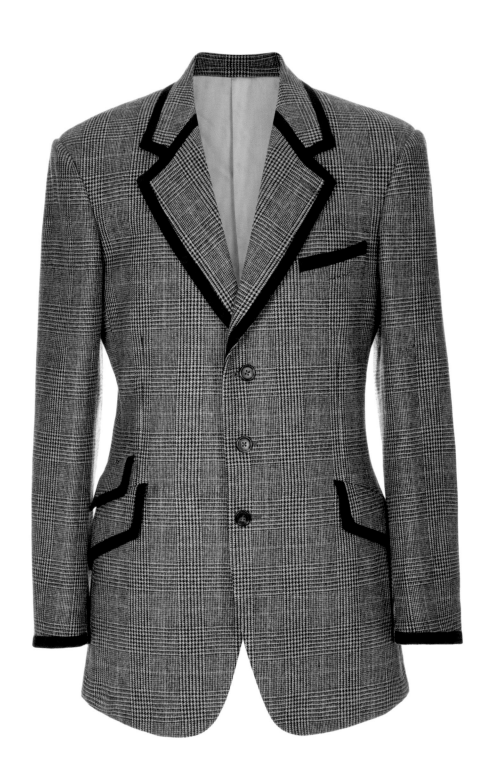

BRITISH TRADITION
Menswear

BRITISH TRADITION

Womenswear

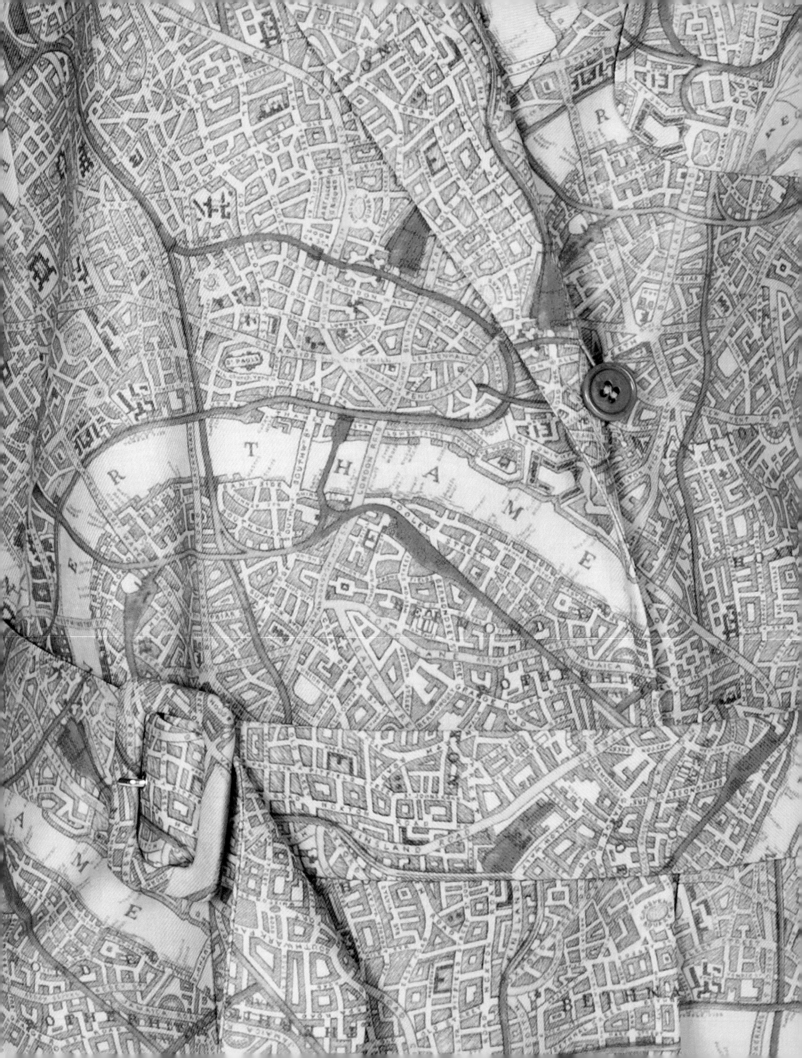

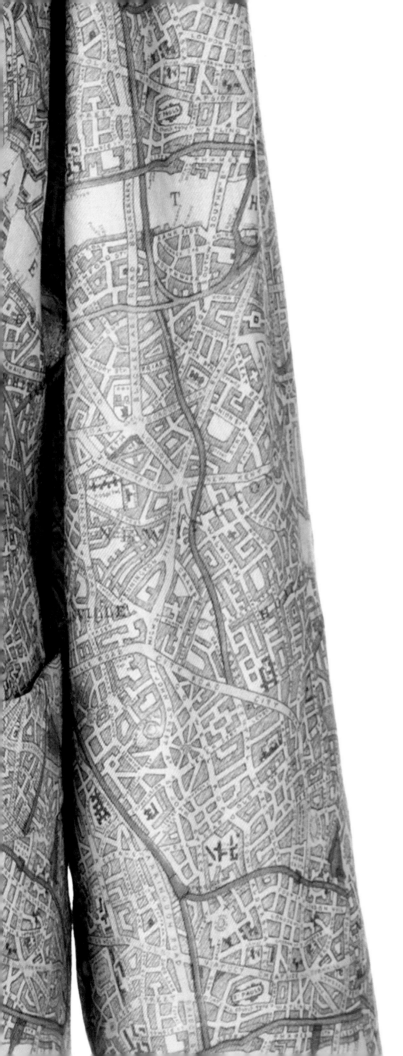

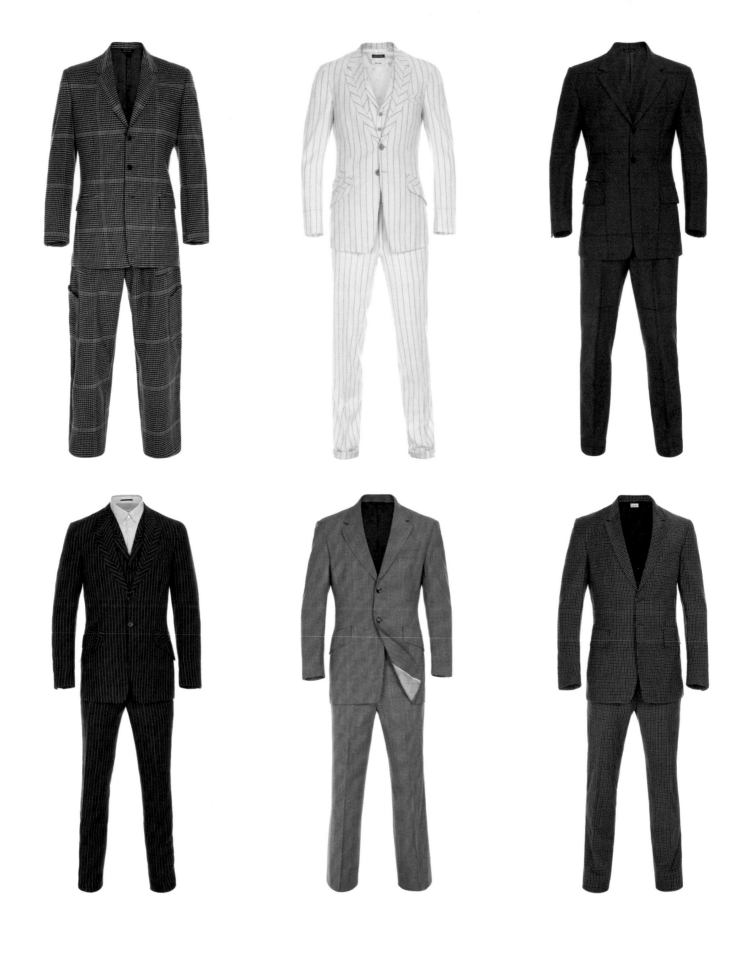

BRITISH TRADITION

Menswear

BRITISH TRADITION
Womenswear

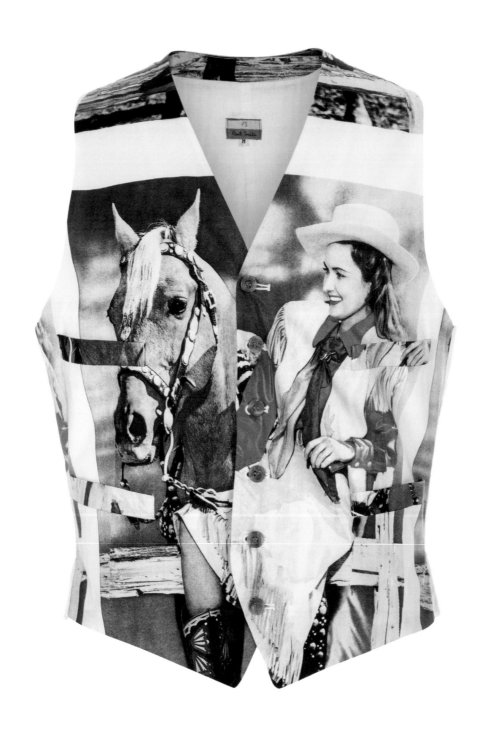

PRINT

Menswear

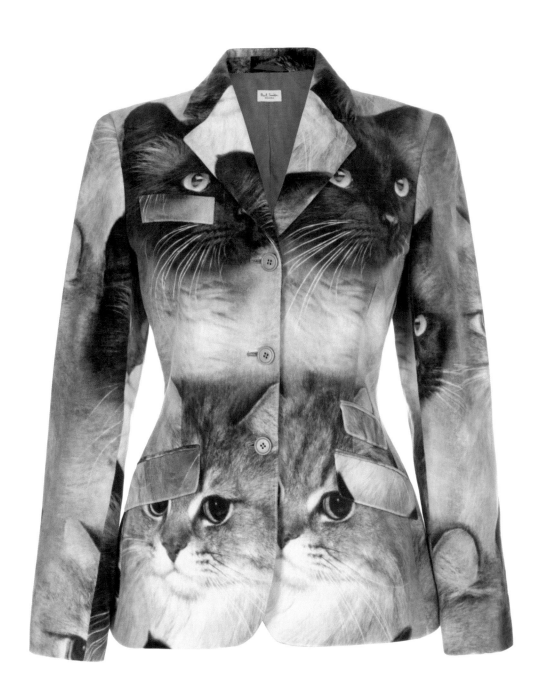

PRINT

Womenswear

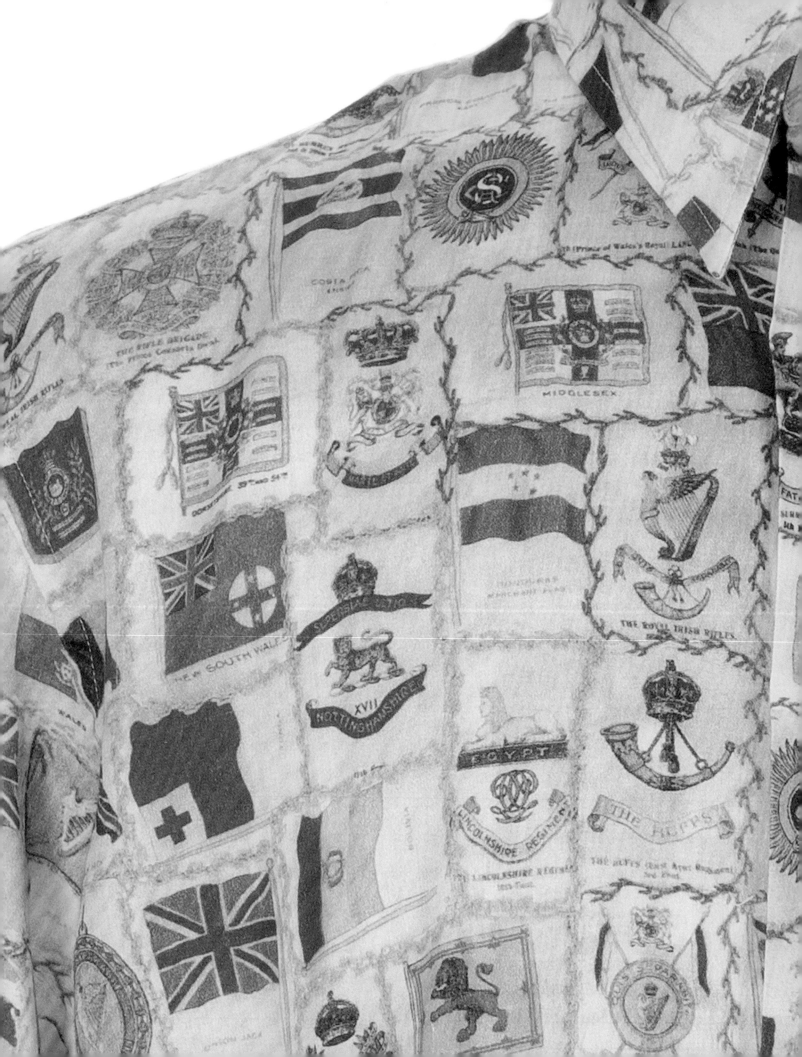

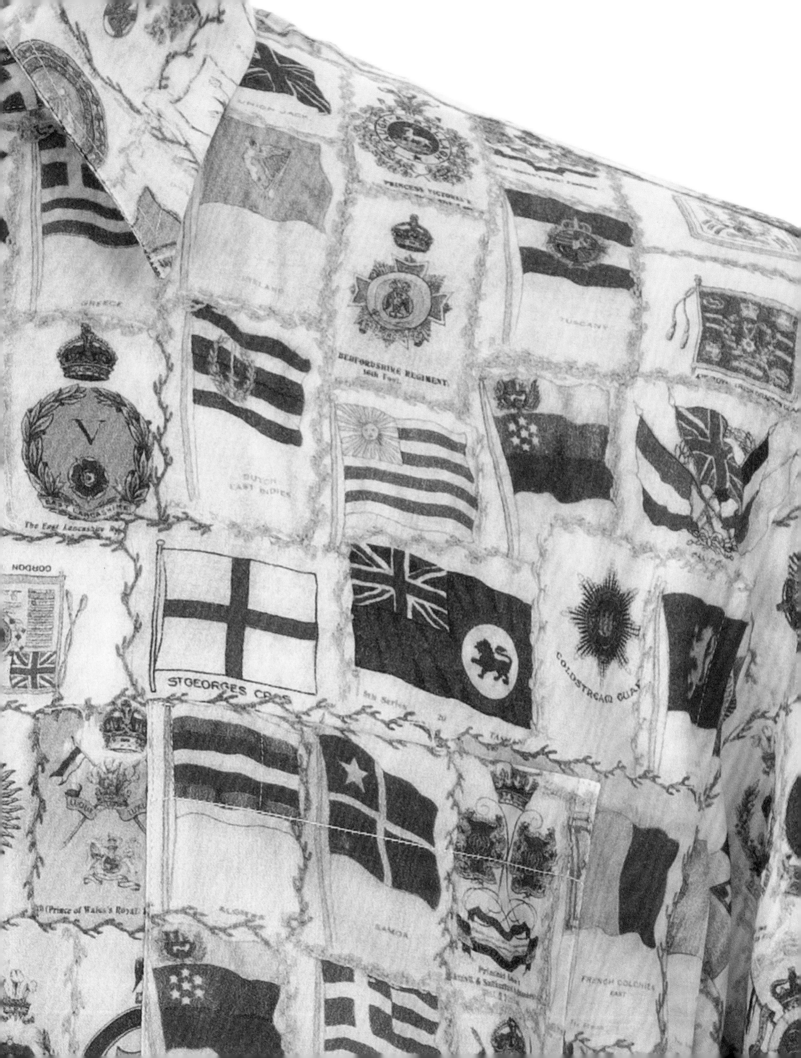

PRINT

Menswear

PRINT

Womenswear

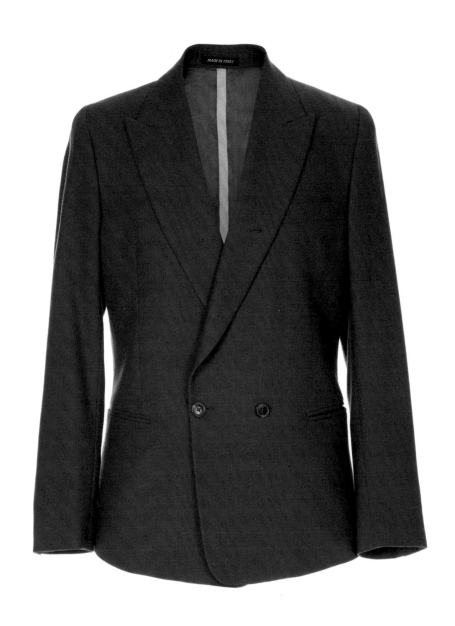

COLOUR

Menswear

COLOUR

Womenswear

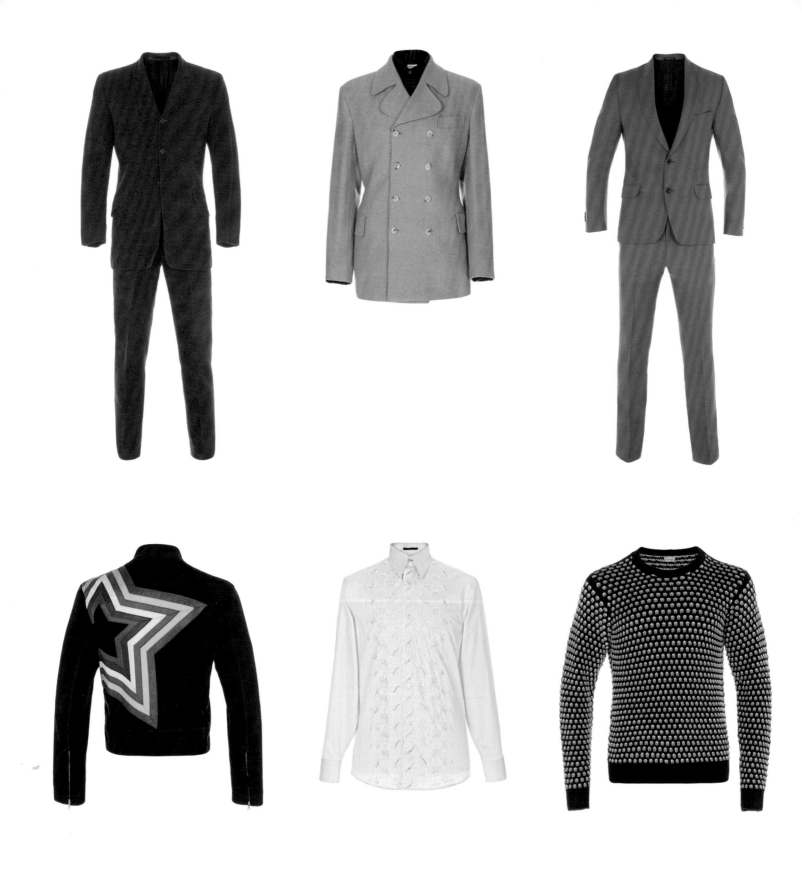

COLOUR

Menswear

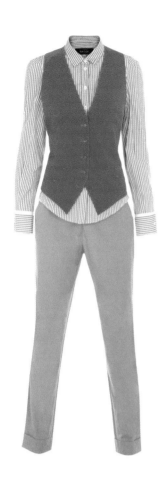
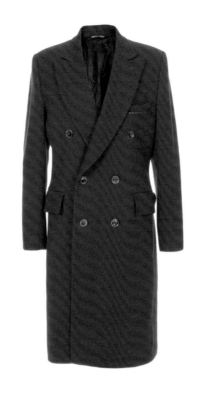
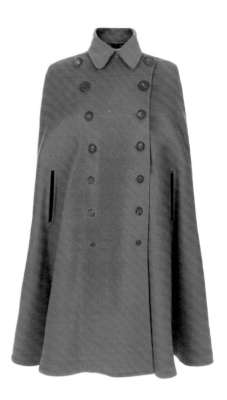

COLOUR

Womenswear

TRAVEL

Menswear

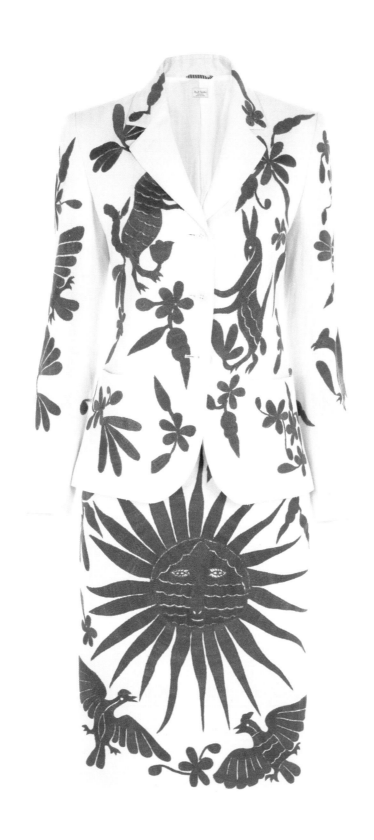

TRAVEL

Womenswear

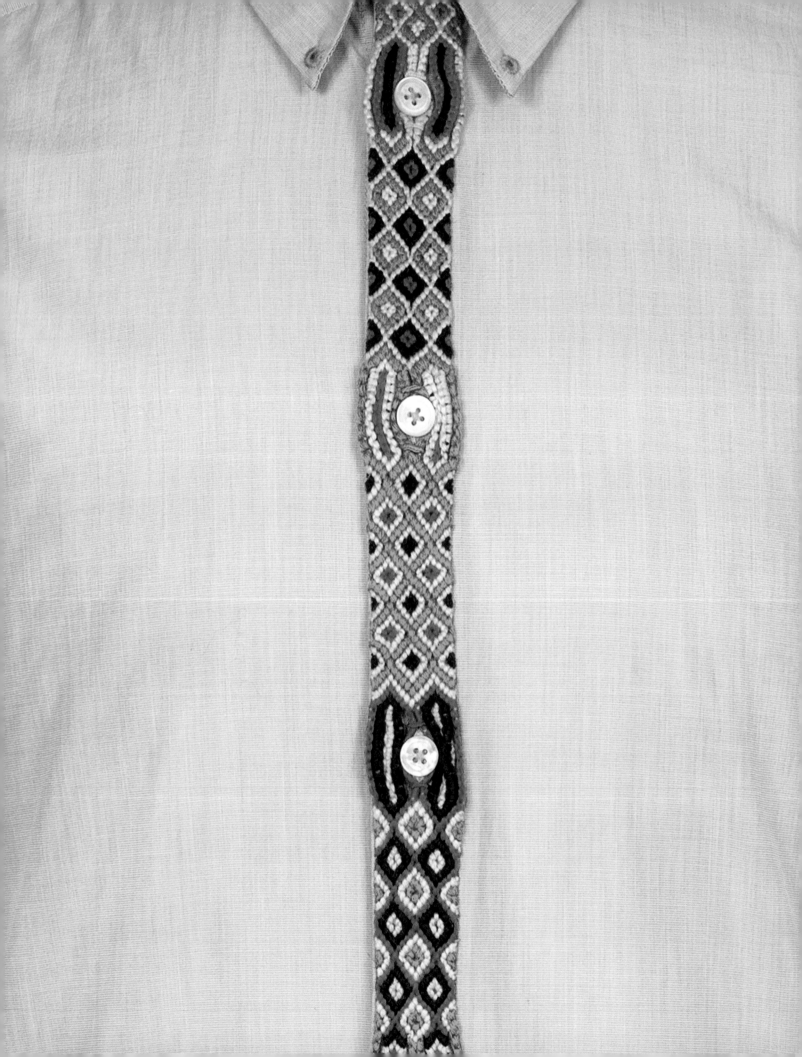

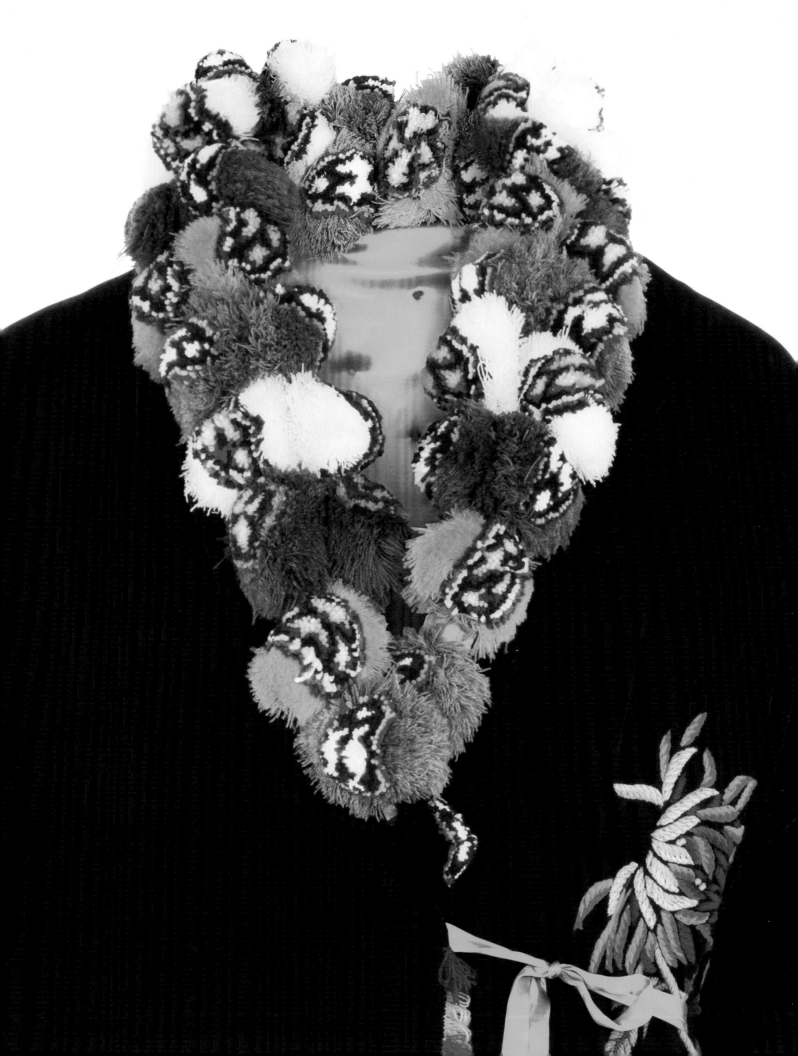

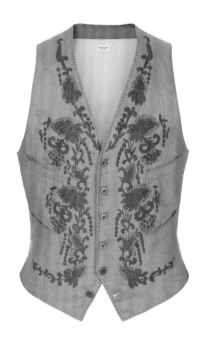
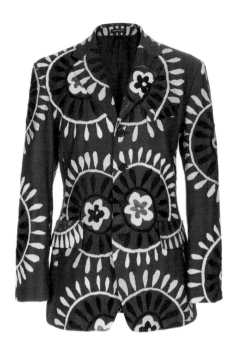
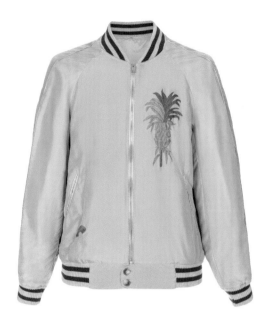
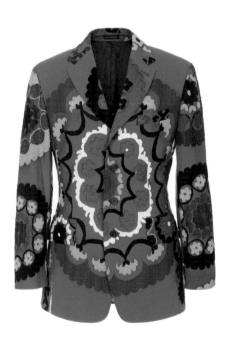
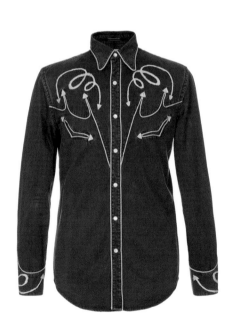

TRAVEL

Menswear

TRAVEL

Womenswear

PHOTO PRINT SHIRTS

Smith was one of the first designers to use the photographic print technique on fabric. As a keen photographer, it was a logical step for Smith. Early prints dating from the 1980s used Smith's own photographs. They included images of men in turbans photographed on a trip to India, ivy growing from a wall, and wood from a wood pile seen on a country walk. The imagery for shirts has ranged from apples, leaves, flowers and clouds through to horses, budgies, kittens, jellyfish, sharks' teeth and a plate of plastic spaghetti.

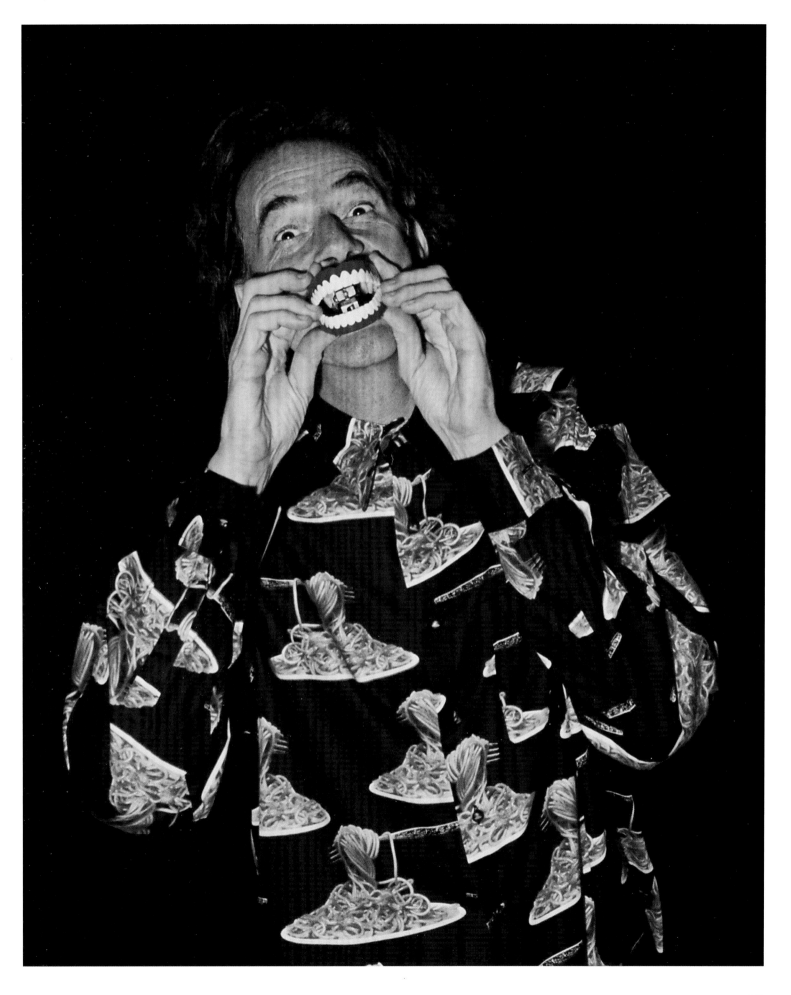

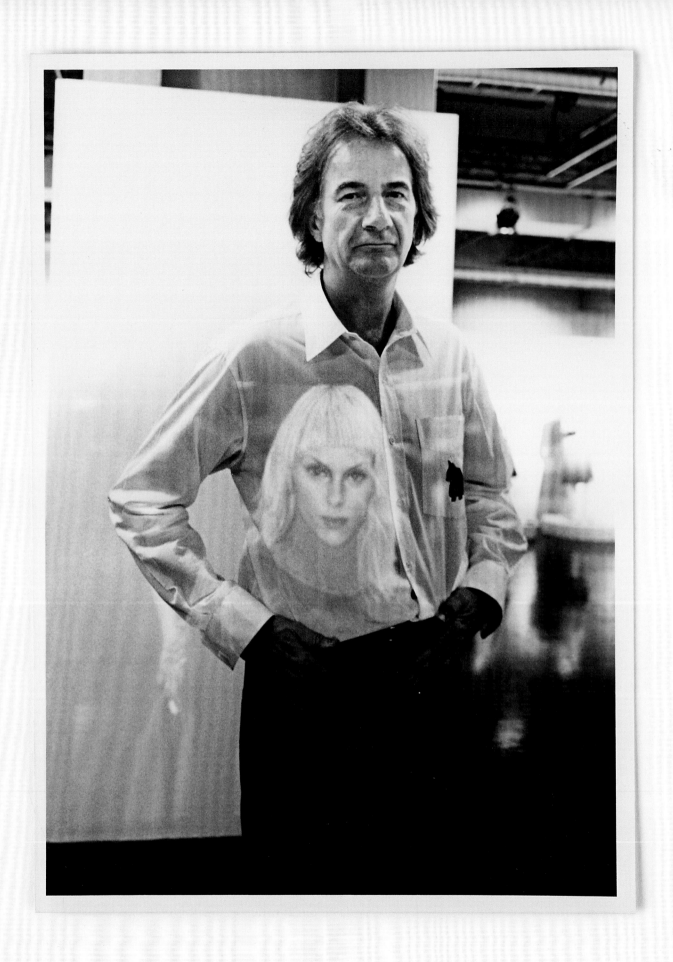

ABOVE AND OPPOSITE *Paul experimenting with image placement for photo print shirts*

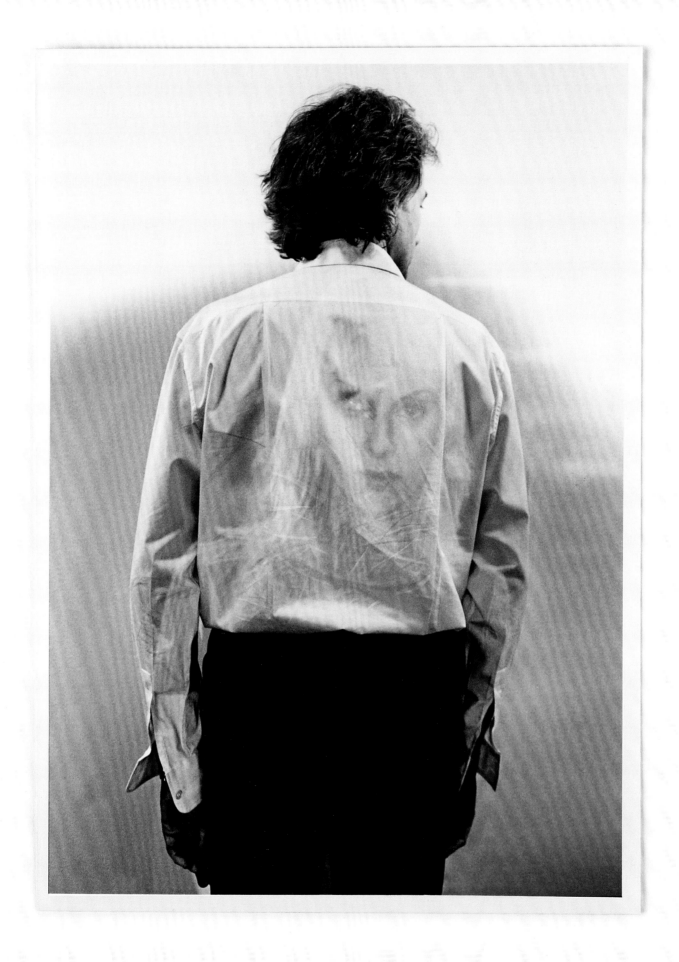

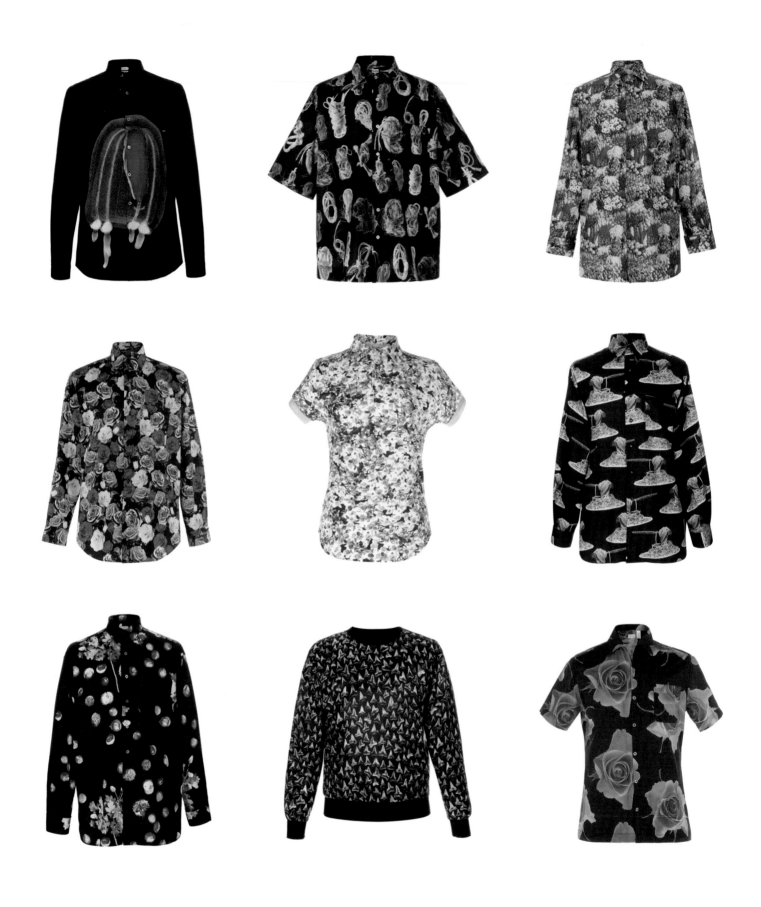

ABOVE *Photo print garments*
OPPOSITE *Autumn Winter 2012 Men's fashion show*

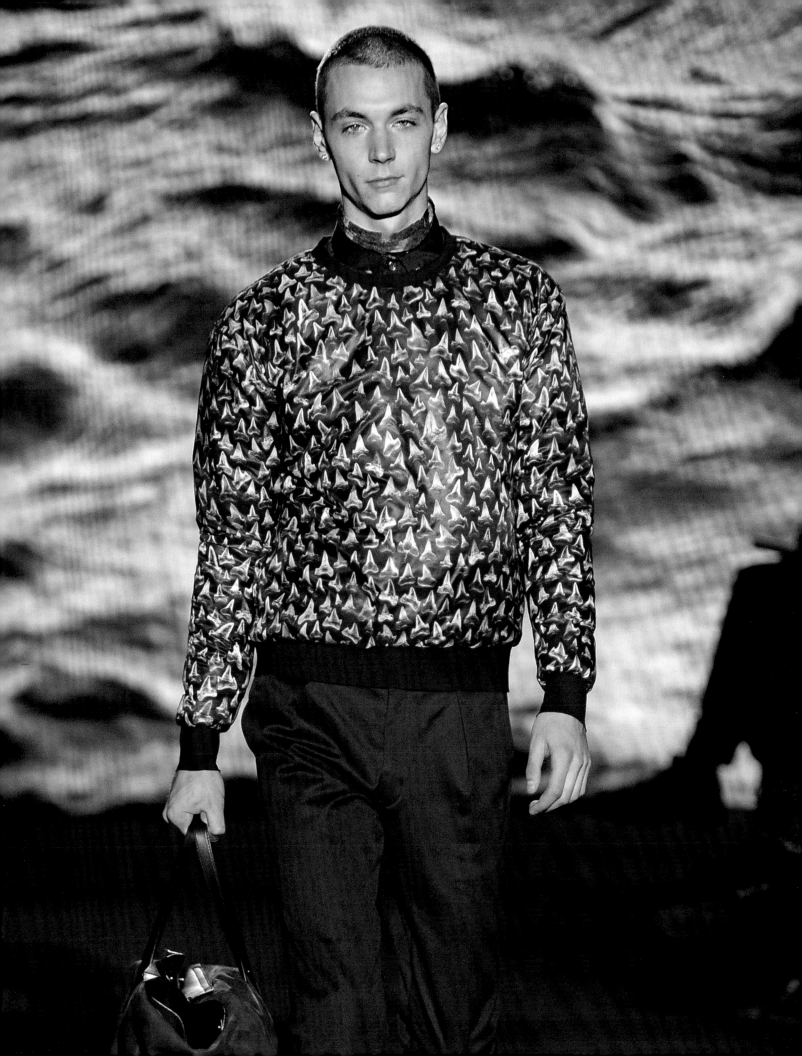

THE SHOPS

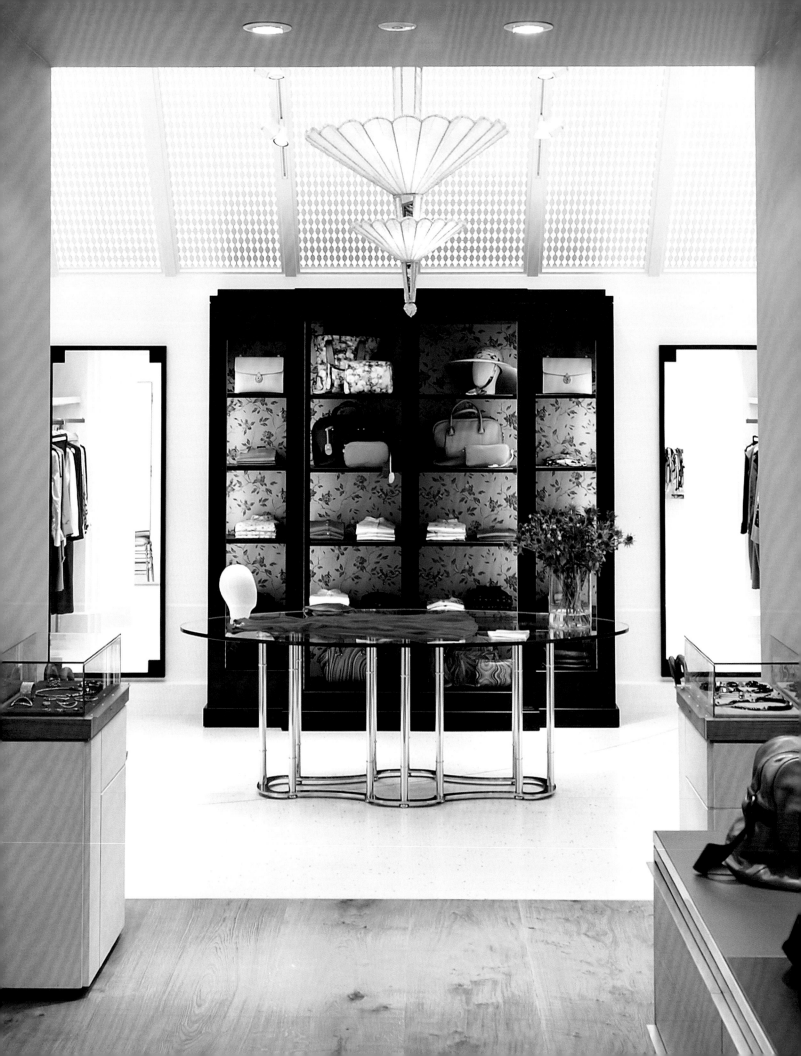

I believe in shops that are executed in an original, personal way by individuals with a vision, and that's become more and more important to me as time's gone on.

We design all of our own shops. In our building, we have twelve or fourteen staff members who are designing either the interiors of our shops or, in some cases, the building also. The difference between Paul Smith and many of the other companies that are in fashion is that many of them have a formula for their shops, whereas I'm very adamant that all of our shops should look different, as I'm very keen on individualism. That's quite a hard job, because we 'think global but act local'.

For example, we've recently opened a shop in Australia, which is in a beautiful house that was built in 1906, and it's essential that we make the shop work for the building and not the other way around. Of course, that's very hard work because you can't just press a button and get a new shop easily. So I'm involved in shop design on a weekly basis. When we do open up a new shop, I normally visit the city if I can, and we have an event of some sort. One

of our shops is actually a furniture shop, which is in Mayfair, London, and so I'm often involved in various conversations about the furniture and interesting things that are bought for the shop.

I believe in shops that are executed in an original, personal way by individuals with a vision, and that's become more and more important to me as time's gone on. Throughout the eighties and nineties, big business and global marketing led to blandness and uniformity so that shops are the same wherever you go. I wanted to do something completely against that, away from the main designer-shopping zones. The premise is always the same: when you come into a Paul Smith shop, even if you don't buy anything, you should have a pleasant experience. The shops offer something completely modern, but with a sense of traditional values in the way that customers are treated. That's why it means so much to me.

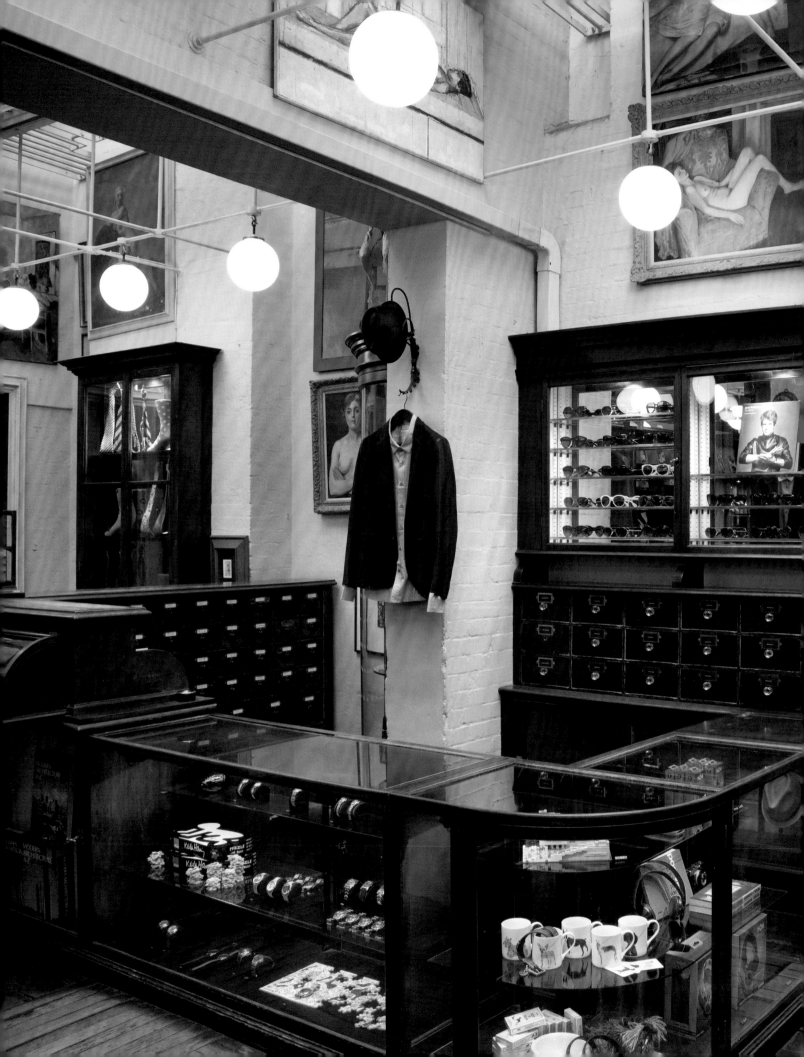

FLORAL STREET, LONDON

1979

Paul Smith opened his first London shop at 44 Floral Street, Covent Garden in 1979. Inspired by the success of his Nottingham shop and following on from his menswear show in Paris, Smith needed a London space to house his collections. He found it in a tiny, dilapidated bakery, originally a warehouse extension for a wholesale fruiterer in the old Covent Garden Market. Smith's vision was for a highly organised display area on the ground floor, kept separate from the normal activities of a shop.

Designer, Peter Wigglesworth found a solution in the chameleon nature of Covent Garden itself with shops and businesses by day; restaurants, theatres and the opera by night. During the day the shop operated in a traditional way. The interior was minimal and functional incorporating bare concrete walls, matt black steel and glass and utility grey carpet. At night the shop was transformed into a stage for display. The wide glass frontage became a screen defining a stage area and allowing for continuous back projection of slides or film. A passer-by would be able to see one or two examples of Paul Smith clothes or a complete film of his latest fashion show in Paris. 44 Floral Street was slowly transformed from an unremarkable shell of a shop into an elegant and stylish menswear shop.

In 1983, the neighbouring shop came up for sale and Smith bought it. Restored original fittings from a nineteenth century apothecary shop and polished wooden floorboards re-invented the space. New and vintage toys, accessories, and Japanese gadgets sat alongside clothing.

In 1987 Smith acquired 41-42, Floral Street, originally a bicycle shop. Elegant mahogany cabinets graced the walls, with a dedicated suit room in the basement. With the launch of his women's collection, Smith added the Paul Smith womenswear shop in 1994, and created a 'boudoir' room in the basement with luxurious velvet charcoal fabrics and hand-picked antique furniture.

In 2002, 44 Floral Street became the modern Shoe Shop as it is today and the basement at number 43 stocked the extended suits collections, Paul Smith London. Today, Floral Street houses the Paul Smith collections for men and women. With an extensive selection of jewellery, books, art, and antiques, the shops reflect the character of Smith and his designs - classic with an unexpected 'twist'.

WESTBOURNE HOUSE, LONDON

1998

Westbourne House was the realisation of Smith's long-term dream to have a shop inside a house. Westbourne House is a large double-fronted Victorian residence on the corner of Westbourne Grove and Kensington Park Road in London's Notting Hill. Paul commissioned the architect Sophie Hicks to restore the exterior and redesign the interior in a way that extends and plays on the idea that this is a shop within a home. The rooms are arranged on three floors, laid out symmetrically on each level on either side of an extraordinary central-core stair tower made of glass and acrylic.

Each room has its own character and includes unusual antique furniture. The Kensington Room on the ground floor, housing women's shoes and accessories, is designed as a chic, private dressing room for the lady of the house in a 'Hollywood Regency' style. The Dining Room, housing accessories, is inspired by the conventions of a mediaeval dining hall. Its central focus, a long refectory table, doubles as a display case for leather goods, watches, pens, and various Paul Smith gadgets. The Archer Room on the first floor houses informal menswear and evokes the atmosphere of a gentlemen's club room. At the top of the house, the Gurston Room is a unique, specialised workroom and fitting department for a bespoke Paul Smith tailoring service.

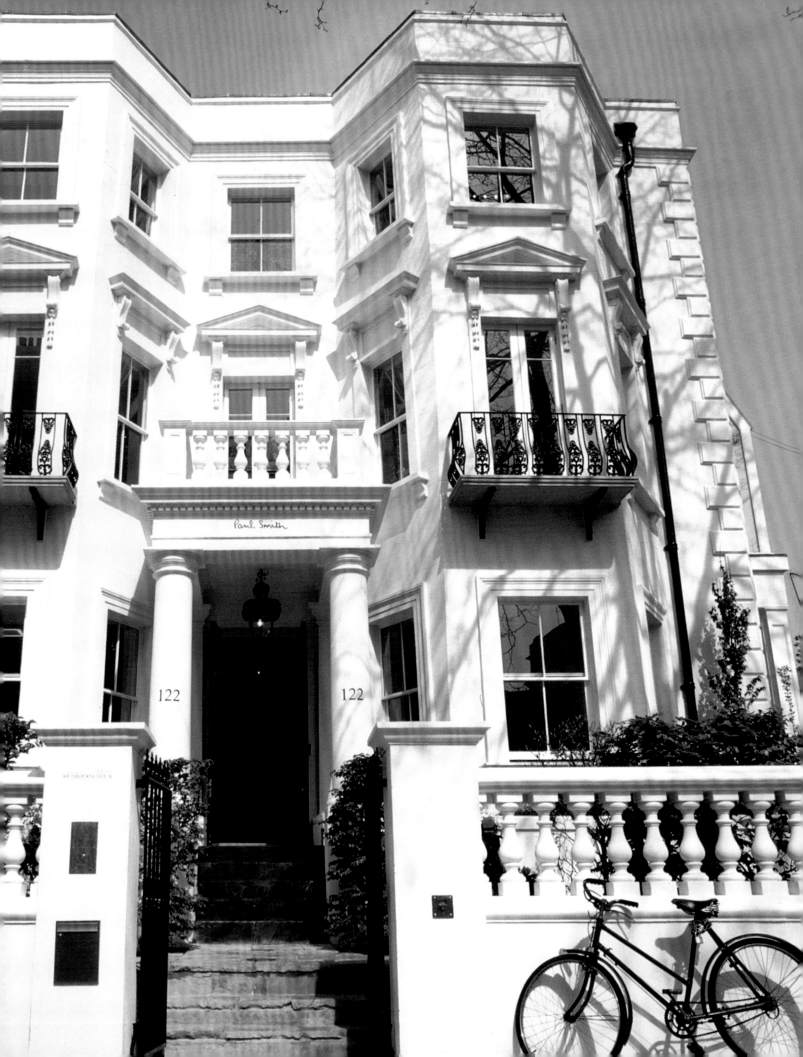

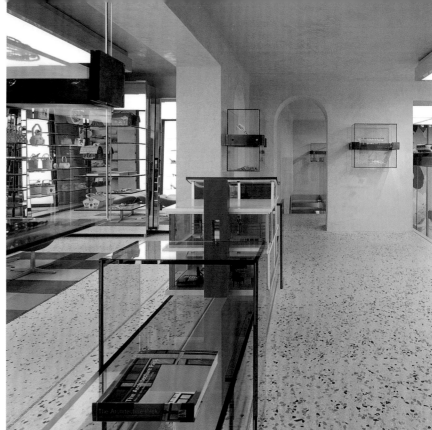

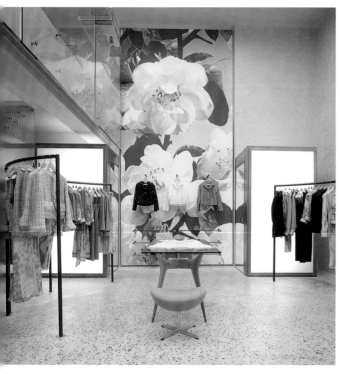

PALAZZO GALARATI SCOTTI, MILAN

2001

The Paul Smith shop in Milan is set within a spacious eighteenth-century palazzo facing onto a noisy street in Milan. The collections are laid out in double-height rooms which were part of a former cloistered courtyard. There are intimate spaces as well as dramatic views from upper galleries. The shop combines British and Italian styles and was designed by Sophie Hicks, who was responsible for Westbourne House, London, and for the perfume bottles for Paul Smith's highly successful original men's and women's fragrances.

Treated as a 'found' space by the architects, the idiosyncrasies of the building, which has been altered over centuries, are accentuated rather than concealed. The shop offers one of the most comprehensive selections of Paul Smith clothes, antiques and one-off pieces including books, china, records, and jewellery.

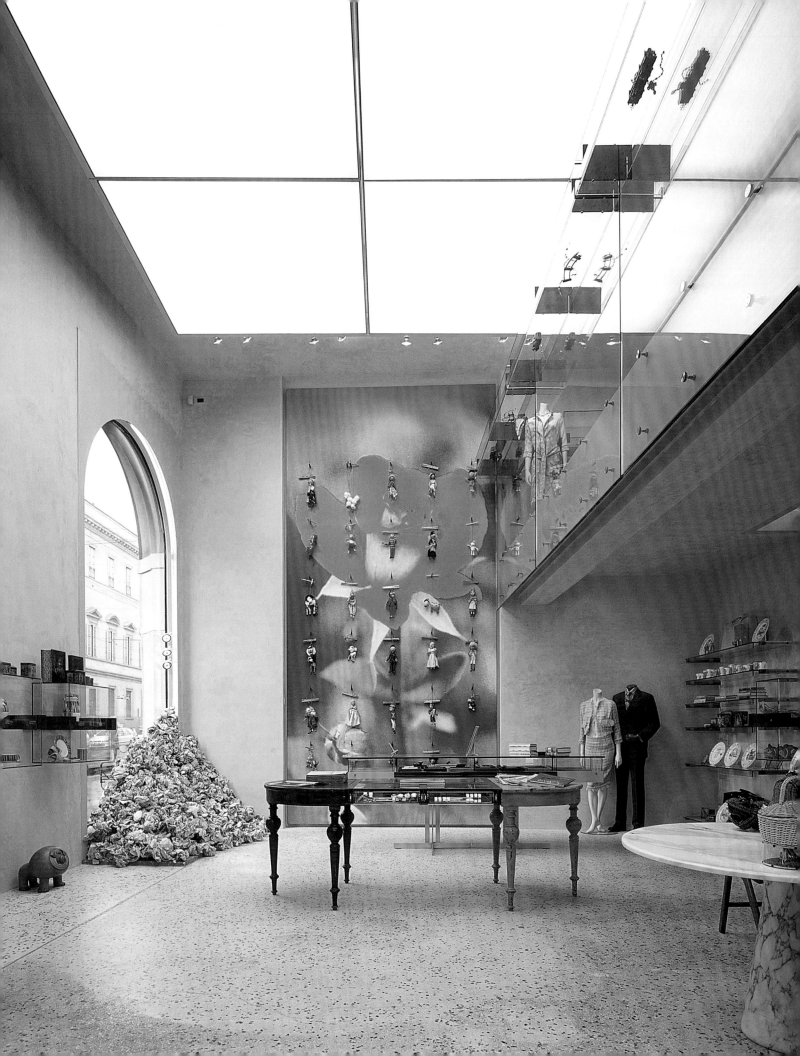

WILLOUGHBY HOUSE, NOTTINGHAM

2005

Smith opened his very first shop in Nottingham at 6 Byard Lane, with Pauline Denyer, now his wife, in 1970. Willoughby House was his first flagship shop in his hometown of Nottingham. It is an impressive Grade II-listed five-storey building, built in 1738 for the Honourable Rothwell Willoughby.

The shop interior, designed by Smith, was inspired by his early visits to couture fashion houses and complements the eighteenth-century building's history. Virtually unchanged, Willoughby House features original staircases, cornices, flagstone floors, and floorboards. Large Georgian sash windows covering the front and rear of the building give natural light and a view straight through to the hidden garden. On the first floor, the Women's Room mixes traditional with modern elements. The walls are panelled in pink and magnolia, and the ceiling carries ornate Venetian glass chandeliers. In the Men's Suit Room, suits hang amongst pieces of French 1940s oak furniture.

MELROSE AVENUE, LOS ANGELES

2005

Imagine a huge California-pink shoebox, right on Melrose Avenue. As with all his shops worldwide, the designs are coordinated by Smith himself and the style is always complementary to the city surroundings. The design idea for the L.A. shop was inspired by the book *Casa Luis Barragán: Poetry of Colour*. The distinctive style of Barragán's architecture shows his love of popular colour, which is also a key element of Paul Smith designs. The L.A. shop exterior is painted a strong pink to stand out against a cloudless blue sky, and act as a contrast to the eclectic mix to be found inside the shop.

A typical feature of Paul Smith shop interiors is mixing the old with the new. The L.A. shop was the first Paul Smith shop in the U.S. to sell Paul Smith men's and women's collections together. The space is divided into a series of rooms that evoke the look and atmosphere of film sets, so relevant to the West Hollywood address. Traditionally the Paul Smith shopping experience is designed to be full of surprises. In the L.A. shop, in addition to the Paul Smith collections and products, there is vintage furniture and objects, including old and contemporary books and a selection of jewellery.

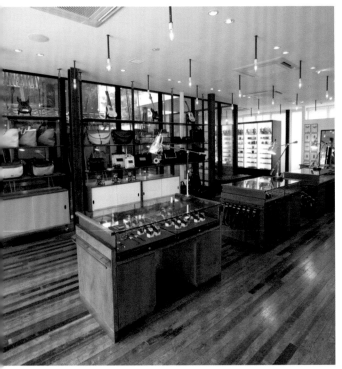

SPACE, TOKYO

2006

Space was Smith's first flagship shop in Tokyo. Up until this point, Paul Smith men's and women's shops in Japan had remained separate, with the focus on each as an individual label.

Unique in its design, the glass-and-steel shop is located in a residential area of Jingumae and sits in a bamboo garden. On the third floor of the shop, there is a roof garden and the space next to it is used as a gallery to show works by international artists. In the basement of the building, there is a bookshop.

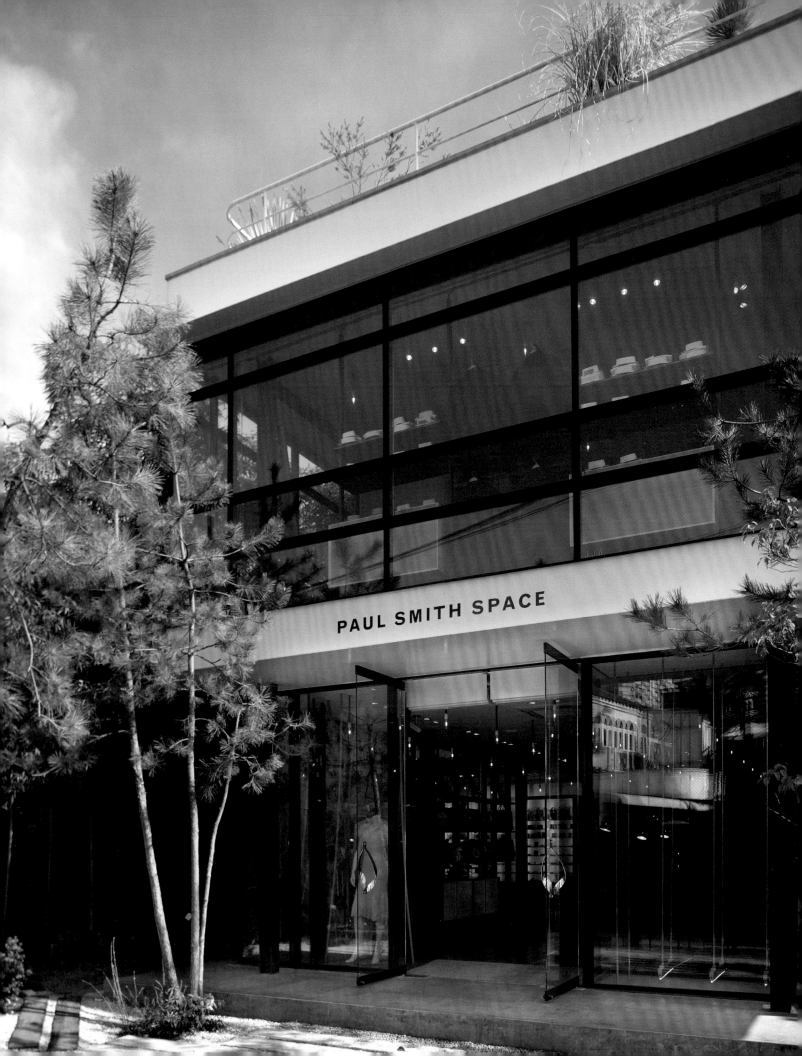

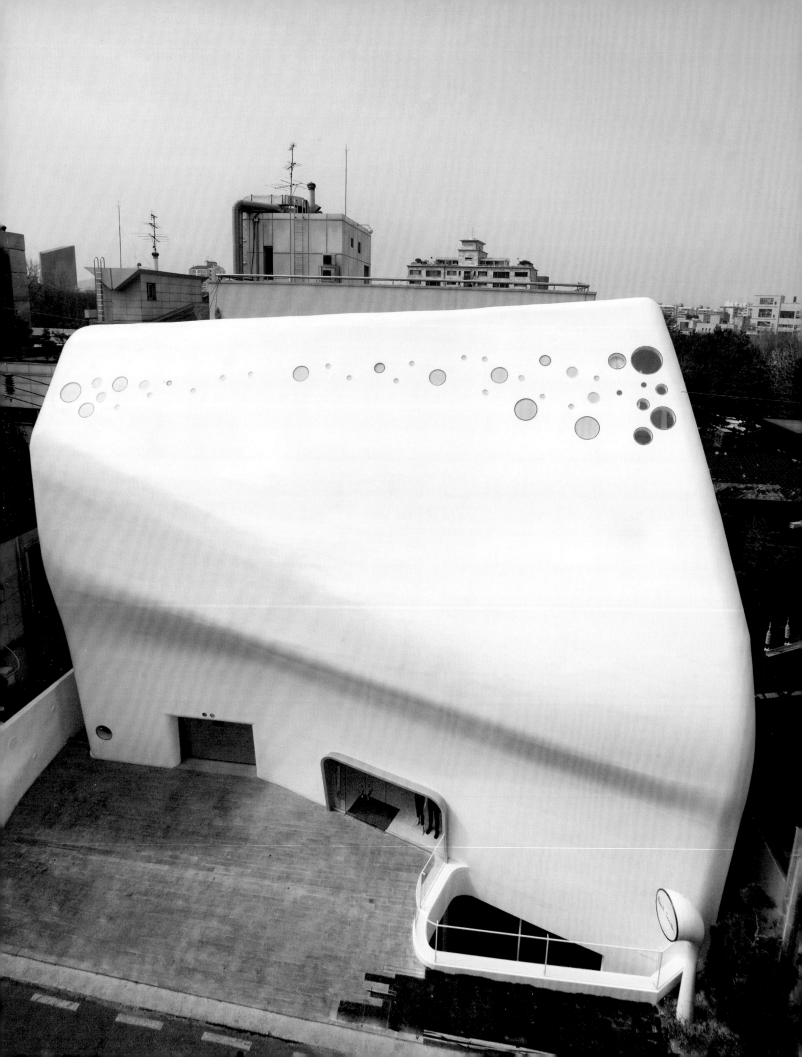

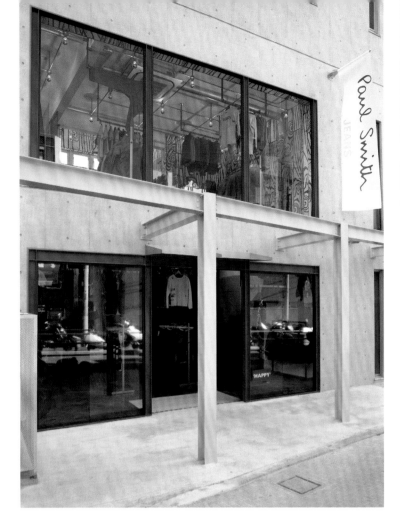
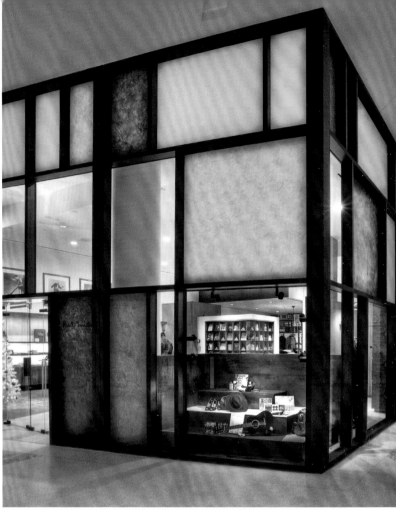

OPPOSITE *Exterior of the Seoul shop*
ABOVE LEFT *Exterior of the Paul Smith Jeans Happy shop, Japan*
ABOVE RIGHT *Exterior of the Las Vegas shop*

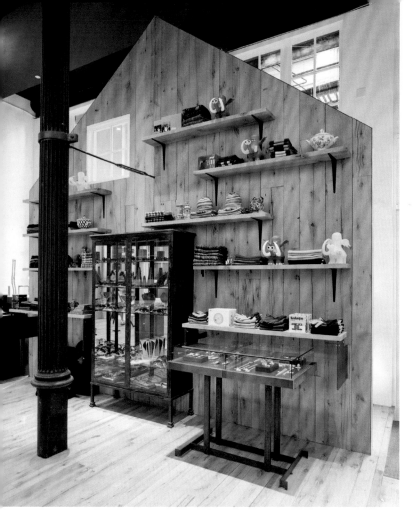

ABOVE LEFT *Interior of the New York shop*
ABOVE RIGHT *Interior of the Faubourg Saint Honoré shop*
OPPOSITE *Stairwell and picture wall in the Antwerp shop*

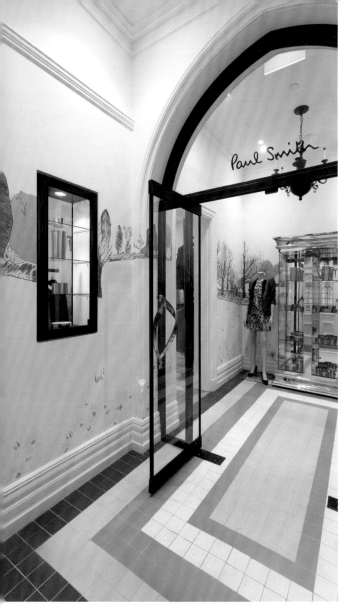

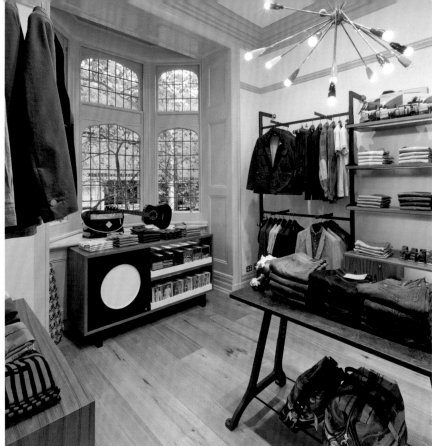

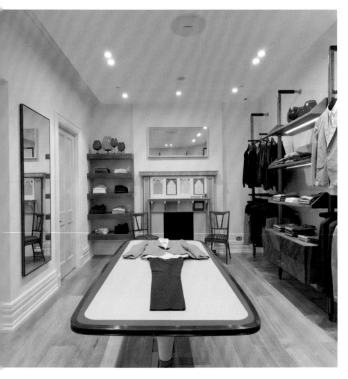

MELBOURNE, AUSTRALIA

2012

The first stand-alone Paul Smith shop in Australia is located in a heritage-listed, former professional law chambers on Collins Street, one of the principal shopping areas in the city. The red-brick building carries an impressively detailed façade featuring gothic lead-lined and stained-glass windows. The shop displays an extensive selection of clothing, jewellery, books, art, and antiques throughout a series of spacious rooms across two floors connected by a traditional staircase. Original features, including pale painted wood panelling and original tiled fireplaces, were maintained and are highlighted.

Visitors enter an airy, tiled front lobby decorated with hanging illustrations and a hand-painted, primary coloured landscape running along the walls. Elegant 1960s American brass display cabinets stand at the perimeters to showcase accessories and objects. The Paul Smith men's collection is presented in a room with a brightly painted fireplace and traditional walnut furniture. Next door, the women's collection hangs from a curved brass rail running the width of the room, with glass shelves highlighted by a dramatic coral chandelier.

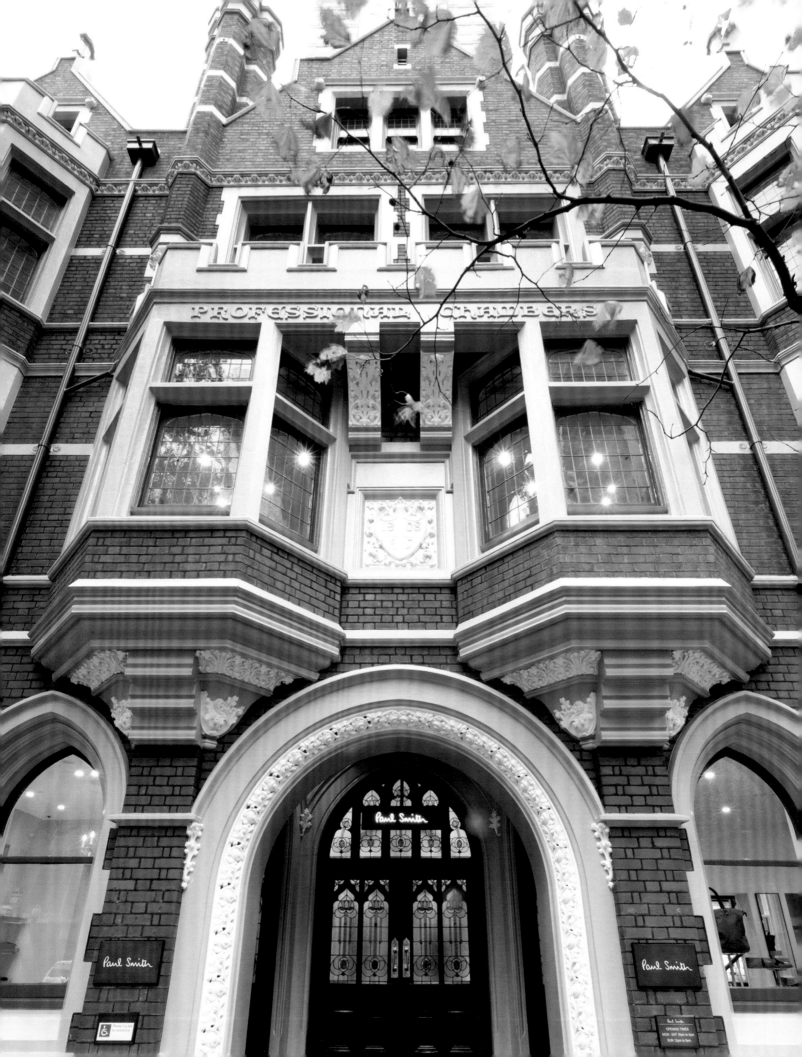

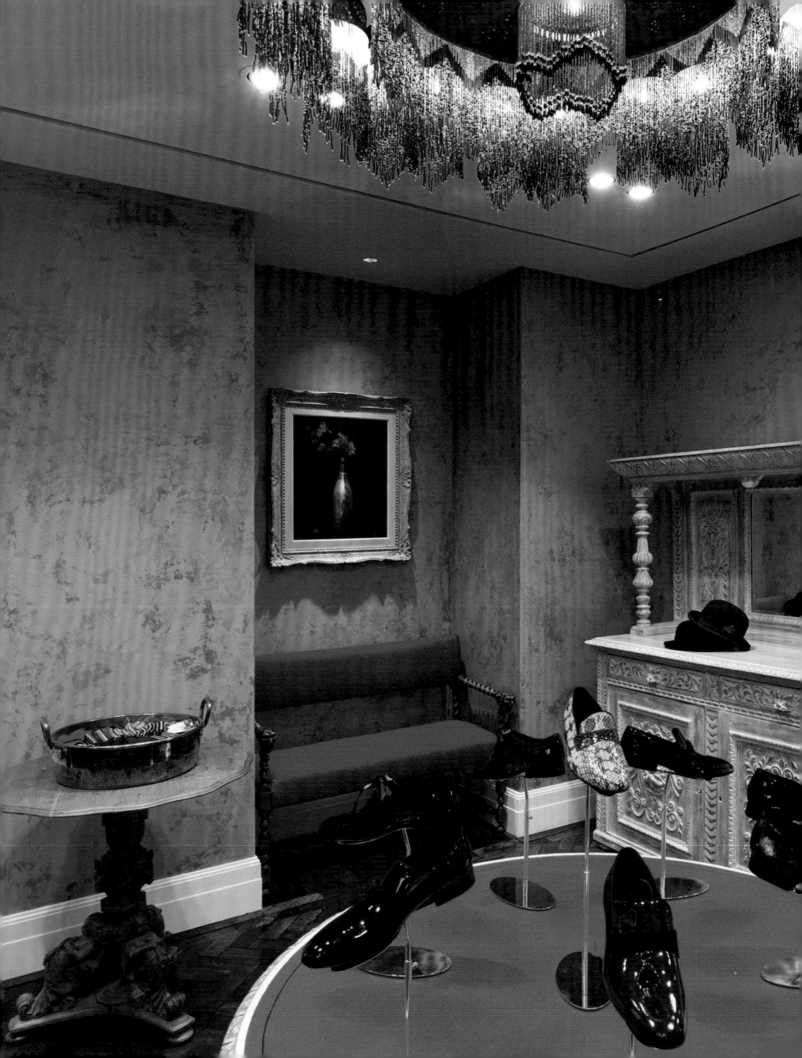

RUE DE GRENELLE, PARIS

2012

The fifth Paul Smith shop to open in Paris is located in the fashionable shopping district of Rue de Grenelle in the 7th arrondissement. The design of the dedicated women's shop combines antique furniture and fittings with white terrazzo flooring and elegant bronze details. The space is divided into three main areas - clothes, accessories, and shoes.

The space was conceived as a boutique-cum-art gallery, where three distinct areas display different artists and photographers. The first is dedicated to women's shoes, with images by British photographer Hugh Stewart. The main room is occupied by womenswear pieces with seasonally changing images. The final room houses the Paul Smith Black Label diffusion line and is decorated with watercolours by Lydia Webber.

THE IMAGE

I've been taking photographs since I was eleven, and photography is one of my hobbies. A few years ago it was suggested that I take the photos for the ads, which is something I've done ever since.

We have weekly meetings called 'creatives', which are where, if we have a new fragrance coming out, we'll work on the bottle, the packaging, the advertising, the photography, the graphics, and so on. We also have our advertising campaigns twice a year for the main collections for women and men. I normally take the photos for these campaigns. I've been taking photographs since I was eleven, and photography is one of my hobbies. A few years ago it was suggested that I take the photos for the ads, which is something I've done ever since.

When I have time, I also take the photographs for magazines around the world. More recently, I haven't had so much time and so that's been reduced, but previously, I've taken interior photography for Italian magazines and fashion photography for magazines in France, Italy, Germany, Britain, and Japan.

AUTUMN WINTER 1987 ADVERTISING CAMPAIGN
Photography by Paul Smith

AUTUMN WINTER 1989 ADVERTISING CAMPAIGN

Photography by Hugh Hales-Tooke

SPRING SUMMER 1991 ADVERTISING CAMPAIGN

Photography by Hugh Hales-Tooke

SPRING SUMMER 1992 ADVERTISING CAMPAIGN

Photography by Hugh Hales-Tooke

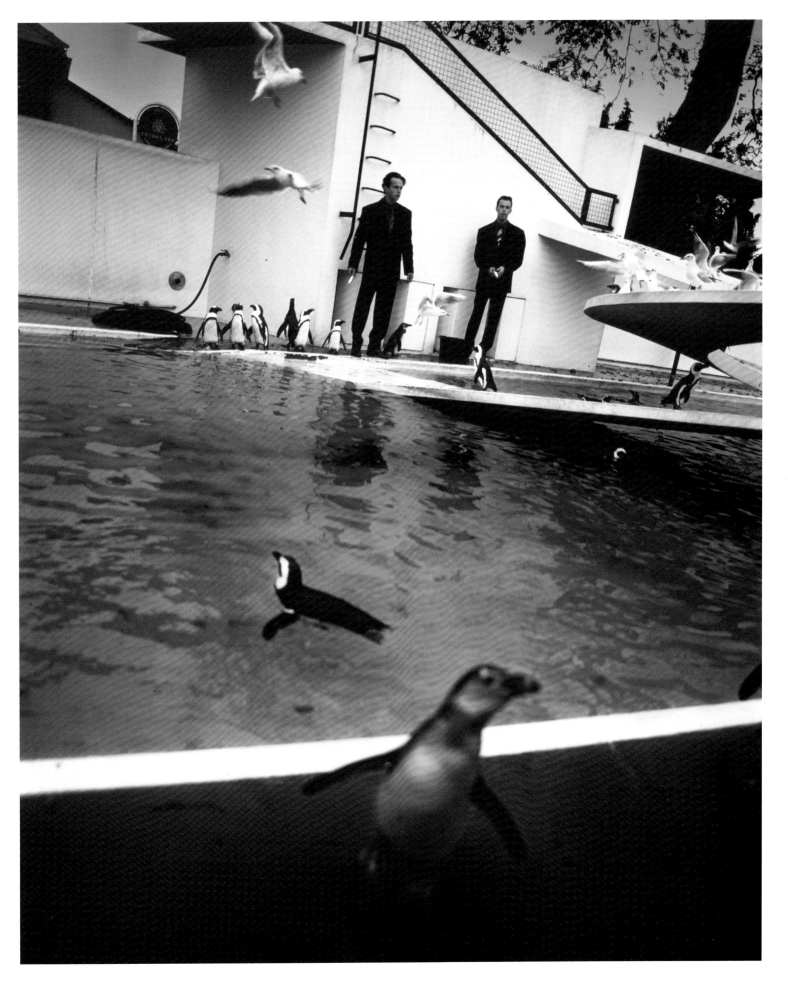

SPRING SUMMER 1994 AND AUTUMN WINTER 1994
ADVERTISING CAMPAIGNS

Photography by David Bailey

PAUL SMITH COLLECTION
AUTUMN WINTER 1994 ADVERTISING CAMPAIGN
Photography by Mario Testino

PAUL SMITH COLLECTION
SPRING SUMMER 2001 ADVERTISING CAMPAIGN
Photography by Mario Testino

SPRING SUMMER 2003 ADVERTISING CAMPAIGN

Photography by Sandro Sodano

AUTUMN WINTER 2003 ADVERTISING CAMPAIGN

Photography by Sandro Sodano

AUTUMN WINTER 2006 AND SPRING SUMMER 2007
ADVERTISING CAMPAIGNS

Photography by Julian Broad

SPRING SUMMER 2013 AND AUTUMN WINTER 2013
ADVERTISING CAMPAIGN
Photography by Paul Smith

PHOTOGRAPHY

ABOVE *Langar Hall photographed for* Grazia Casa, *2010*
OPPOSITE *Aynhoe Park photographed for* Tatler, *2011*

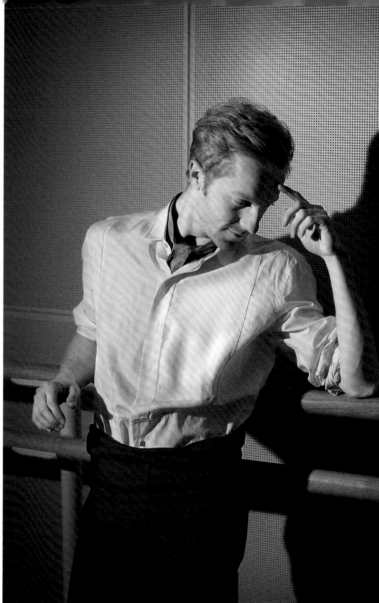

ABOVE *Portraits for The Royal Ballet, 2010*
OPPOSITE *Fashion shoot in the Nottingham*
Warehouse for Numéro Tokyo, *Japan, 2010*

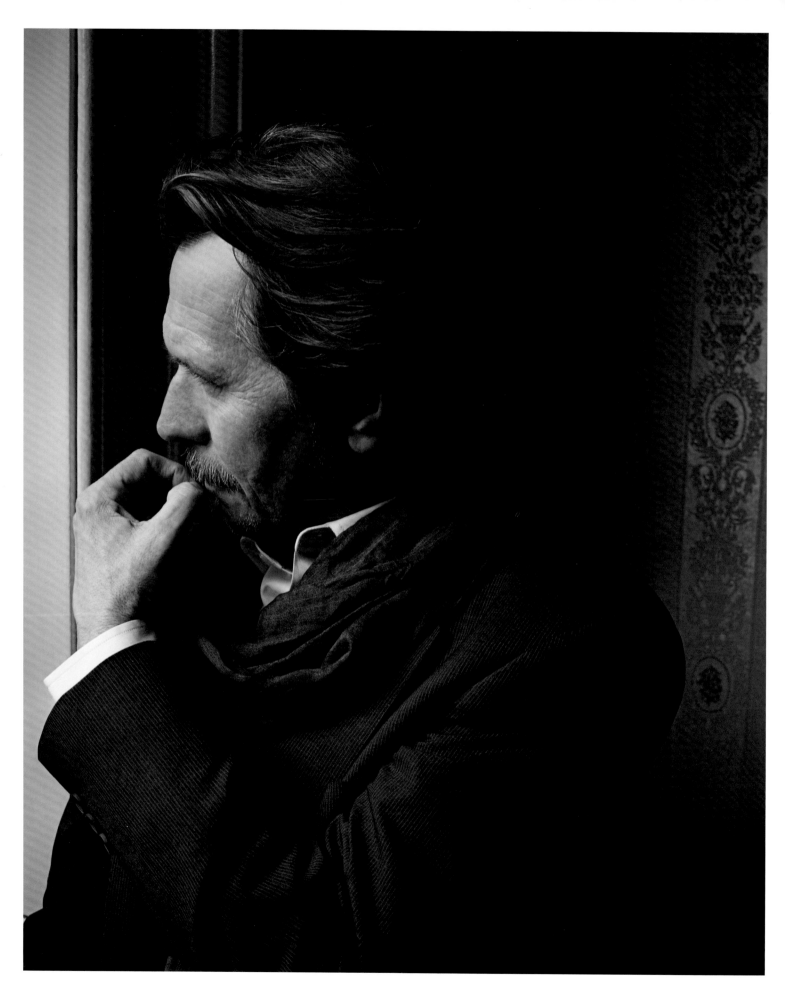

OPPOSITE *Portrait of Gary Oldman, 2012*
ABOVE *Interiors shoot at Magome, Japan, 2010*

ABOVE *Fashion shoot for* Men's NON-NO, *Japan, 2012*
OPPOSITE *Portrait of Tali Lennox for* L'Express Styles, *France, 2011*

COLLABORATIONS

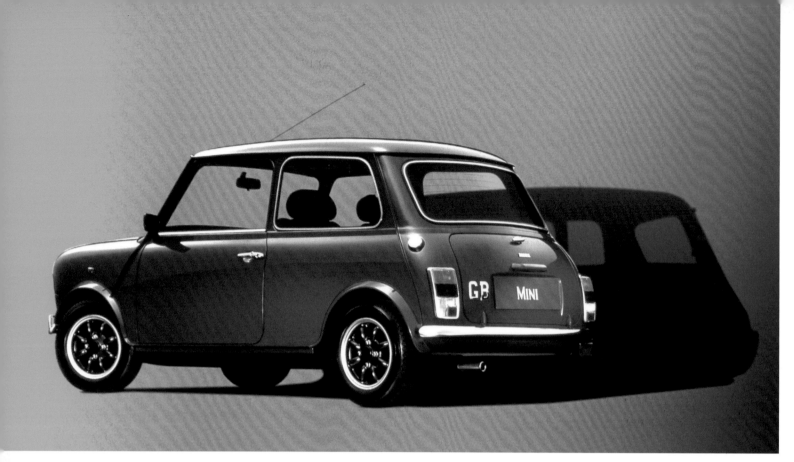

MINI

1998

One of the first Paul Smith collaborations was with the famous British car brand Mini. Rover, manufacturers of the Mini in the 1990s, spotted a particular item in Paul Smith's Spring Summer 1995 womenswear collection. It was based on a pun featuring a bold black-and-white print of a Mini car on a mini skirt. Identifying a clear admiration for the car, Rover asked Paul to design a limited-edition model. The resulting car featured an interior in black leather. The coachwork was a discreet blue, derived from the colour of one of Smith's own shirts, a small square of which he provided in order for the colour to be matched. The interior of the glove compartment, boot, and bonnet are a vivid lime green, reminiscent of the lining of a Paul Smith suit. Smith later conceived a second Mini painted in ultra-bright candy stripes, drawing on the patterning of one of his more expressive shirts.

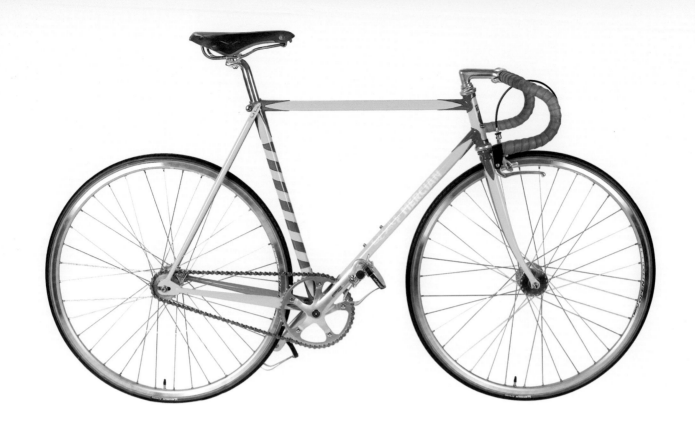

MERCIAN CYCLES

2007

Smith's long-standing passion for cycling resulted in a collaboration with the Derby-based bicycle makers Mercian. Smith was invited to select two styles of bike, a Mercian track and a tour bike, both of which he personalised. Both models feature unique Paul Smith designs and were created in a selection of colourful custom-made frames.

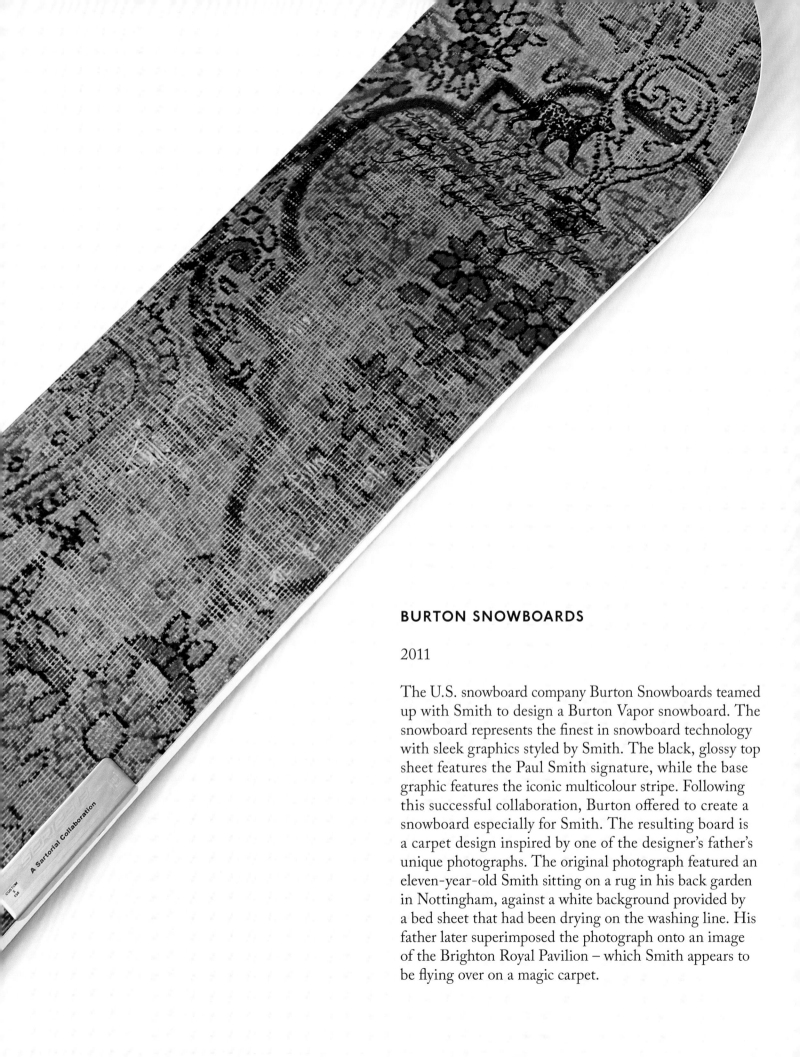

SERIES *A Sartorial Collaboration*

CUSTOM

BURTON SNOWBOARDS

2011

The U.S. snowboard company Burton Snowboards teamed up with Smith to design a Burton Vapor snowboard. The snowboard represents the finest in snowboard technology with sleek graphics styled by Smith. The black, glossy top sheet features the Paul Smith signature, while the base graphic features the iconic multicolour stripe. Following this successful collaboration, Burton offered to create a snowboard especially for Smith. The resulting board is a carpet design inspired by one of the designer's father's unique photographs. The original photograph featured an eleven-year-old Smith sitting on a rug in his back garden in Nottingham, against a white background provided by a bed sheet that had been drying on the washing line. His father later superimposed the photograph onto an image of the Brighton Royal Pavilion – which Smith appears to be flying over on a magic carpet.

MANCHESTER UNITED FOOTBALL CLUB

2008 – 2014

The relationship between Manchester United and Paul Smith began in 2008, when Smith was approached by the club and asked to supply the team and its officials with suits for the UEFA Champions League Final in Moscow. He has since signed an agreement with the club to design and supply formalwear and accessories for all first team players and officials until 2014.

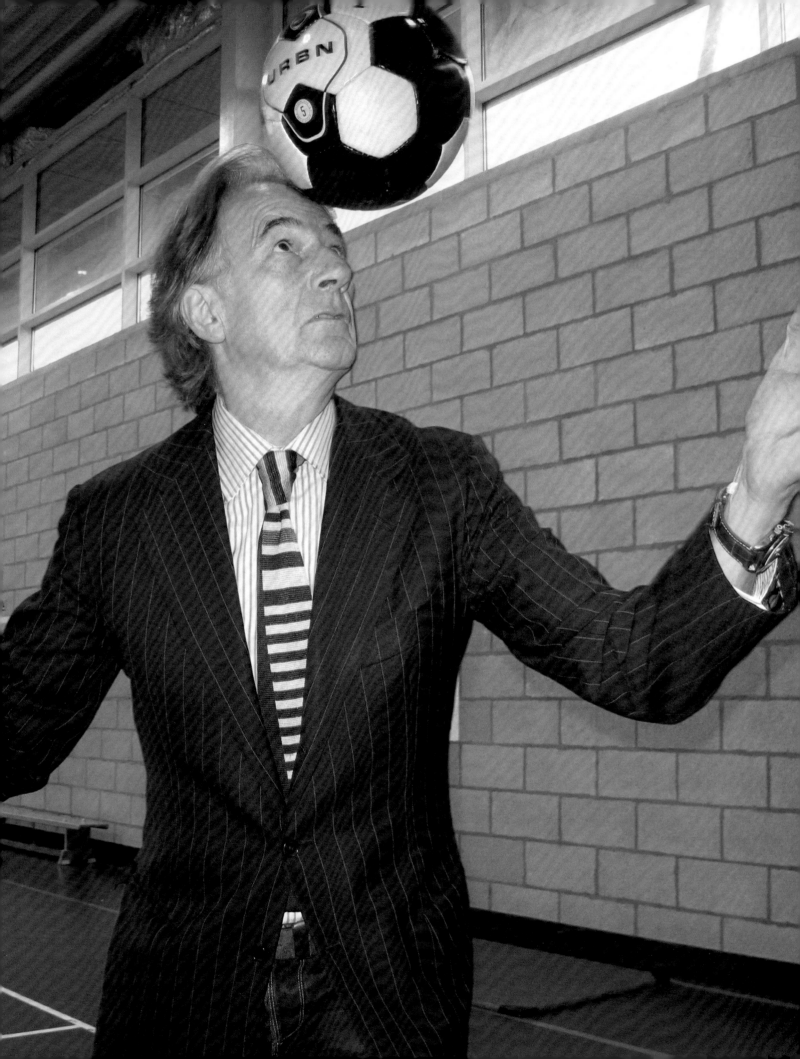

JOHN LOBB

2012

Paul Smith and British bootmaker John Lobb collaborated on three special edition shoes, combining the tradition, expertise and quality of a hand-made John Lobb shoe with the sense of optimism that Paul Smith is known for. The collaboration made its debut on the Paris catwalk at the Spring Summer 2013 show and was later available from John Lobb stores and selected Paul Smith shops worldwide. Paul Smith brought his signature punctuation of colour to three iconic John Lobb styles - *Westbourne*, *Willoughby* and *Lucca*.

EVIAN

2008

Paul Smith collaborated with Evian to design a limited edition bottle. The design was in vibrant colours that referenced the iconic Paul Smith Multistripe, imbuing the bottle with a sense of energy and fun.

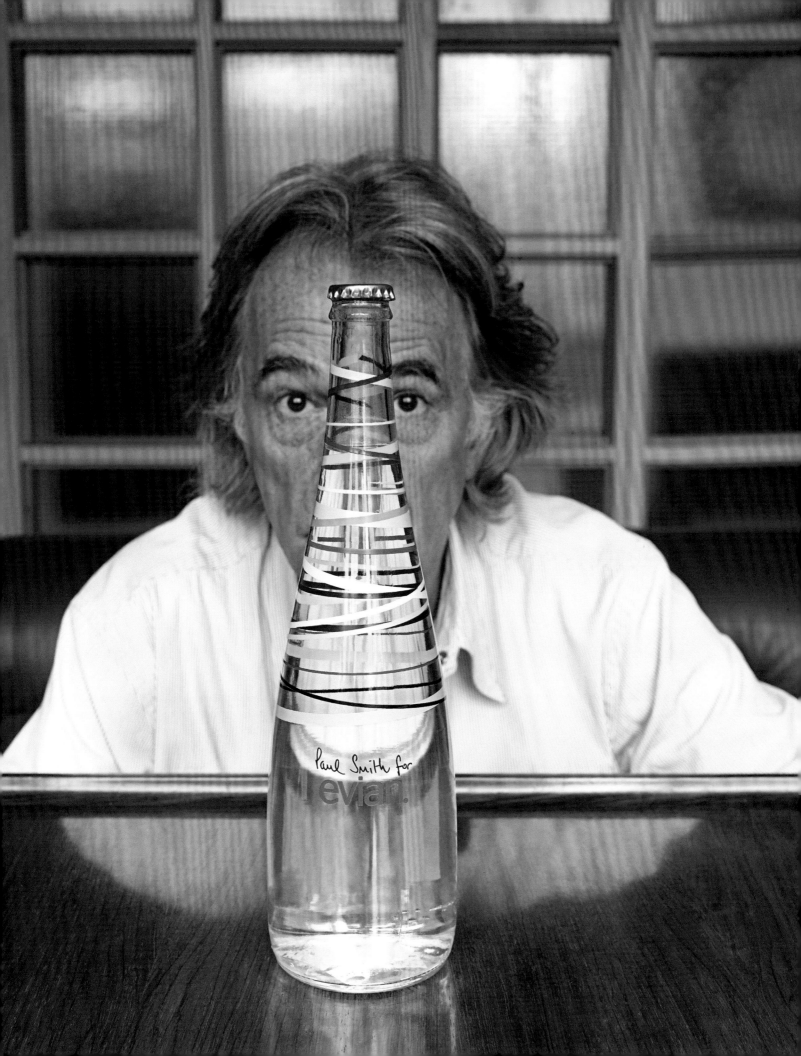

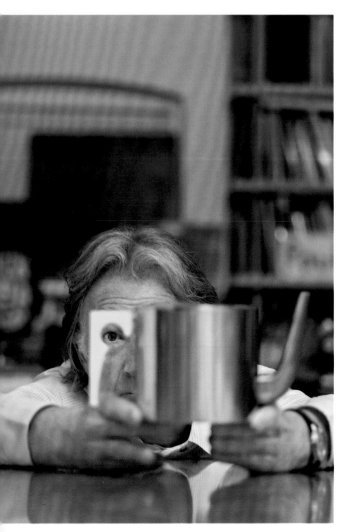

STELTON

2009

To mark the 50th Anniversary of Arne Jacobsen's *Cylinda*, Stelton invited Paul Smith to reinterpret the design with a fresh and contemporary update. Smith had long admired the work of Danish designer Arne Jacobsen, best known for designing the *Egg* and *Series 7* chairs. He was flattered to be asked to re-invent the now iconic *Cylinda* collection. The collection respected the integrity of the original design with tea and coffee pots in hand polished stainless-steel while incorporating highlights of colour on the handles.

The Arne Jacobsen *Cocktail* set was also thoughtfully re-worked. A cocktail mixer, jug, ice-bucket, mixer spoon, tray and coasters were re-coloured in black. Each piece carried a different engraved quote by Smith, 'take pleasure seriously', or 'start something new'.

LEICA CAMERAS

2012

Leica Cameras invited Smith to design a special edition of the Leica X2 digital camera. This camera, the Edition Paul Smith, was limited to just 1,500 units. A particularly striking feature is the unusual combination of colours chosen by Smith for the body. The metal top plate of the camera is finished in dazzling bright orange. Here, only the dials on the top for setting the aperture and shutter speed maintain the familiar classic black design of the original X2. A hand-drawn, engraved light bulb 'doodle', with which Smith calls attention to the unusual pop-up flash on the top of the camera, is a further design highlight. In stark contrast to the orange of the top plate, Smith chose an eye-catching brilliant yellow for the metal baseplate. The makeover is rounded off by a natural cowhide leather finish in racing green. In addition to its own unique serial number, each camera bears one of a series of consecutive limited-edition numbers. The camera is presented in distinctive packaging in coordinated colours.

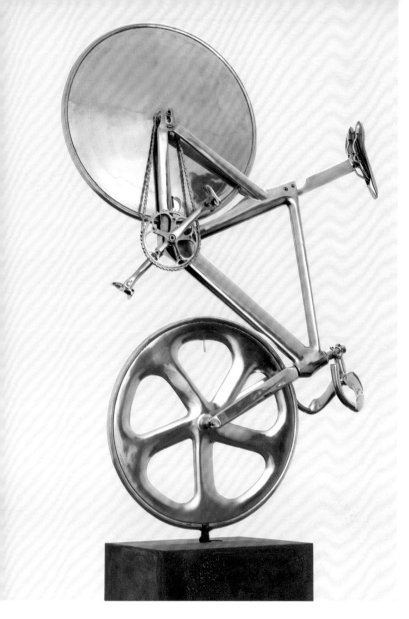

CHARMING BAKER AND PAUL SMITH

Triumph in the Face of Absurdity, 2012

Smith teamed up with artist Charming Baker to produce a sculpture to commemorate the London 2012 Olympic Games. They were commissioned as part of London 2012's Britain Creates project, which celebrated the year of London hosting the Olympics and Paralympic Games. The sculpture, made from aluminium and steel, is called *Triumph In The Face Of Absurdity* and is based on the bicycle ridden by British gold medalist, Sir Chris Hoy. A polished aluminium track bike is balanced vertiginously on its front wheel. On closer inspection, a tiny mouse is revealed bearing the gleaming bike Atlas-like on his shoulders. The irreverent gesture, characteristic of both Smith and Baker, deflates the monumentality of the sculpture, while making its position seem all the more precarious. The sleek lines of the machine built for speed, are emphasised by the liquid mercury-like sheen of the polished metal, which contrasts with the industrial patina of the Corten steel plinth.

MAHARAM

2003

Maharam, founded in 1902, evolved from a source of theatrical textiles for costume and set design to become a pioneer of performance-driven textiles for commercial and domestic interiors. Maharam invited Smith to design a range of seating textiles. *Bespoke Stripe* is an upholstery textile inspired by Smith's take on traditional British tailoring. The term 'bespoke' refers to the tailoring tradition exemplified by Savile Row in London, known since the 1800s for fine custom tailoring and menswear. *Bespoke Stripe* builds on Smith's tradition of textile innovation with a collection of classic menswear fabrics designed for seating application, and features vibrant multicoloured stripes embedded in a menswear pinstripe.

THE RUG COMPANY

2001

Smith was invited by Christopher and Suzanne Sharp, founders of The Rug Company, to bring his inspirational designs to rugs. He was one of the first fashion designers to join the company's Designer Collection. Smith's rug designs are strong in pattern, form, and colour, and they are an extension of his designs for clothes, shirts, and knitwear. He has recently extended his collection for The Rug Company with handwoven wall hangings and cushions. The collaboration has produced a collection of twenty-five designs for rugs including *Swirl*, *Carnival*, *Passion Flower*, *Faded Glory*, and *Stripe*, many of which have become bestsellers. The Paul Smith Rug Collection is knotted by hand at The Rug Company workshops in Nepal.

PENGUIN

2006

TRIUMPH

2005

Paul Smith and Triumph, the legendary British motorbike manufacturer, joined forces to create an international collaboration incorporating bikes, clothing and accessories. Smith customised nine individual Triumph *Bonneville* motorbikes. Each carried a unique Paul Smith design with Union Jack and target print side panels, stripe and chevron mud guards, Multistripe and check tanks, and vividly coloured mock croc and paisley seats.

Smith designed men's and women's motorbike inspired boots in a selection of vintage-feel leathers incorporating interesting details. Soles were photographically printed with an image of a vintage Triumph racing bike, providing that quintessential Paul Smith twist.

TALKS

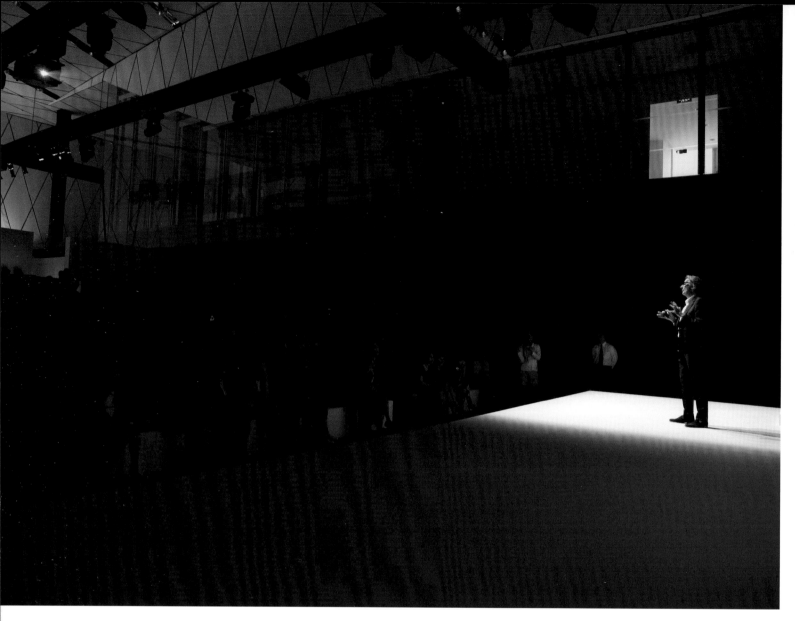

ABOVE *Paul's talk in Beijing, China, 2013*
OPPOSITE *Paul's talk in Tokyo, Japan, 2013*

I get asked to give talks a lot, but unfortunately we have to say 'no' to most people because of my time restraints. But I normally talk once a month at a school, college, or university. More recently, for instance, I've spoken at schools in London, in the countryside, and at a fashion college in Tokyo. I like to try and give back to young people who are interested in creativity, design, or just life itself, because my talks are very much about how to do things, not just about fashion. Also we invite students to look around the studio here in London, and that's another way of communicating with young people. Not only do they get something from it, but I always definitely get something from it. So that's a really great thing we do; people are fascinated by the processes that take place here.

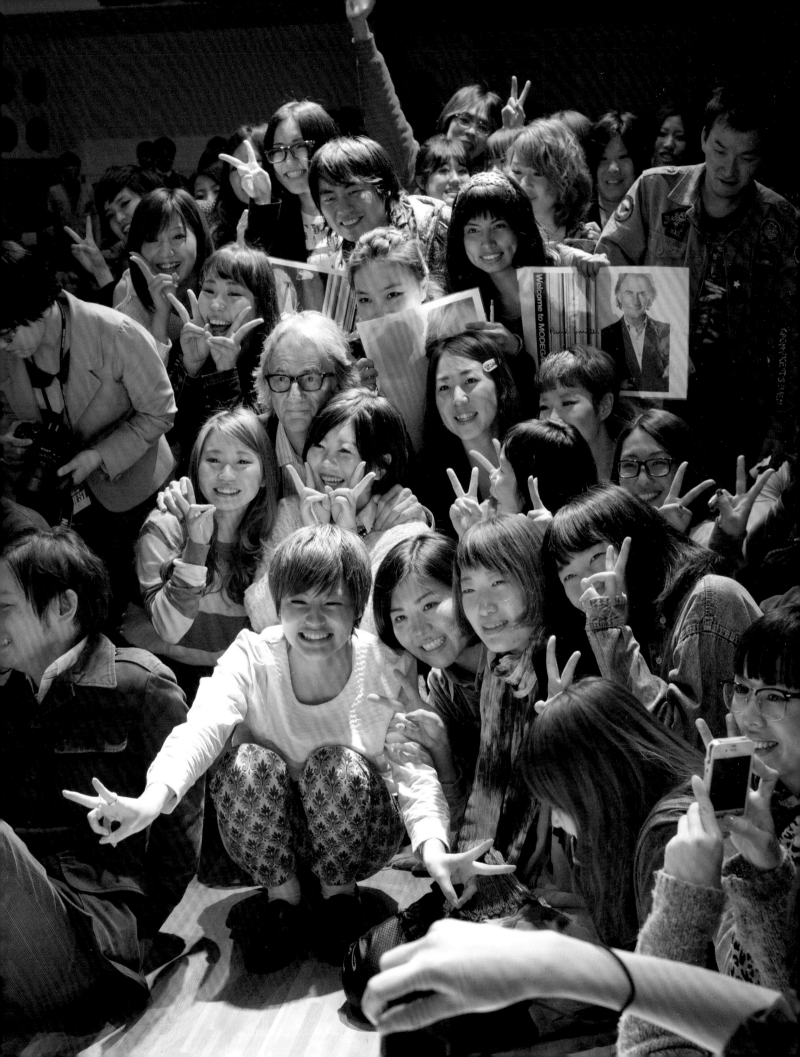

NOTTINGHAMSHIRE
EDUCATION COMMITTEE

BEESTON FIELDS

COUNTY SECONDARY

BOYS' SCHOOL

SCHOOL RECORD

Name *PAUL B. SMITH.*

Sisson & Parker Limited, Nottingham

ABOVE *Paul's school record book, 1958–1962*
OPPOSITE *Paul's school report, 1961*

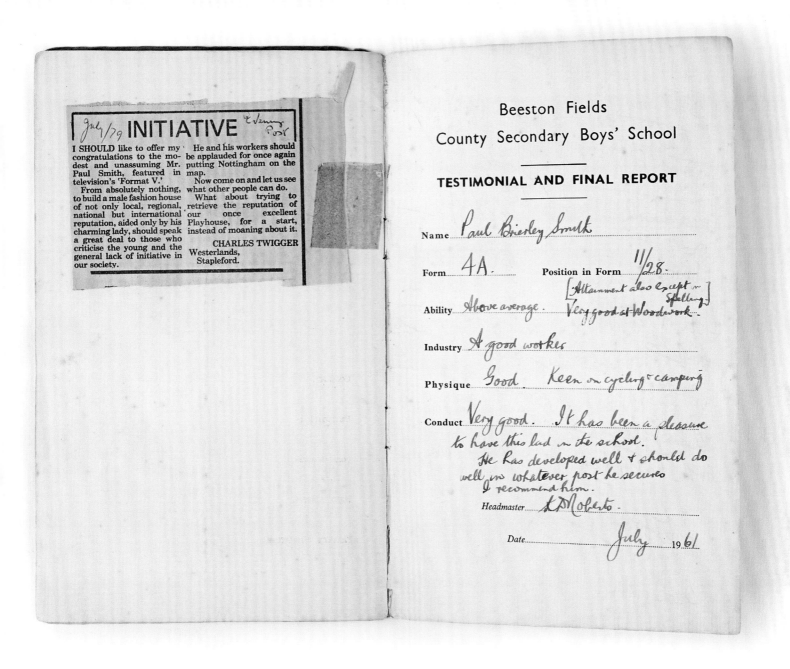

Beeston Fields
County Secondary Boys' School

TESTIMONIAL AND FINAL REPORT

Name *Paul Brierley Smith*

Form *4A.* Position in Form *11/28.*

Ability *Above average.* [Attainment also except in Spelling] *Very good at Woodwork.*

Industry *A good worker*

Physique *Good Keen on cycling & camping*

Conduct *Very good. It has been a pleasure to have this lad in the school. He has developed well & should do well in whatever post he secures I recommend him.*

Headmaster *L.D. Roberts.*

Date *July* 19 *61*

BEESTON FIELDS SCHOOL

In December 2012, Paul Smith received thirty-three letters sent by ten and eleven-year-olds from his old school in Beeston, Nottingham. They wrote to him asking if he could help them out with a design for their school tie. Smith arranged to visit the school. He looked at the ties the children had drawn, showed them some of his own designs, had a tour around the school and then finished the day with a game of football.

In June 2013 the children from Beeston Fields Primary School visited Smith in London. Some of them had never left Nottingham, so Smith rented a coach to bring them to London. He suggested that, with some clues from Paul Smith, the children should design the ties themselves. Smith selected four finalists from the class who were then allowed to choose their favourite. The chosen design was a colourful stripe which the children nick-named 'The Rainbow Tie'. They decided on the name, because there were many different nationalities in their class - they thought a rainbow was appropriate as it touches different people from different countries and backgrounds. Smith then took them to the balcony at Somerset House, pointing out the Thames, the Shard and the London Eye and later showed them around the design studio at Kean Street. Just before they left to return to Nottingham, the children were presented with the new school ties.

Period ending February 1958.

Name P. B. Smith. Form 1A3.

	Marks gained	Position	Grade
SPEECH	17	7	B
SPELLING ..	18	9	B
COMPOSITION	41	7	A
READING	17	8	B
COMPREHENSION ..	39	3	A
ARITHMETIC	36	10	B
ARITHMETIC: MENTAL ..	38	14	B
ART	34	6	B
HANDWORK	87	1/17	A
P. E.	20	27	D
SCIENCE	41	3	A
MUSIC	16	12	B
FRENCH			
~~BIOLOGY~~ Mensuration ..	39	1	A
R. E.	45	1	A
HANDWRITING ..	20	6	A
HISTORY	18	18	C
GEOGRAPHY	44	1	B
ALGEBRA	42	3	A

Summary of Period's Work

POSITION IN FORM 1st

NUMBER OF BOYS IN FORM 31.

GENERAL REPORT: An excellent report. Paul quietly gets on with his work in class and wastes little time. His work is invariably neat and well thought out and he shows a keen interest in all his lessons.

CONDUCT. Excellent.

DETENTIONS: —

FORM MASTER JWParker.

Very well done!

HEAD MASTER K.D.Roberts.

PARENT'S SIGNATURE H. Smith delighted with this result.

ABOVE *Paul's school report, 1958*

Period ending ___February, 1960.___

Name ___Paul Smith.___ Form ___3a.___

	Max.	Marks gained	Position	Grade
SPEECH	50.	38	9	B
SPELLING	25.	16	28	C
COMPOSITION ..	50.	31	17	B
READING	50.	30	28	B
COMPREHENSION ..	50.	38	4	B
ARITHMETIC ..	100	71	24	C
ARITHMETIC: MENTAL	..			
ART	50.	41	4	B
HANDWORK ..	100..	88	1/16	A
P.E.	100..	30	26	D
SCIENCE	50.	37	6	B
MUSIC				
FRENCH	50.	45	5	B
~~BIOLOGY~~ Mensuration.	50	35	9	A
R.E.	50..	32	20	B
HANDWRITING ..	25..	24	1	A
HISTORY	50.	37	14	B
GEOGRAPHY ..	50.	33	5	B
ALGEBRA	50.	42	6	A
	950	668		

Summary of Period's Work

POSITION IN FORM ___16th___

NUMBER OF BOYS IN FORM ___33___

GENERAL REPORT: Paul has made good progress. His class position shows a marked improvement.

CONDUCT ___Very good.___

DETENTIONS: ___—___

FORM MASTER ___C. Good___

A good move-up in class position.

HEAD MASTER ___K. D. Roberts___

PARENT'S SIGNATURE ___Harold B. Smith___

LEFT *Beeston Fields Primary School visit to Kean Street, 2013*

236

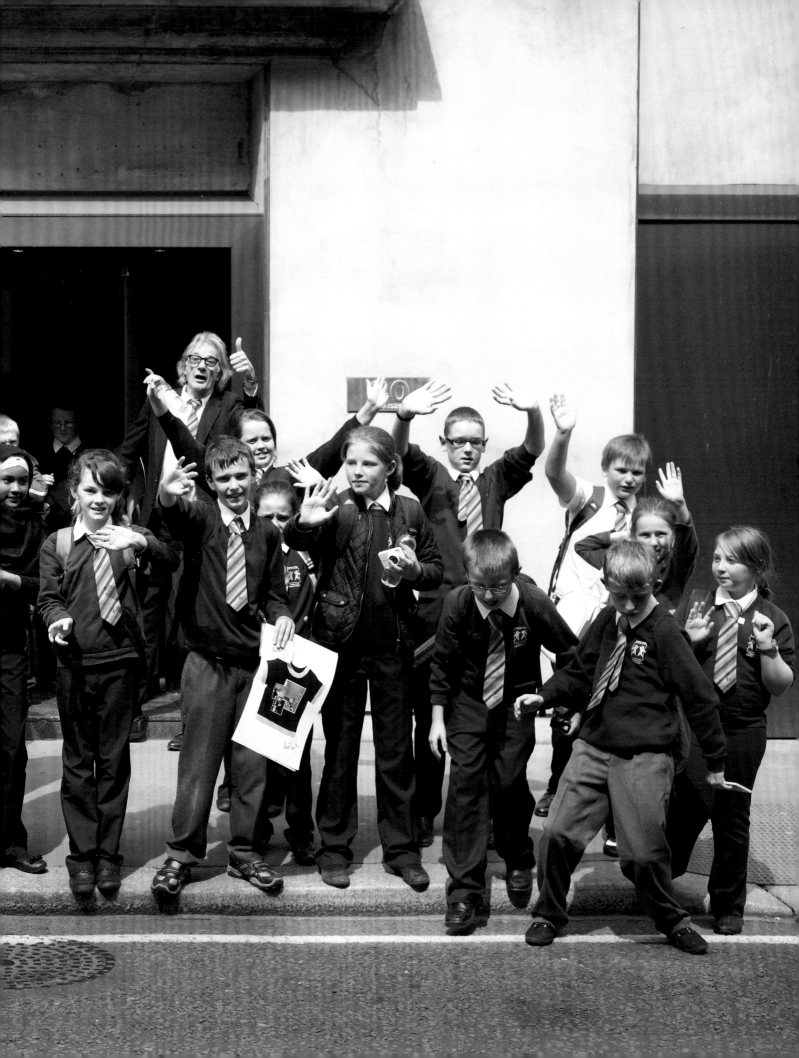

THE OFFICE

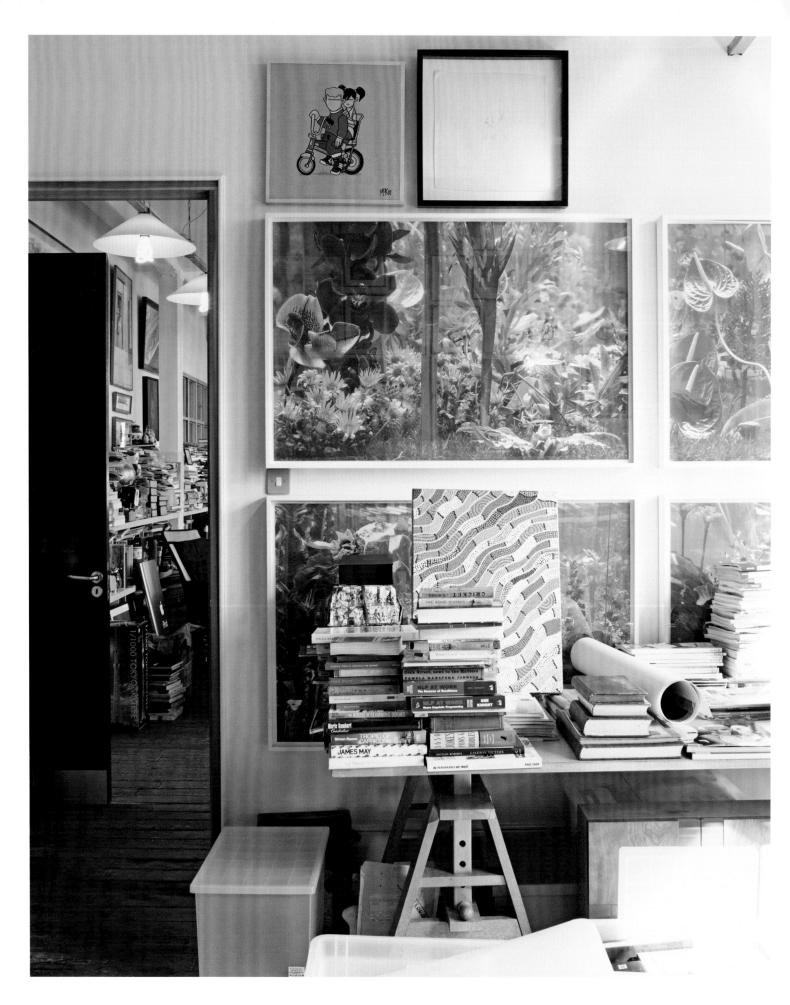

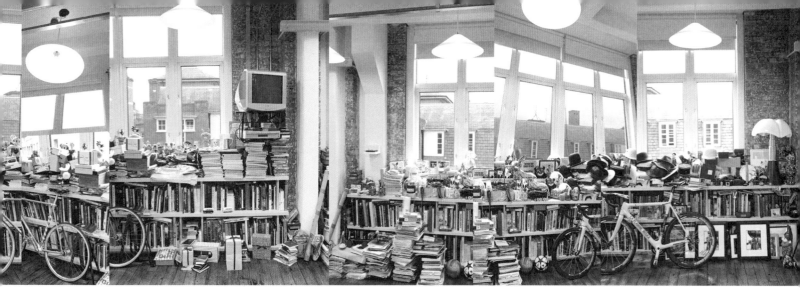

Visitors find the space chaotic; for me it seems very organised.

My office is full of all sorts of things: books, kitsch things, beautiful things, special things, objects. They're all to do with my fascination with how things are created and why they're made. This is especially true of toys. Children are pretty hard to please sometimes, and I think the design of toys is very interesting. The same is true of more up-to-date objects, like the high-tech things produced by Apple or modern communication tools. It's really a mix of things that are very basic and things that are very high-tech, things that are kitsch and things that are beautiful. From all of the things accumulated in my London office, one idea will form and be the inspiration for a collection or for the design of a shop.

When I first arrived in this office, the space was empty. Since then, I have consciously filled it with things that 'talk to me'. I know the exact location of each object, each gadget – except when I come back from holiday. If someone has put something away, it becomes a problem and I am lost. Visitors find the space chaotic; for me it seems very organised.

OPPOSITE AND ABOVE
Views of the office interior at Kean Street, London

SCALE MODEL

Smith is regularly sent gifts and letters from all over the world. Objects such as a watering can, a football, a pair of waterskis, and a surfboard have arrived through the post but never in a box – always with the address and stamps on the actual object. One of Smith's most treasured objects is a perfect scale model of his office made of paper and laser-cut metal. It contains pink cherry blossom and from the window, instead of views of office buildings, it has views of Mount Fuji.

The model was created by a young man who was having problems finding a suit to fit and had always loved Paul Smith clothes. Smith, whilst in Japan, sent a suit for him, and as a thank you, he created the scale model from photographs of the office interior.

OPPOSITE *Scale model of Paul's office*

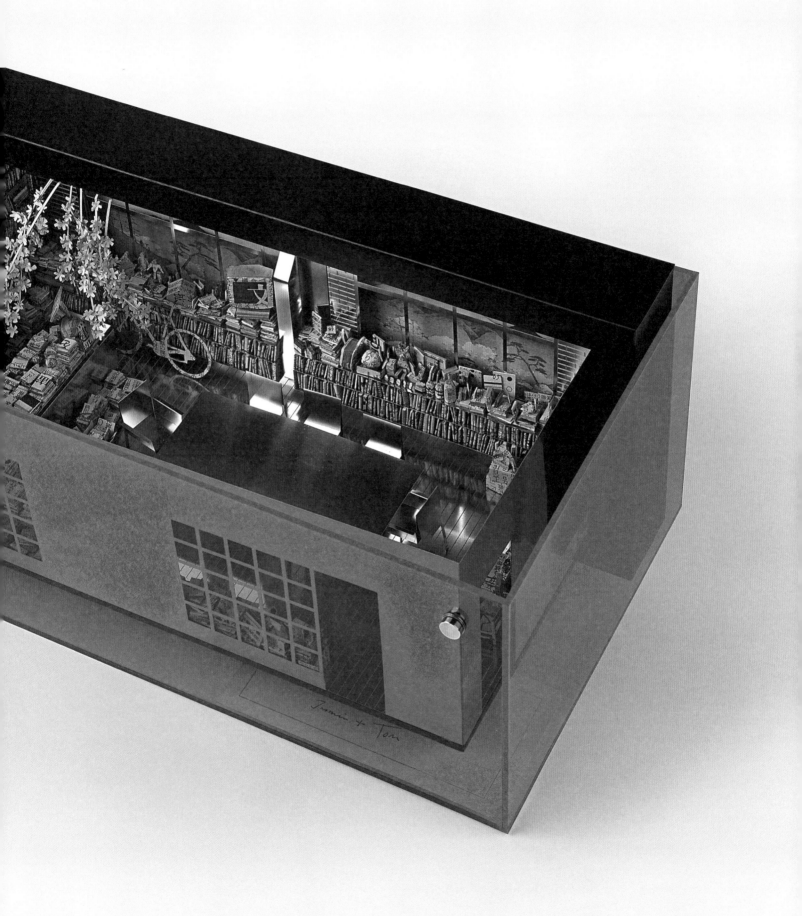

CYCLING JERSEYS

One of Smith's biggest passions is cycling. He recalls that between the ages of eleven and seventeen, he had nothing else in his life apart from cycling, and he continues to follow the sport today. Many of Paul's friends are professional cyclists and regularly send him signed jerseys. In the office there are jerseys from Mark Cavendish, Victoria Pendleton, Nicole Cooke, Chris Hoy, David Millar, and Bradley Wiggins. There are jerseys from the Japanese national champion, the Belgian national champion, the *Tour de France*, *Giro d'Italia*, and the *Vuelta a España*. There are also important jerseys from the 1960s and 1970s, including one from Smith's cycling hero, Jacques Anquetil. One of Smith's most prized jerseys is from 1973, from the world championship winner Felice Gimondi. This jersey is made from wool; today all cycling jerseys are made from Lycra.

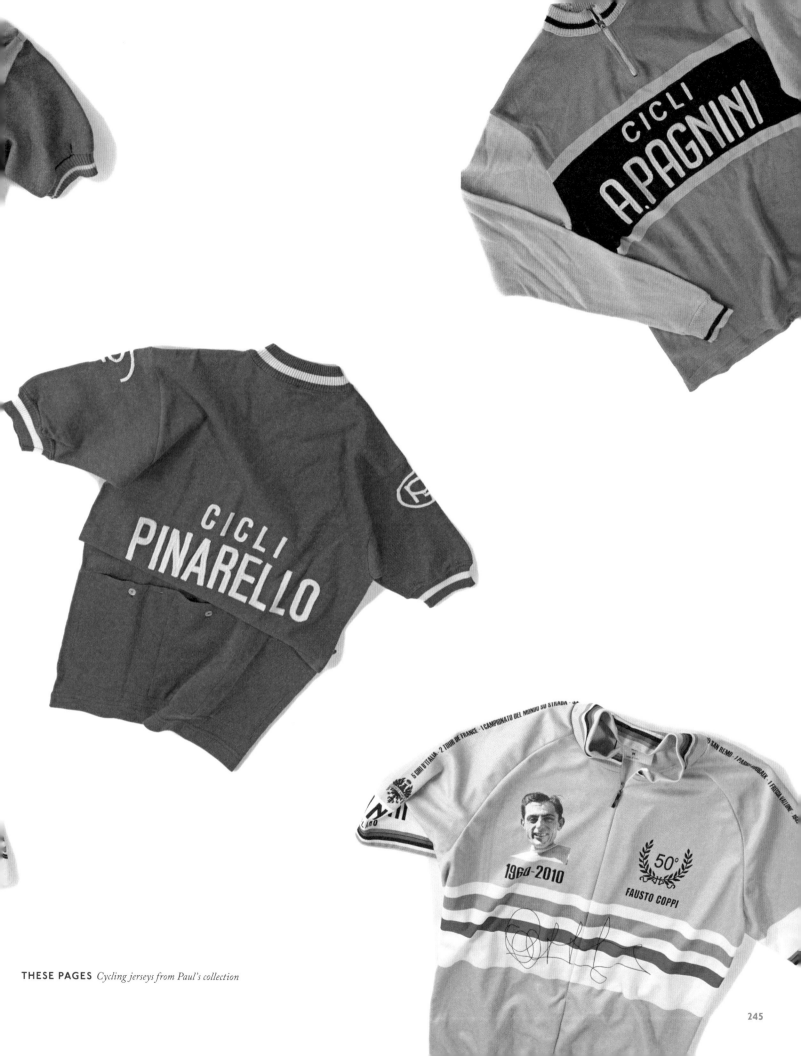

THESE PAGES *Cycling jerseys from Paul's collection*

VINTAGE CAMERAS

One of Smith's favourite phrases is 'inspiration is all around us', and he uses a camera to keep track of his sources of inspiration. His camera is with him at all times and serves as a 'visual diary'. Smith's interest in photography came from his father, who was an amateur photographer and founder member of the local camera club. Smith recalls watching his father's photo setups in the back garden and then seeing him develop photographs in a homemade darkroom in the attic of the house. Smith's father bought him his first camera when he was eleven years old, and the designer continues to take photographs every day.

Smith's collection of photographic prints, photography books, and vintage cameras has been built up over many years and reflects a love of all aspects of photography. It includes early Brownie box cameras, a 1930s Rolleiflex camera, Ricoh solar-powered cameras, a wartime Leica Luftwaffe camera, Ilford colour cameras from the 1950s, and an unusual Polaroid tin camera from Africa.

OPPOSITE *Cameras from Paul's collection*

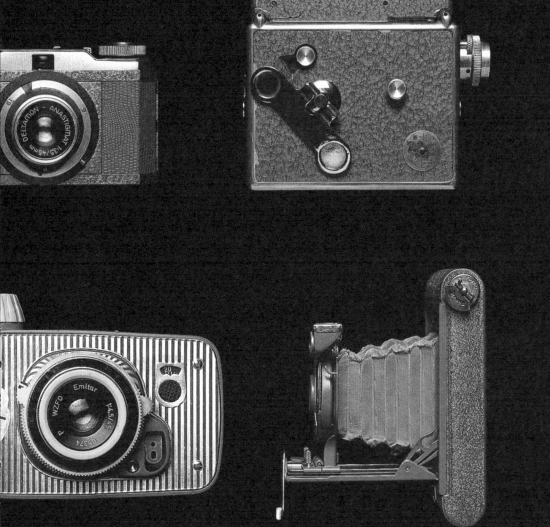

RABBITS

Smith's love of rabbits is well known. A chance remark made while gazing out of a window during a train journey with a friend in the 1980s - 'If I see a rabbit, it will be good luck for me' - inspired Paul's friend to send a large toy rabbit to his office. Today Smith receives between six and twenty rabbits a week, and there are currently eighty boxes full of rabbits stored in the warehouse in Nottingham. Rabbits can be found everywhere in the office – in the form of toys, sculptures, and in books. There are rabbits made from ceramic, cloth, paper, and carved wood. On one occasion, a woman even turned up at a Paul Smith fashion show in Paris carrying a live rabbit!

TRAIN SETS AND RUBBER CHICKENS

When he first started travelling to Japan in the 1980s
and felt the mood getting too serious during business
meetings, Smith would, at the appropriate time, place
a metal suitcase onto the table in front of him and open
it to reveal a toy train set. Alternatively, he would pull
from his bag a rubber chicken. His meetings in Japan
became very popular with businessmen, many of whom
joined the meetings just to catch a glimpse of the famous
train set or the rubber chicken.

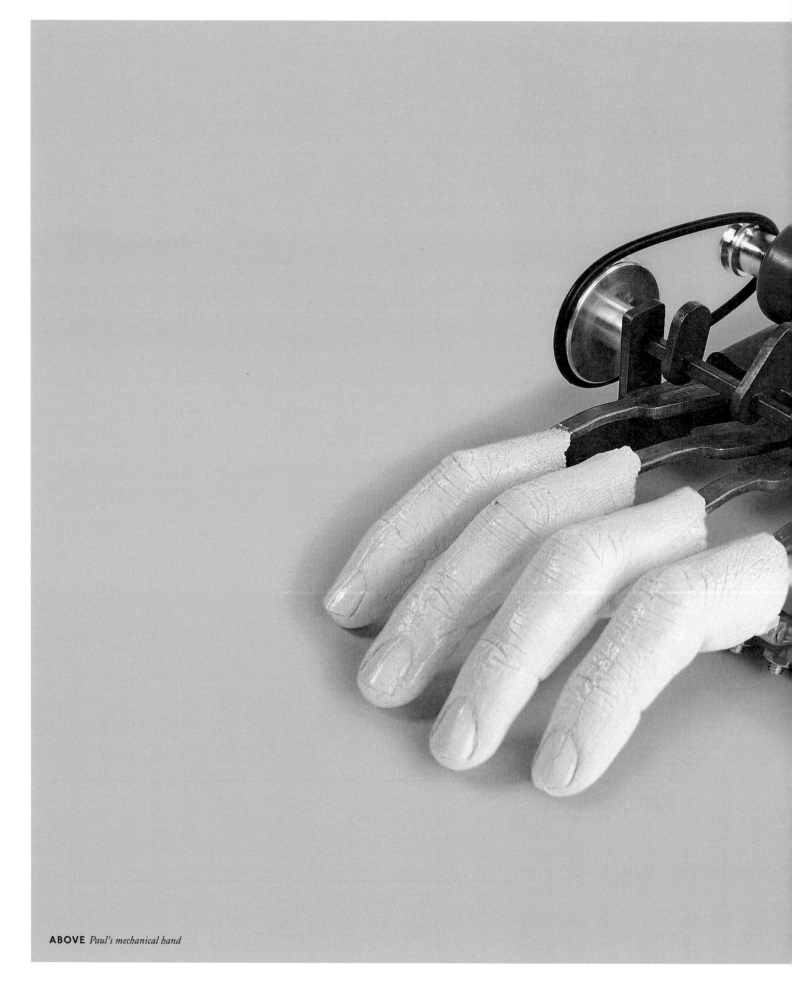

ABOVE *Paul's mechanical hand*

MR. MACHINE

Smith received Mr. Machine as a gift from a close friend, Eddy French. He liked him so much that he then went on to buy others in the series. Mr. Machine was a popular children's mechanical toy originally manufactured by the Ideal Toy Company in 1960. It is an eighteen inch tall robot-like mechanical man, wearing a top hat. The body had a giant windup key at the back. When the toy was wound up it would 'walk', swinging its arms and repeatedly ringing a bell mounted on its front. After every few steps Mr. Machine would emit a mechanical 'Ah!', as if it were speaking. The gimmick of Mr. Machine was that the user could not only see all of his mechanical 'innards' through his clear plastic body, but could also take the toy apart and put it back together, over and over again like a Lego toy or a jigsaw puzzle. Mr. Machine was one of Ideal's most popular toys. The company reissued it in 1978, but with some alterations.

MARGOT'S CORNER

Margot has been writing to Smith for many years. Her handwritten letters as well as gifts contained within beautifully handcrafted envelopes and packaging have inspired a corner in the office known as 'Margot's Corner'. One Christmas, she sent Smith a Nativity scene modelled out of whole peanut shells. The Nativity is complete with a Mary, Joseph, baby Jesus, three kings, and an angel Gabriel.

OPPOSITE *The peanut nativity scene, Margot's corner*

BRUCE WEBER

One of Smith's friends is the photographer Bruce Weber. Close to Weber's New York home is the coincidentally named Paul Smith College. Weber frequently sends Smith souvenirs from the college – baseball caps, T-shirts, bags – with the name 'Paul Smith' emblazoned across them. Smith keeps this memorabilia in a Bruce Weber bag in his office, together with examples from their many collaborations over the years.

ABOVE *Gifts to Paul from Bruce Weber*
LEFT *Collaborations between Bruce Weber and Paul*
OPPOSITE *Bruce Weber at a book signing, Floral Street*

BRUCE
HERE

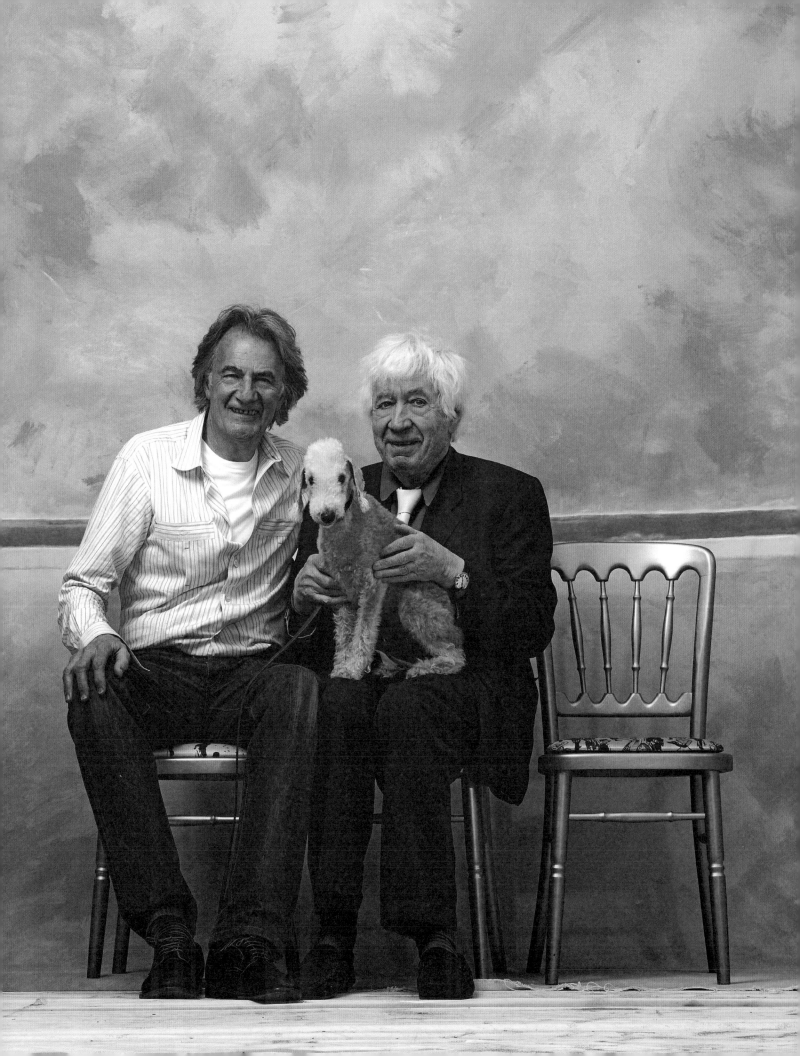

CRAIGIE AITCHISON

Smith has collected art and photography for many years. The walls of his offices at Kean Street, London, and the interior walls of many of his shops are covered with works of art, some by established artists, including Le Corbusier, Peter Blake, Marc Quinn, David Bailey, Bruce Weber, and Banksy. Some are by unknown artists or students from the Slade, and others are anonymous sketches sent to Smith. One of Smith's favourite artists is Craigie Aitchison (1926–2009). He is a great admirer of Aitchison's paintings composed of simple lines and vibrant, optimistic colours. In April 2008, Smith organised an exhibition of Aitchison's work in the gallery of his Tokyo shop Space.

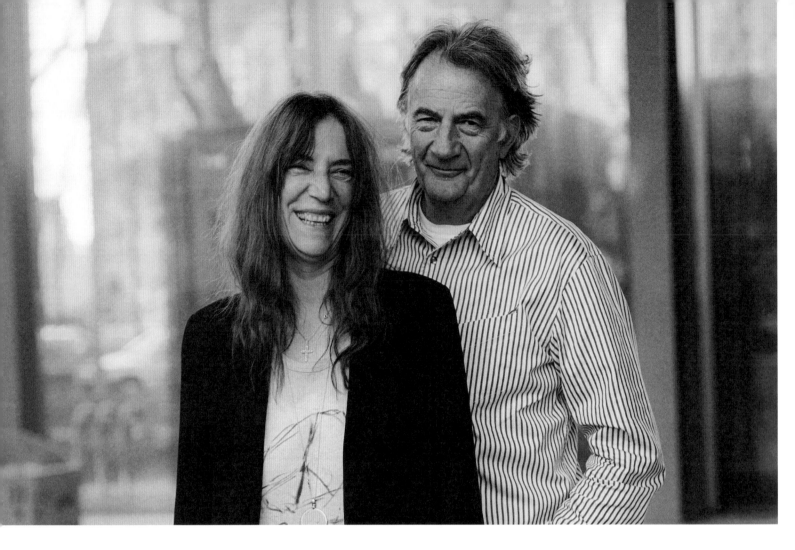

PATTI SMITH

Many Paul Smith customers are musicians, a number of whom he has interviewed and photographed. In particular, Smith has been a fan of Patti Smith ever since he first saw her in concert in 1972. He liked the fact that she wrote poetry, took photographs, and painted. Over many years, Patti Smith has sent Smith a large number of her photographs, which are hung on the walls of the office.

ABOVE *Paul with Patti Smith*
OPPOSITE *'Mr. Howdy Doody', a gift to Paul from Patti Smith*

ACKNOWLEDGEMENTS

The authors would like to thank:

Pauline Denyer Smith

Alan Aboud and his team -
Jamie Register, Lisa Comerford, Jo Mansfield,
gratefully assisted by Jo Woolhead, Robin Kelly,
Pauliina Lehtonen and Anthony Gerace.

Giulia Ascoli at the Design Museum, London

Charles Miers at Rizzoli

Graham Addinall

The Paul Smith team - *London* - Jonathan Towle, Shelley
Landale-Down, Kirsty Taylor, Adam Herbert, Isabel
Vince and Colette Youell. *Nottingham* - Jackie Hart, James
Pakenham, Dominic Garton, Emma Middleton, Maria
Piliero, Charlotte Watts, Oliver Leach, Frances Beale,
Robert Pickup and Mo Brittain. *Paris* - Odile Idkowiak.
Tokyo - Michiko Katsura

Hettie Judah

Rainer Usselman and Caroline Ash at Happy Finish.

TAPS YOU TURN
DOORS YOU BOLT
LIGHTS YOU SWITCH ON

THE LOVE OF LIFE

CONCENTRATE ON THE
DOUGHNUT NOT THE HOLE

HAPPINESS IS THE ROAD
TO EVERYTHING

WORK IS NOT ABOUT SHORTER
HOURS OR LONGER HOURS.
ITS ABOUT EVERY HOUR

WORDS SPOKEN
SOMETIMES DISAPPEAR BUT
WORDS WRITTEN LAST FOREVER

LIFE IS LIKE A JIGSAW. AS YOU
GET OLDER IT GETS MORE CLEAR
AND 'FITS TOGETHER'

CHRONOLOGY

1946	• Paul Smith is born
1970	• First shop opens at 6 Byard Lane, Nottingham
1976	• First Paul Smith collection is shown in Paris
1979	• First London shop opens at 44 Floral Street, Covent Garden, WC2
1982	• Second London shop opens at 23 Avery Row, W1
1983	• Third London shop opens at 43 Floral Street, Covent Garden, WC2
1984	• Paul Smith Ltd. signs licence with Japanese company, American Jacket
1987	• First New York shop opens at 108 Fifth Avenue
• Fourth London shop opens at 41/42 Floral Street, Covent Garden, WC2	
1989	• First London showroom opens at 7/8 Langley Court, Covent Garden, WC2
1991	• Smith receives 'Royal Designer for Industry' award
• Flagship shop opens in Tokyo making a total of 60 shops in Japan	
1992	• Sales/Press office opens in Paris (May)
• Sales/Press office opens in Milan (July)	
1993	• First Paris shop opens at 22 Boulevard Raspail (January)
• Launch of the first Paul Smith Women's collection, Spring Summer 1994 (October)	
1994	• Smith awarded CBE for his services to fashion design (January)
• Launch of Spectacles collection (February)	
• Launch of Luggage collection (April)	
• Launch of Watch collection (October)	
1995	• Paul Smith Ltd. awarded the 'Queen's Award for Enterprise: International Trade' (April)
• Paul Smith *True Brit* exhibition at the Design Museum in London (October 95 - April 96)	
• Launch of the Paul Smith website - paulsmith.co.uk (October)	
1996	• Paul Smith *True Brit* exhibition in Glasgow as part of Festival of Design (September)
1997	• Smith awarded the Honorary Freedom of the City of Nottingham (February)
• Paul Smith *True Brit* exhibition at the Nottingham Castle Museum (May - August)
• Women's shop opens at Sloane Avenue, South Kensington, SW3 (September) |

1998	• First Women's show at London Fashion Week (February)
• Launch of Paul Smith Mini 'Art Car' available in the UK and Japan only (April)	
• Westbourne House opens at 122 Kensington Park Road, Kensington, W11 (May)	
• A bespoke tailoring service is offered for the first time at Westbourne House (May)	
• Paul Smith *True Brit* exhibition travels to Japan (Tokyo, Kobe and Fukuoka) (September)	
• Portrait of Paul Smith by James Lloyd, winner of the BP portrait award, unveiled at the National Portrait Gallery (December)	
• Paul Smith Ltd. and Inter Parfums Inc. sign licencing agreement (December)	
2000	• Launch of 'Paul Smith Men' and 'Paul Smith Women' fragrances (June)
• Smith awarded a knighthood by HM the Queen (November)	
• First shop opens in Milan, at Via Manzoni 13 (February)	
2001	• *You Can Find Inspiration in Everything…* book published by Violette Editions (October)
• Collaboration with The Rug Company	
2002	• London showrooms and headquarters opens at 20 Kean Street, Covent Garden, WC2 (January)
• Milan showroom and press office open at Viale Umbria, 95 (January)	
• Smith judges at the Design Museum 'Designer of the Year' award (June)	
2003	• Smith wins the 'Menswear Designer of the Year' and 'Contemporary Designer of the Year' at the British Fashion Awards (September)
• Collaboration with Maharam	
2004	• Launch of the Paul Smith e-commerce site (October)
2005	• Smith receives the 'Great Britons Award for Business' (January)
• Collaboration with Triumph motorbikes	
• First Los Angeles shop opens at 8221 Melrose Avenue (December)	
2006	• Sales/Press office opens in Sydney, Australia (January)
• Tokyo flagship shop Space opens in Shibuya (April)	
• New York flagship shop opens at 142 Greene Street (October)	
• Collaboration with Penguin Classics to create a limited-edition cover for *Lady Chatterley's Lover* by D. H. Lawrence	
• Broadway Cinema, Nottingham opens the Paul Smith Auditorium	
2007	• Smith is awarded Honorary Fellowship of RIBA - Royal Institute of British Architects (February)
• Smith awarded membership of the Fragrance Foundation 'Circle of Champions' (November)
• Collaboration with Mercian Cycles |

2008
- Globe shop opens at Heathrow Airport, Terminal 5 (March)
- Signs agreement to design and supply first team and officials with formal wear and accessories for Manchester United Football Club
- Collaboration with Evian

2009
- First Las Vegas shop opens at 3720 South Las Vegas Boulevard (December)
- Paul Smith Ltd. awarded second 'Queen's Award for Enterprise'
- Launches a reinterpretation of Arne Jacobsen's *Cylinda* collection with Stelton

2010
- Smith is made an Honorary Senior Fellow of the Victoria and Albert Museum (March)
- Launch of Paul Smith Junior, a new children's wear collection (July)
- *Inside Paul Smith* exhibition held at the Daelim Contemporary Art Museum, Seoul, South Korea (September - November)

2011
- Seoul flagship shop opens at Dosan Park (April)
- First Japanese Paul Smith fashion show, Spring Summer 2012, shown in Tokyo (October)
- Smith received 'British Fashion Award for Outstanding Achievement' (November)
- *Paul Smith: Gentleman Designer* documentary by Stéphane Carrel for Arte (November)
- Collaboration with Burton Snowboards

2012
- Launch of Olympic stamps for Isle of Man Post Office (January)
- Showroom opens in Dusseldorf, Germany (January)
- First shop opens in Melbourne, Australia, at 120 Collins Street (May)
- Collaboration with John Lobb
- Collaboration with Leica cameras
- Collaboration with Charming Baker for London 2012's Britain Creates project
- Women's shop opens in Paris, at 32 Rue de Grenelle (December)
- Showroom/Press office opens in Paris, at 70 Rue des Archives (December)

2013
- Beijing flagship shop opens at 11 Sanlitun Road (May)
- Paul Smith designs the leaders' jerseys for *Giro d'Italia* including the *Maglia Rosa*
- Shop opens at 9 Albemarle Street, London (September)
- *Hello, My Name Is Paul Smith* exhibition at the Design Museum, London (November 2013 - March 2014)
- *Hello, My Name Is Paul Smith: Fashion And Other Stories* book published by Rizzoli to coincide with the Design Museum exhibition (November)

IMAGE CREDITS

ANNA ARCA 80, 82
ALAN ABOUD 33, 37, 90, 91, 100, 107, 217, 231, 237, 269
DAVID BAILEY 93, 186, 187
DAVID BANKS 85
COLIN BARNES 47
NICHOLAS BARTLE 214
NEIL BEDFORD 114
JULIAN BROAD 196-197
DANI BRUBAKER 115
LISA COMERFORD 21
ANTONY CROLLA 8, 9, 16, 17, 22, 23, 26, 27, 28, 30, 31, 215, 232-235, 243-245, 248-258, 263
PAULINE DENYER SMITH 68, 69
RONALD DICK 114

NIGEL DICKER 49
KARL DONOVAN 76
BRUCE GILDEN 227
HUGH HALES-TOOKE 180-185
GEORGE HARVEY 20
ADAM HERBERT 25
KARL KOPINSKI 5
KYOUICHI OKADA 88, 89
STEPHEN LANGMANIS 34, 107
VIVIAN MACKERRELL 63
JAMES MOONEY 14
CHRIS MOORE (CATWALKING) 98, 99
MAX OPPENHEIM 115
PUNKFLOYD (h.mAsAki) 76, 77
RICHARD RIDDICK 222
JOHNNIE SHAND KYDD 18

SHOJI FUJII 32, 78, 79, 111-113, 149
HAROLD B. SMITH 58, 66
PAUL SMITH (SIR) 20, 59, 61, 101, 114, 115, 177, 198-199, 202-209, 259
PAUL SMITH 87
PAUL SMITH LTD 6, 8, 9, 29, 38, 40, 42, 43, 44, 45, 52, 53, 54, 94, 95, 97, 120-144, 148, 152-173
SANDRO SODANO 15, 35, 41, 115, 192-195, 218-219, 220, 223, 241, 247, 260-261
TAROUT 103
MARIO TESTINO 188-191
GÉRARD UFÉRAS 262
ANNEMARIEKE VAN DRIMMELEN 114
ANNELIE VANDENDAEL 115
YURIKO TAKAGI 178, 179

MODEL CREDITS

ERIK ANDERSSON (FM London) *111, 119*
BEX (Premier Model Management) *114*
JIMMY BEAUQUESNE (Nathalie Models Paris) *32, 114, 198*
PAUL BOCHE (Elite Models London) *111, 114*
MARC BRADY (Supa Model Management) *114*
KARLINA CAUNE (Viva Models London) *78, 79*
RAMONA CHMURA (Next Models) *205*
GEORGINA COOPER (Premier Model Management) *194-195*
ELIAS (Bruce and Brown) *115*
SALOMON FAYE (Request NY) *114*
JULIA FRAUCHE (Next Models) *78, 79, 114*

DOMINKA GRNOVA (Next Models) *203*
QUERELLE JANSEN (Storm Models) *198*
BRAD KROENINGER (Premier Model Management) *194*
IRINA KULIKOVA (IMG Models) *113*
TALI LENNOX (represented by Next Management) *209*
ANGUS LOW (Next Models) *111*
STEVEN McCRAE (The Royal Ballet) *204*
SOJOURNER MORRELL (Storm Models) *113*
AGNES NABUURS (Viva Models London) *113*
NOMA HAN (Angels & Demons Models) *111*
MELISSA TAMMERIJN (Nathalie Models) *113*

STEPHANE OLIVIER *77*
TY OGUNKOYA (Premier Model Management) *111*
LOUISE PARKER (Select Models) *78*
YURI PLESKUN (Bananas Models) *149*
BAPTISTE RADUFE (Elite Models London) *111*
TAMARA ROJO *204*
THOMAS SNEESSENS (Success Models) *111*
NASTYA SVIRIDENKO (FM London) *203*
MICHON VAN AS (Next Models) *114*
RENEE VAN SEGGERN (Union Models) *112*
JAMES WELLS (Casting Real) *114*
JEREMY YOUNG (Models1) *115*
ALEXA YUDINA (Supreme Model Management) *113*

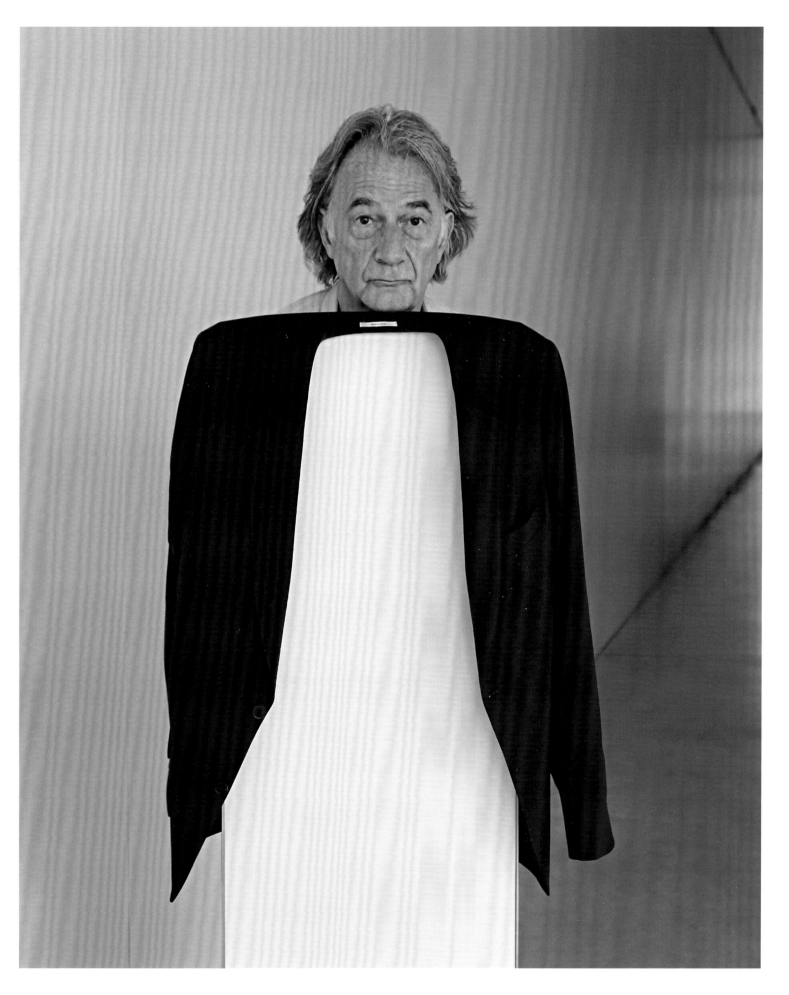

269

INDEX

EVERY DAY
IS A NEW

BEGINING

i want a business and shops that difine me that now changing merely making money isn't interesting

MORE FROM LESS

MAKE STEPPIN STONES out of stumbl-ing Blocks

THE INTELLIGENCE OF THE POOR (deprived)
RESOURCEFULNESS BORN OF NECESSITY
WORKING THINGS OUT BECAUSE YOU HAVE NO CHOICE
THK NRC People

DO WHAT IS CORRECT NOT WHAT IS EASY.

the execution of The idea is the difference between success & failure

The commercial side of Christmas is so sad

It's good to put yourself where you don't belong